Adams Central
H.S. Art
1991

ADAMS CENTRAL

H.S. Art

1991

The PURPOSE of Painting

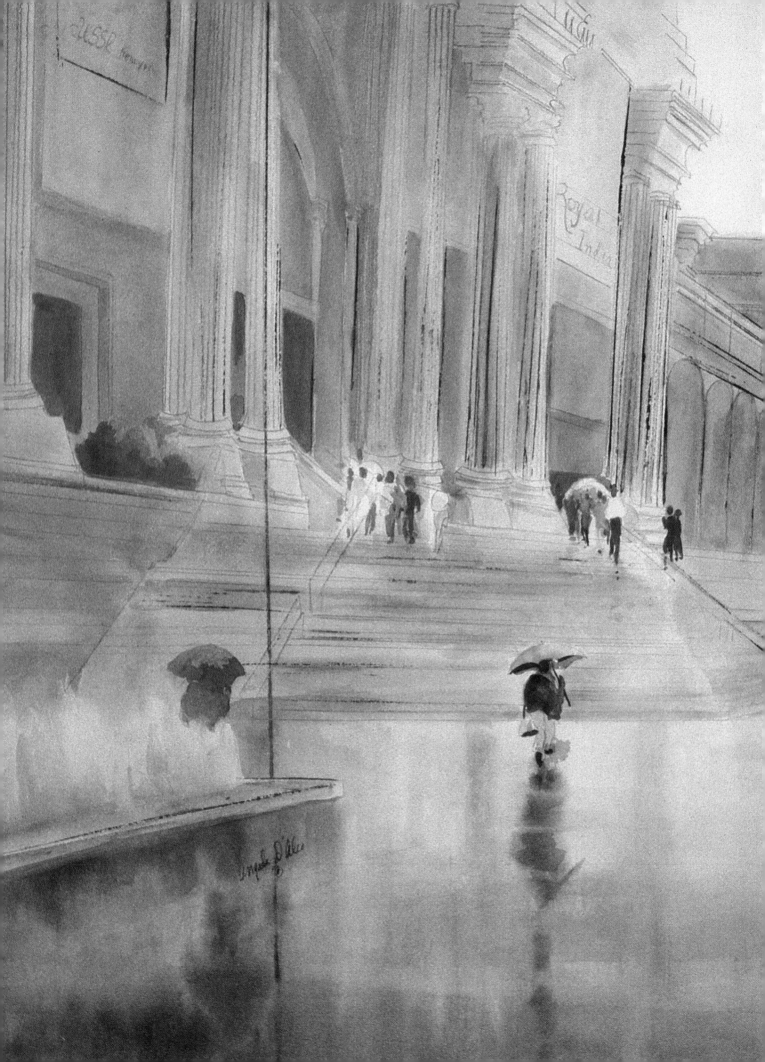

The PURPOSE of Painting

Angela D'Aleo

WATSON-GUPTILL PUBLICATIONS/NEW YORK

Overleaf:
MET SERIES 1
Arches 260 lb., cold-pressed,
26" × 40" (66.0 × 101.6 cm)

Copyright © 1989 Angela D'Aleo

First published in 1989 in New York by Watson-Guptill Publications,
a division of Billboard Publications, Inc.,
1515 Broadway, New York, N.Y. 10036

Library of Congress Cataloging-in-Publication Data

D'Aleo, Angela.
 The purpose of painting : thoughtful approaches to expressing
yourself with watercolors
 p. cm.
 Bibliography: p.
 Includes index.
 ISBN 0-8230-4456-4 : $27.50
 1. Watercolor painting—Technique. I. Title.
ND2420.D33 1989
751.42'2—dc19 88-28309

Distributed in the United Kingdom by Phaidon Press Ltd.,
Littlegate House, St. Ebbe's St., Oxford

Printed and bound in Spain by
Printer Industria Gráfica, S.A.
Barcelona. D.L.B. 42.248-88

First printing, 1989

1 2 3 4 5 6 7 8 9 10 / 93 92 91 90 89

Edited by Candace Raney and Lanie Lee
Designed by Jay Anning
Graphic production by Ellen Greene

This book is the result of many years of effort and dedication. I would like to thank everyone who was involved in making my dream come true:

Eloise Gardiner Giles, my mentor, taught me to see and think as an artist. She proved to me that anything could be said by using watercolors, and introduced me to many of the techniques used in this book, which I pass on to the readers. But most of all, Eloise is a great artist, teacher, and friend who taught me to believe in myself and gave me the encouragement to keep painting.

Flavia Helen Wyeth, a great artist and friend, who is the spirit of this book.

My family, especially my husband, John; my son, John; and my daughter, Kristen, who helped me through it all. My sisters Rosemarie and Josephine for always being there.

My friends, for their encouragement and assistance whenever it was needed, especially Daniel Illig and Grace Oberle.

The wonderful staff at Watson-Guptill: Mary Suffudy, Glorya Hale, Candace Raney, and Lanie Lee.

Finally, I would like to thank the editor-in-chief of *American Artist* magazine, Stephen Doherty. He made me feel that I could make this book into a reality.

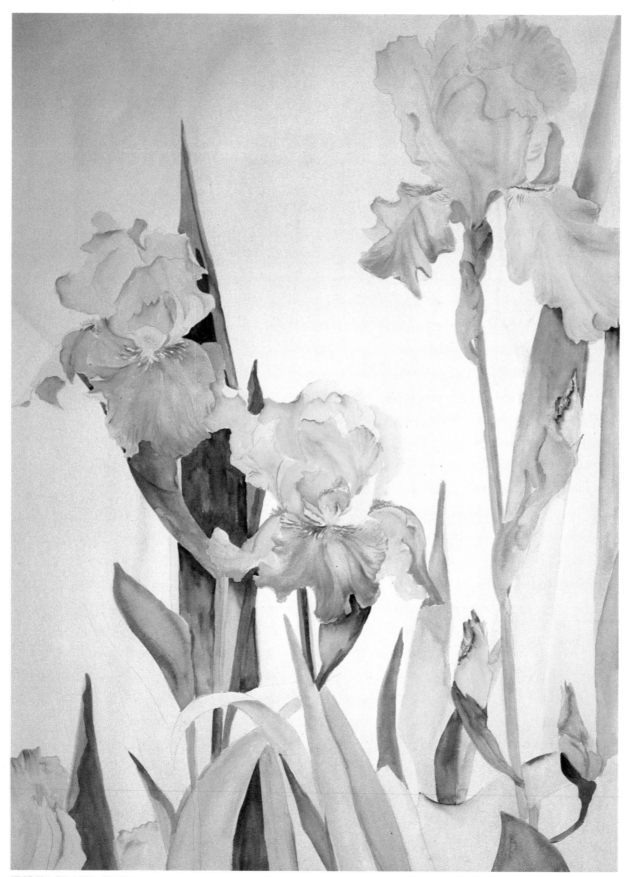

IRIS IN GRAND STYLE *Arches 140 lb., cold-pressed, 45″ × 35″ (114.3 × 88.9 cm)*

CONTENTS

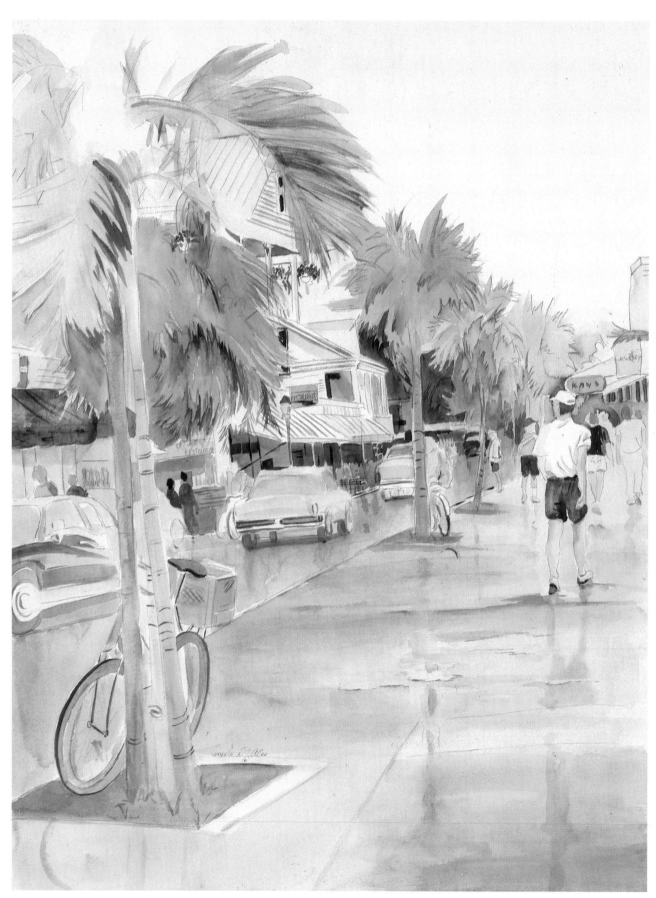

KEY WEST *Arches 140 lb., cold-pressed, 30″ × 22″ (76.2 × 55.9 cm)*

PREFACE

Having always been interested in art, I worked in all the different mediums: oils, acrylics, and pastels to name a few. But when I was introduced to watercolor, I found the method of expression I was looking for. Working with watercolors is the most diversified and challenging medium. It invites the use of limitless techniques on countless supports. Because of this, my search for knowledge has been endless.

While reading *The Art Spirit* by Robert Henri, I found several statements that ultimately had the greatest influence on my work. Henri writes that, "It would be easy to divide artists into two classes: those who grow so much within themselves as to master technique by the force of their need, and those who are mastered by technique and become stylists." As I read on, he wrote how we are all fascinated in watching any demonstration of an acquired skill, but unless the skill is directed toward an expressive or productive end it becomes a diversion. The following statement also by Henri really made me think about what I was doing with all the knowledge I had gained in my ambitious quest to be an artist: "Without a positive purpose, means effect only an exercise in means." I had to ask myself: What is the purpose of painting?

Through years of research, reading, thinking, experimenting, observing, and teaching, I found the answers I had been looking for. It is with that enthusiasm that I write this book, to help artists who have knowledge of working in watercolors, but still may need to find their purpose in painting.

INTRODUCTION

What do all the paintings in museums have in common? What makes them worthy of being there? Some have poor technique; others have unappealing subjects. Many paintings we don't even understand what we are looking at. Why were these artists sought out and their paintings revered? What is the one thing they all possess? The one thing that unites them all is that they *painted with purpose*. Once we understand the purpose, then the appreciation sets in. Even if we don't like the piece, we are in awe of the fulfillment of the artist's purpose.

How many times have we said: "Why didn't I think to paint it that way?" or "How did the artist invent that technique?" When viewing an art exhibit such as the American Watercolor Society show, we have all wondered, at one time or another, why some of the paintings were accepted. We know we have seen better. I will reveal the answers to these questions as well as show you how to create a watercolor painting that will say what you want it to — putting your painting in the category of "museum quality."

In order to accomplish our purpose, we must know about technique, but always keep in mind that it is an "invention of expression to fit the idea to be expressed." Techniques are demonstrated throughout this book to clarify how they were used to achieve my purpose.

The book begins with finding our purpose — how to go about it and how to apply this purpose to a watercolor painting. I show how painting with a purpose affects the outcome of the subject in a painting. There is a thorough explanation of how the rules of design give us a logical, systematic approach (creating unity through dominances) to designing a watercolor painting.

In the chapters on drawing, I clarify how much to draw and what type of drawing is necessary to paint a watercolor. There are also illustrations that reveal the purpose of the different types of drawings: the misunderstood information drawing, the simple sketch, and the intricate master drawing. The section on composition includes demonstrations on how to extract the necessary elements from nature onto the watercolor paper. I show how to develop a motif that will guide the viewers to where we want them to look.

A full explanation of how to paint a vignette is given with many illustrations of completed vignette paintings.

The chapter on color illustrates how to select colors to make them work for us, and explains why they are successful. I provide color schemes that are foolproof, and they can guarantee perfect unity of color. Different watercolor papers are used in this book with explanations on how and why they work to produce a wide range of effects. In addition, there are demonstrations on various techniques: tissue paper and press paint for texture; drop wash, dry glazing, and working wet glazes for gradation; and exploding colors for spontaneous painting. How to include pen and ink calligraphy to expand our watercolor painting vocabulary is also explained.

The all-time question of "What to paint?" is discussed as well as the development of "style." A revealing chapter on thinking and seeing as an artist opens up new doors on how we will approach a painting. This is followed by an explanation on how to edit a watercolor. There are little tricks of the trade on saving and reclaiming lost whites. I also clarify how we can critique our own work. A thorough checklist with illustrations will be the only guide that is necessary to accomplish this important task. The final chapter poses the question "When is a painting finished?" The answers will be a new beginning to the way in which your next painting is created.

Due to the advance nature of this book, there are no color charts and worn-out diagrams illustrating the text. Instead there are completed paintings with detailed captions. The paintings in this book vary in style, color, technique, paper used, subject, and size. The one thing they all have in common is that each one was painted with a purpose. Every color, stroke, shape, value, and relationship can be accounted for. As diverse as they are, I know why every element is there. Throughout the book, I interject specific explanations of these elements. (This will take more viewer participation, but the end results will be worth the effort.) And each chapter is written so that it expands on the knowledge gained from the previous chapter. By the end of this book, you will have experienced a transformation from a technician who paints pictures into an artist who creates paintings.

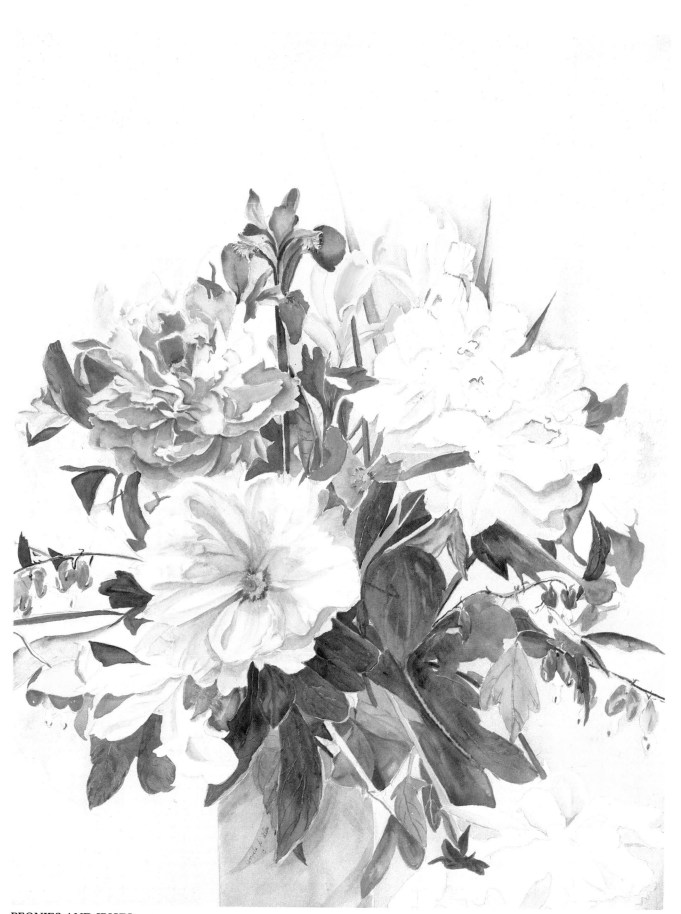

PEONIES AND IRISES *Arches 300 lb., cold-pressed, 30″ × 22″ (76.2 × 55.9 cm)*

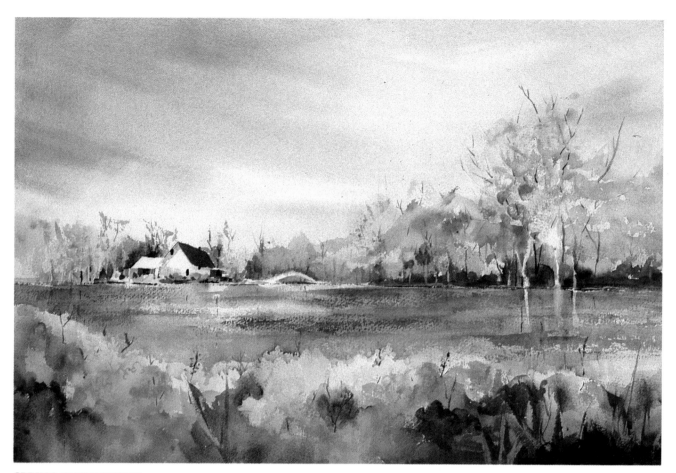

SPRING REFLECTIONS *Arches 140 lb., rough, 15" × 22" (38.1 × 55.9 cm)*

The colors of each season are so unique that I always try new ways to show them off. I see faraway places as exotic and appreciate a personal, view where others live. In this painting I took the opportunity to share with my viewers a part of Long Island and its beauty in the springtime.

This painting was done spontaneously without any drawing or sketching. It shows the feeling of delight I had when I received the bouquet from my children. As I was putting the picked flowers into a glass vase, they started spreading apart in an interesting pattern against the rim of the glass. An accurate, detailed painting would not have expressed my feelings toward this subject.

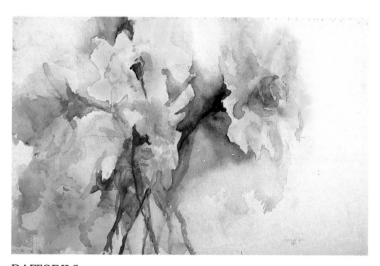

DAFFODILS *Arches 140 lb., cold-pressed, 15" × 22" (38.1 × 55.9 cm)*

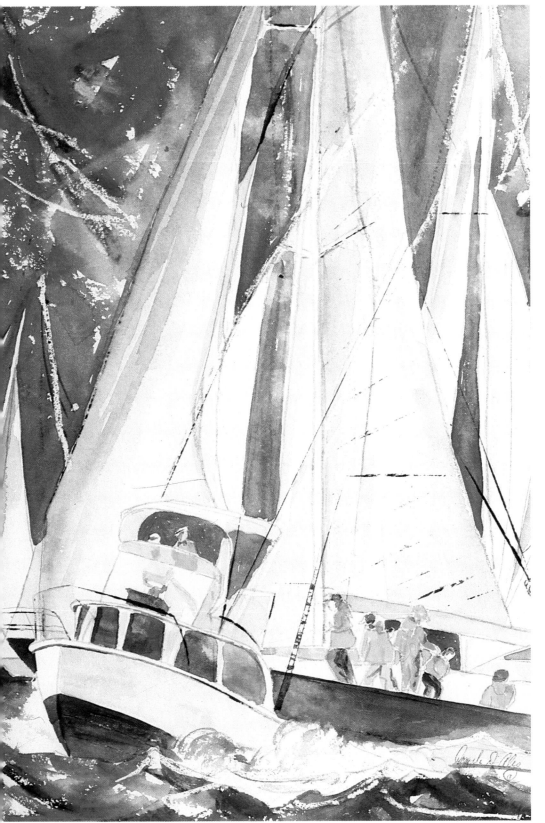

My love for sailing is the impetus for many of my paintings. When I am in the middle of a sailing race, it evokes a feeling of excitement. To transmit this feeling, I worked with a structured drawing, vibrant colors, and sharp value contrasts. Using fiberglass paper ensured that the colors would remain brilliant. The paper was also receptive to the way I applied paraffin markings and scratched the surface, to obtain the abstract design in the sky and water.

REGATTA RACE *Aquarius, 22" × 15" (55.9 × 38.1 cm)*

1 FINDING OUR PURPOSE

Purpose is the reason why we paint what we paint. This is not to be confused with our goal. A goal is what we want to do with our work after it has been completed. Our purpose dictates how we apply the pigments and arrange the colors, values, and shapes. As Robert Henri, the great artist and teacher, stated in *The Art Spirit*, "Without a positive purpose, means effect only an exercise in means."

Finding our purpose is so obvious and simple that many times it is overlooked, because it seems insignificant. First, we must establish a subject. Then we must express why it is so appealing to us, and what we want to say about it. Next we must find the best method to interpret the subject. Finally, while we are painting, we must always remember the reason *why* we are interested in the subject. Try to restrain from just copying the surface of the subject. It may take some time to understand the impetus that lured us to this place, person, shape, or thing that we want to transform into a painting. It is easier just to grab our paints and begin copying what is before us, but then we will have what everyone can see for themselves. These are the kind of paintings that we tire of easily, and are soon forgotten.

Today, very few artists realize they must have a purpose. They think that all they need is skill. Other artists are always searching for some unusual way of painting. They feel that "if I could only learn that technique, then I could paint anything." Robert Henri has also said, "The man who is forever acquiring technique with the idea that sometime he may have something to express, will never have the technique of the thing he wishes to express."

When focusing in on what it is about the subject we want to paint, we must keep in mind to trust our sensations. It doesn't have to be a profound statement or a complex idea. We need not become serious, deep philosophers to paint a bowl of fruit or even a city scene. However, it is necessary to have one positive direction in which we plan to express the subject, or else we are back to copying what we see.

The following are some of the functions of art.

· to clarify, intensify, or enlarge our experience of life

Present the subject in a way that will exaggerate the essential and leave the obvious vague. This will force viewers to focus on what we have selected. It may give them a unique feeling or provoke a new thought.

· to record the way things, places, and people look

What is commonplace to us may be exotic to others. No photograph can translate a sense of a place or person or thing the way a painting can. An artist finds out what it is that needs to be said about the subject and then paints it.

· to capture the essence of the faith and philosophy of our time

Whatever we paint, it is a projection of the artist who painted it. Therefore, if we paint true to our purpose, we are showing the philosophy of our time.

Someone who paints an elaborate still life of fruit with other decorative items is showing one life experience. In contrast, someone who is involved in religious or political turmoil is experiencing a much different life. The art, if it is a true expression of ourselves, will reflect our exposure and environment. It is up to us to be sensitive and true to these sensations. Do not paint something because it seems to be an intriguing subject. That would be painting the surface of it. No matter how well the painting is executed, it will not hold up to the test of time.

· to bring order to the chaotic material of human experience

The subject may be chaotic, but the painting must not be. Order and unity must be imposed in a painting if it is to be understood. We may even want to suggest chaos, but to do so it must be organized. The order comes by unifying the purpose. It is important to choose one direction to communicate our idea. Show a strong conviction of what you want to say, and then direct all efforts to accomplish that goal.

· to decorate a surface, an embellishment

Decorating a surface is as serious a motive for painting as any other. We can have the most freedom in this area. Decorative paintings are usually patterns of colors and shapes that are pleasing to the eye and easy to read. Their purpose is to visually delight the viewer; there are no hidden meanings, reasons for shock value, or mystical messages. As long as our intention is clear on what we want to do, we cannot fail. *A painting cannot be judged a failure if it does not achieve what it did not set out to do.* Those of us who enjoy decorating a surface, and are looked down upon by those with other intentions, should not worry. Our paintings are as valid as any others as long as our purpose has been fulfilled.

• to communicate

Art is a universal language. Pictures and symbols usually communicate better than words. With the use of art symbols, each viewer can interpret the painting into their language (filling in their specific image). Every detail does not have to be included. Mere suggestions of objects (flowers, people, animals, buildings) will communicate the artist's ideas. Where many words are needed, one picture could tell it all. Art can also communicate feelings that could not otherwise be expressed into words. With the use of color and directional thrust, the artist can try to communicate feelings with or without the use of a representational image.

• to illustrate

When we illustrate in a painting, it is necessary to make the illustration easy to read. Impeccable technique may be required to develop a subject clearly. It is a separate art form than creative painting. Norman Rockwell was a master of illustration. Those who frown upon his reputation as a master fail to understand that as an illustrator, which he never claimed to be anything other than, he was a master.

As we approach different subjects, we may have different reasons for painting them. With one subject we may just want to decorate a surface, while with another subject, we may want to communicate an idea. The above list can be your guide. You may want to use one or more of the functions, or you may have some of your own to add. The purpose I often use is to show the subject in a way that will exaggerate the essential and leave the obvious vague. The feelings I experience are suggested through my use of color and the way I present my subject.

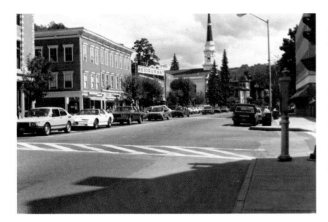

To do a painting of the town in this photograph, you could use any one of the mentioned functions of art (listed in this chapter). Each function would result in a different outcome. It could be illustrated, decorated, or distorted. I chose to do a painting to clarify and intensify the town. I painted the subject in a way that would exaggerate the essential and leave the obvious vague; this forces the viewer to focus on what I choose. Once I establish what it is I want to say, then I can decide the method, colors, paper, type of drawing, and composition.

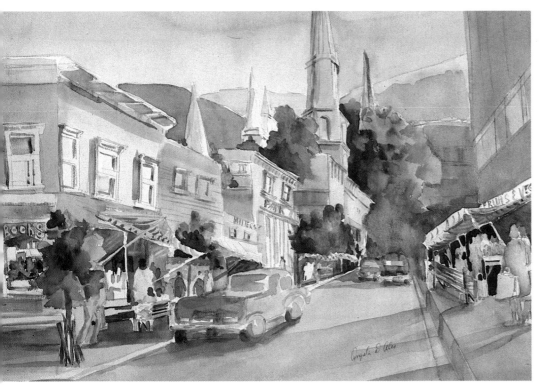

MAIN STREET, MONTPELIER, VERMONT
Arches 140 lb., cold-pressed, 15" × 22" (38.1 × 55.9 cm)

My intention here was to capture the charm of the town with its red-and-white striped awnings, the church steeples, and the Bear Pond Bookstore on the corner. I also wanted to paint the town's natural setting with the hills in the background, the trees planted along the sidewalks, and the flower boxes filled with a colorful array of seasonal delights.

There are many ways I could have interpreted this town, using any number of techniques and colors, but I had to decide what my purpose was for this painting and commit myself to fulfilling it.

2 PAINTING WITH A PURPOSE

Once we find our purpose, we can begin choosing how we will execute the painting to fulfill it. Even experienced painters need to stop and think about how they will execute a new painting. Finding a different subject does not make for a different painting if we paint everything the same way. Aimlessly working in different techniques without knowing why or thoughtlessly choosing colors is not what painting is about. We must always consider what we do.

Every one of us can look at the same scene and feel differently about it. We may see different characteristics of a subject that we will want to paint. Therefore we must paint independently of everyone else and meet our own sensations. Restrain from trying to put everything into one painting. For example, we may decide our purpose is to decorate a surface, but in the middle of the painting we may become involved with the object. At this point we may decide to try to intensify the object with details. In this type of situation it is best to save the idea or leave the present painting and do another one with that purpose in mind. There has to be a unity of purpose. Every stroke, color, value, and shape must be directed toward fulfilling it. All painting activities, technique, paper, color, and style, are selected to complement our purpose.

It is easy for an artist who is experienced in watercolor painting to become too comfortable with the same palette, paper, and style. Painting with a purpose is a challenge for those who have become set in their ways. It requires an open mind willing to reevaluate the reasons for wanting to paint a particular subject, instead of using a stock technique that has worked for previous paintings. This may mean working with new colors, selecting a new paper, finding a new brush that will effectively give us the best results, or even inventing a new technique. For instance, you may be considering a change in the way paint may be applied. There are many techniques discussed in the book where no brush is initially used to create a soft, spontaneous effect. These techniques are not easy, safe, or as predictable as using a brush. But the effort is worth it when the desired effect is achieved.

Drawing is another factor to be considered. Not every painting requires a detailed, accurate rendering of the subject. Sometimes if a drawing is too strong, it can overshadow the purpose. Other concerns include the way we handle edges. A painting with all hard edges will transmit a different impression than one with all soft and amorphous edges. Geometric shapes will create a different sensation than curves. Strong colors will say one thing and pale colors another. Even the size of a painting can influence our purpose. Painting on the same size paper because that is what we are used to may drastically change what we are trying to express. (A city scene or a landscape may call for the challenge of working on a larger surface to display the feelings we want to convey.)

We develop habits in any task performed routinely. Aware of it or not, careful study of our paintings will indicate certain habits. We may automatically transform a subject into the same mold by using all our comfortable methods. But painting with a definite purpose, and applying all activity toward achieving it, will result in a painting that has total unity, conviction, and strength. All these activities must be carried out through the entire painting process — never deviating from its purpose, and never falling back into what is comfortable and easy. Never do any painting activity without thought to its purpose. Always ask yourself: Why this color? Why this paper? Why this technique? Why this brush? Why this stroke? Why? Playing it safe creates frustration in the artist, and it will eventually bore the public.

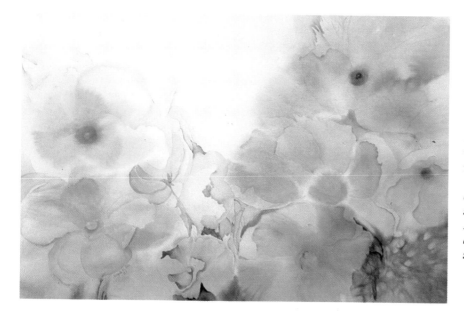

DELICATE BLOOM
Arches 140 lb., cold-pressed, 22″ × 30″
(55.9 × 76.2 cm)

My intention here was to convey the soft, delicate luminous feeling that these flowers suggest. With no specific type of flower in mind, I aimed for a universal symbol for the flower. Once I knew what I was after, I directed all my painting activity toward fulfilling my goal.

Since I wanted to make the soft edges of the flowers predominant, a structured drawing was not necessary. I used the exploding colors technique and worked wet-into-wet to create the soft edges.

PARROT TULIPS
Arches 140 lb., cold-pressed, 30″ × 22″
(76.2 × 55.9 cm)

In this painting I wanted to show the decorative character of the parrot tulip. I exaggerated the massive heads with dramatic coloring of almost black petals. To capture the decorative qualities of the flowers, I decided to simplify the foliage and prevent them from competing with the flowers.

Once my purpose was established, I then decided on how I would paint this piece. An accurate, structured drawing was necessary (a loose wet-into-wet would not do here, with all the fine detail). I also decided on a white background to intensify the dark, rich colors. A full sheet of 30″ × 22″ paper gave me all the room I needed to properly display the flowers and to enhance the dark colors I wanted.

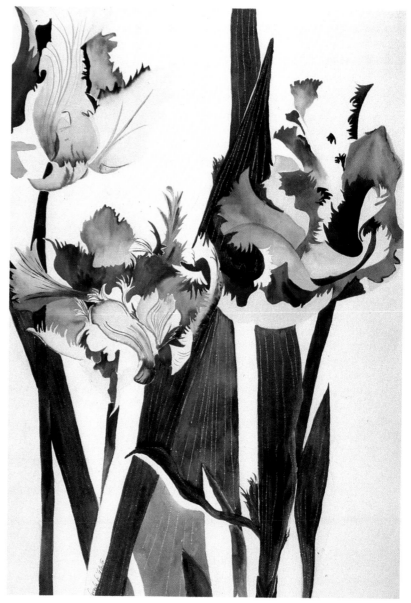

3 THE RULES OF DESIGN

Once we have established our painting purpose, we need to gather and organize all the necessary information to communicate it. The characteristics we decide to express about the subject will determine what laws of design we will deliberately impose to get our message to the viewer. The visual components of directional thrust, area, color, and color temperature are the tools the artist has to work with. A writer has to deal with words. How the words are used will determine if we cry, laugh, gain knowledge, or become confused. Similar to writers, we must have something to say and present it in a rational manner. To mindlessly paint things exactly the way they look does not create art — it merely copies it. But arranging a subject in some order and adding personal expression — that is art.

There is a systematic approach to the way we can arrange and use these visual elements to work for us. This system is called the *rules of design*. These rules unify the painting and ensure that every element is directed toward fulfilling its purpose. Unity is achieved through dominances of color, color temperature, direction, and area. A slight conflict of these dominances will create excitement and interest.

The rules of design were created for the sole purpose of giving the artist a way to extract a desired subject from nature's chaos. Without the rules, nothing worthwhile will be achieved, no matter how great the technical execution. All master artists know the rules of design. These artists have served their apprenticeship and learned the rules before they deliberately choose to break them or create new rules for the sake of personal artistic expression. To do away with the rules without a purpose is futile.

The order of the components — direction, area, color, and color temperature — is established by creating a dominance. The artist chooses which dominance for each component will best express his or her purpose. Repeating this dominance with variation is necessary for interest and avoidance of monotony. Therefore, having a slight conflict is essential. In most cases, if aware of these rules, the artist will recognize a dominant feature in the subject and develop it further. Other times a dominance must be imposed. Recognizing the psychological effect each element has will help in choosing which dominance meets your need and which one is suitable to express your feelings about the subject.

Directional Dominance

When the time comes to place the subject onto the paper, we can arrange it in a number of ways: straight across in a horizontal, straight up and down in a vertical, in a triangular pattern, in an oblique manner, in a curvilinear pattern, or in rectangles. Brushstrokes and calligraphic lines can also create these directions. The direction the artist chooses will depend on what it is he or she wants to say about the subject. This intentional imposing of a directional dominance will psychologically influence how the viewer interprets the subject. In order to reinforce a directional dominance's communicating power, it is important to emphasize it with variations of that direction.

Horizontal
A horizontal directional dominance can communicate a feeling of calm, quiet, relaxation, stability, or tranquillity. A landscape, water scene, still life, or even a figure stressing a horizontal thrust will reflect these emotional qualities to the viewer. When a slight conflict of a vertical, curve, or oblique is added, it not only adds interest, but it will also dramatize the dominance. We can also repeat the dominance in every element during the painting process. Brushstrokes, lines, arrangements of objects, and shapes can have a horizontal direction imposed on them.

Triangular
The triangle represents solidity, unity, stability, and order. The pyramids in Egypt are exemplary models of this. They suggest the powers that are instilled in the triangle. Some subjects that have triangles in their structure are church steeples, buildings with peaked roofs, and sails on a boat. Organizing a painting in a triangular dominance can unify many subjects. Depending on how these triangles are used, they will transmit conflicting sensations.

One way to reinforce a triangular dominance is to make a triangular visual path to connect the objects and shapes. This composition allows the viewer to follow the triangular pattern of objects, shapes, or color. It also generates more enthusiasm into the painting. (This is an effective way of arranging flower paintings.)

Using variations of the triangle, such as tilting it so that it is no longer sitting on its stable base will create

a feeling of movement, uneasiness, drama, or excitement. (These are the same reactions received from obliques.) Since they both suggest movement, wave peaks and sails on a boat are two subjects that frequently use tilted triangles. It is up to the artist to reinforce the dominance by repeating it and dramatizing it so that the purpose is understood.

Curvilinear

The curve is used to convey gentle, rhythmic, and dreamlike qualities. Artists who paint figures, flowers, and landscapes usually prefer the curvilinear dominance because it is naturally suited to those subjects.

Pierre Auguste Renoir used a curvilinear dominance when he did a painting of his wife, *Madame Renoir*. In it he exaggerated the roundness and curves of her face and figure to express a soft, gentle femininity (a quality that was associated with most women during that time). In comparison, the paintings of women by Pablo Picasso and Willem de Kooning, where oblique dominances were used, reveal hard and aggressive qualities. Since their purpose was quite different from Renoir's, they had to use another directional dominance.

Flowers are another subject where nature helps us and supplies the dominance. In their natural setting, flowers swaying in the breeze can suggest a soft, delicate rhythm. A conflict to the curves of the flowers can be the straight lines in the stems and leaves. Similarly, landscapes can use winding paths, rolling hills, and swaying trees to create a rhythmic quality to reinforce a curvilinear dominance. The artist who wants to suggest qualities other than gentle, smooth, and rhythmic should choose another directional dominance.

Rectangular

This dominance can neatly group objects and force organization into a painting. There is a feeling of structure, strength, solidity, and order in this dominance. A city scene with a multitude of billboards and signs has a strong inclination toward a rectangular dominance. If the subject is a house with many windows, windowpanes, clapboards, bricks, shutters, window boxes, steps, and fencing, it would also create the potential for a rectangular dominance. Even natural subjects can use this dominance; for example, a still life with many shapes can be grouped into rectangles. (Figures, flowers, or a nonobjective abstract can also have this dominance imposed upon them.)

It is important to remember that a more stable and structured painting will develop from using this dominance. If that is not the intention of the artist, then another dominance must be imposed.

Oblique

When we slant or slope objects, lines, shapes, or brushstrokes, we transmit a feeling of movement, agitation, excitement, unbalance, tension, drama, and uneasiness. Just think of the leaning tower of Pisa and the feelings that its image evokes.

To suggest a natural dominance, such as the movement of skiers, involves taking what is before us and dramatizing their natural oblique characteristics — the hills, the figures, and the ski poles. When the dominance is not natural to the subject, we can impose the dominance to suggest the feeling it provokes. For instance, we can deliberately slant an entire group of buildings in a town, as well as all its other details. By doing so we transform a static scene into one of movement. We can also group the subjects into oblique shapes to create an oblique directional path that guides the eye through the painting. This principle of taking the subject and giving it a new direction, one that suits the artist's needs, can be applied to any subject and to any shape.

Vertical

This dominance is suggestive of stability and growth. Trees, plants, and people grow upward. Tall buildings, masts on sailboats, columns, and pillars all infer order and a sense of strength and support. Any subject we wish to convey these characteristics to can have this dominance imposed upon it. You can do this in several ways: creating vertical shapes or brushstrokes, turning the paper vertically, using calligraphic lines to imply verticals, or creating a vertical visual path that guides the eye (such as repeating colors, shapes, or values vertically).

Conclusion

Any painting that does not enforce a directional dominance will lack character and unity. It will only be copying instead of creating. For example, a landscape composed of water, hills, trees, and a house must be organized to unify all the shapes. There should not be any isolated shapes. One direction needs to be repeated over and over with variation to eliminate boredom. The possibilities are endless if we can stretch the imagination — after all, that is what being an artist is all about.

FISHING ON A DOCK
Arches 140 lb., cold-pressed, 15″ × 22″
(38.1 × 55.9 cm)

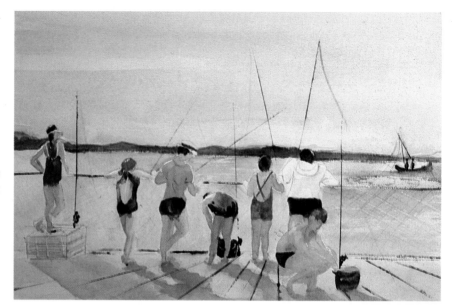

I chose a horizontal directional dominance to suggest this tranquil scene. Dock fishing always instills a calm, peaceful feeling in me.

Although the figures are all vertical, they form a horizontal line. This directional dominance is reinforced by the horizontal brushstrokes in the sky and in the water. Other reinforcements I used were the horizon line and fence; the dock and other large shapes form horizontal bands that run across the paper. Subtle conflicts of obliques and curves were added to support the horizontal dominance, but I was careful not to have the subdominance challenge or overtake it.

SMALL BOAT RACE
Aquarius, 15″ × 11″ (38.1 × 27.9 cm)

This subject suggests a triangular dominance. As soon as I started sketching, the triangles began appearing everywhere. I made sure I continued to impose them wherever possible to keep unity in this action painting.

The sails are the obvious triangles, but note that within the sails there are the suggestion of triangles turning every which way. The boats and the peaks of the waves are triangular as well as the spaces between the sails (the negative spaces). I also forced a triangular path for the viewers to follow through the painting. I started with the figure on the left (a bright red–orange shape) that leads the viewers to the top of the sail (an orange shape) and then I guide them back down to the small figure on the lower right (a bright orange shape).

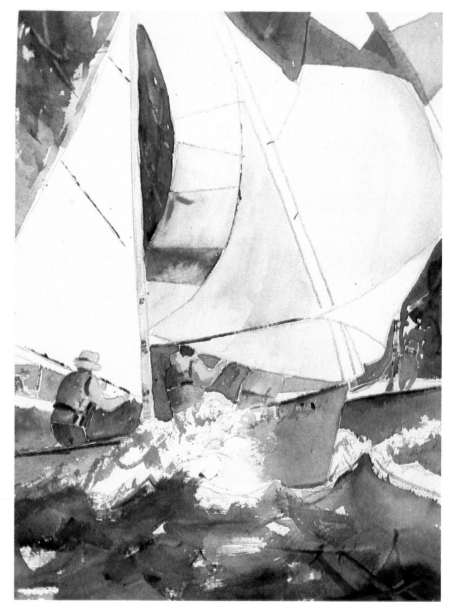

FLOWER REFLECTIONS
Arches 140 lb., cold-pressed, 22″ × 30″
(55.9 × 76.2 cm)

To emphasize the curvilinear directional dominance in this painting, I repeated the curves in the shapes of the containers and in their reflections. I used a pattern of curves to suggest the flowers instead of giving isolated descriptions of each flower. The conflict to all the curves are the straights of the stems.

INSIDE THE BARN *Arches 140 lb., cold-pressed, 15″ × 22″ (38.1 × 55.9 cm)*

I imposed a rectangular directional dominance to organize the subject of this chaotic scene inside of a barn. To keep from getting too busy, I kept my colors neutral. The subdominance of curves help tie the painting together and adds interest. The focal point is where I placed the sharpest value contrasts and the purest colors. Many of the shapes were negatively painted; this gives the impression of depth.

I enjoyed working on this painting once I established my dominance. Every time I looked up at my subject, I would see a new shape to use to reinforce the rectangles.

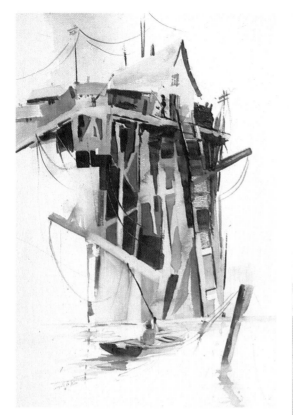

FISHING SHACK *Arches 140 lb., cold-pressed, 22" × 15" (55.9 × 38.1 cm)*

Working from a very traditional sketch of a fishing shack, I imposed an oblique directional dominance. Repetition of the dominance throughout this vignette painting created a visually exciting statement (even the negative spaces are oblique in shape). The subdominant curves that I imposed in the roof of the shack, the boat, the ropes, and the telephone lines relieve all the obliques and add interest to the composition.

Note the way the orange shapes are related obliquely. The placement of every line and shape was used to direct the viewers to where I want them to look. The pole in the foreground interlocks the horizon line and directs us into the painting. The fishing pole is pointed to a strong oblique that zigzags us through the entire painting until we reach the top.

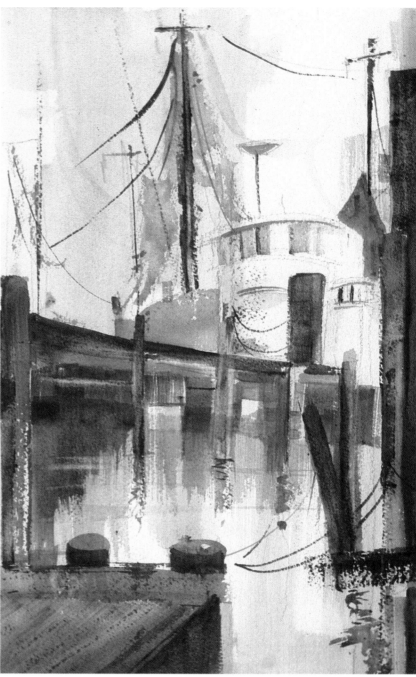

TUGBOAT AND PILINGS *Arches 140 lb., cold-pressed, 15" × 11" (38.1 × 27.9 cm)*

I used a vertical dominance in this painting to create order in this scene and to suggest the stability and strength of the tugboat.

Working on location, I had to decide what I wanted to paint; there were too many subjects in this one area. I focused on one small part of the tugboat and used the shapes around it to repeat my vertical directional dominance. I even turned my paper vertically. The directional conflict are the curves of the rigging and wires.

Area Dominance

In order to organize a painting, we must know where to put our subject and what size to make the important elements, shapes, values, and colors. According to our purpose, we arrange the spaces between the positive and negative areas as well as the dominant characteristics so that they perform a specific function.

Character is achieved by establishing distinguished space division; that is, making one part of the painting more important than another to avoid a half-and-half painting. This will keep the work from looking like wallpaper. It will also tell the viewers what is important to the artist by making them know where to look and what to look at.

There are many ways of achieving area dominance and many motives for choosing the different methods. For example, the largest part of a painting can be the busy area. The focal point and most of the color and activity can be in this area. Counteracting the large area with a smaller rest area is one way of establishing an area dominance. This quiet spot in the painting, with not much happening in it, will give the viewers a place to refocus and rest. Viewers will contemplate longer on the painting because of the rest they are offered, and they will not get confused.

On the other hand, even though dominance may suggest the area to be larger in size, it does not always make it the most important part or the point of interest. One way to emphasize a focal point is to make it small rather than large. The small area can be very busy, filled with shapes and colors, and have a larger rest area to support it. This rest area of the painting will dramatize as well as emphasize the smaller busy area. To make this effective it is necessary to keep the distinction clear and not fill the large rest area with unessential details. We have all at sometime put grass, spatter, and other details in the foreground of a landscape because we felt it needed something. This happens when isolated areas are evaluated independently rather than judged in relationship to the whole painting.

The same rule applies to texture. A painting that has a dominance of texture must be relieved by an area that is free from texture — and vice versa. In a painting with all soft edges there must be a conflict of some hard edges. And a large hard-edged area must be complemented by a smaller soft-edged area. That one small conflict can be the single element that finishes a painting as well as saves it.

Manipulating the area dominance can change the viewer's perspective of the subject. In many cases, the artist can choose how large or small to present the subject. But we must always be aware that size will change the viewer's reaction. The greater the distinction in size between the positive and negative, the more dramatic the impact. The same subjects can be used for other paintings by changing the area dominance to present a different emphasis, thereby fulfilling many purposes.

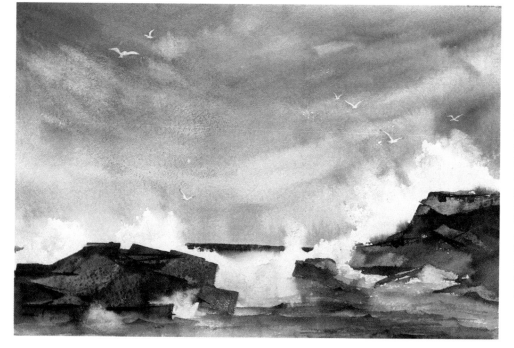

ROCKS AND SURF
Fabriano 140 lb., rough, 15″ × 22″ (38.1 × 55.9 cm)

In order to paint this subject effectively, I had to first establish my area dominance so I would know where and how large to make the objects. I wanted to say "rocks and surf" and make it dramatic, not melodramatic. To accomplish this effect, I made the sky the largest area but kept it relatively quiet. All the attention is forced to the rocks and surf below (placing the greatest value contrast in this smaller but aggressive area).

SKYSCAPE
Arches 140 lb., rough, 15″ × 22″
(38.1 × 55.9 cm)

The horizon line in this painting is used as a divider to create a dramatic area dominance that shouts "sky." Space division becomes more distinguished the farther away you get from a 50–50 painting. This painting has an 80–20 space division.

I wanted to involve the viewer in the large sky area so I created a pattern with the clouds. I worked wet-into-wet to keep the painting loose as well as unstructured, except for the house shape which is the focal point and contains the most description.

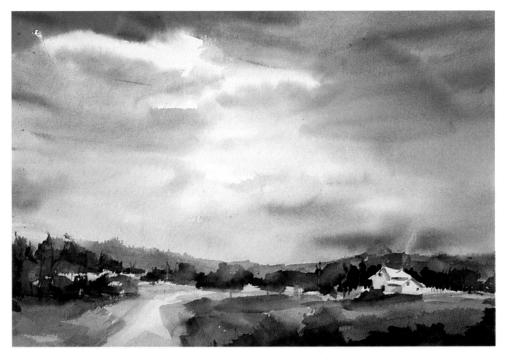

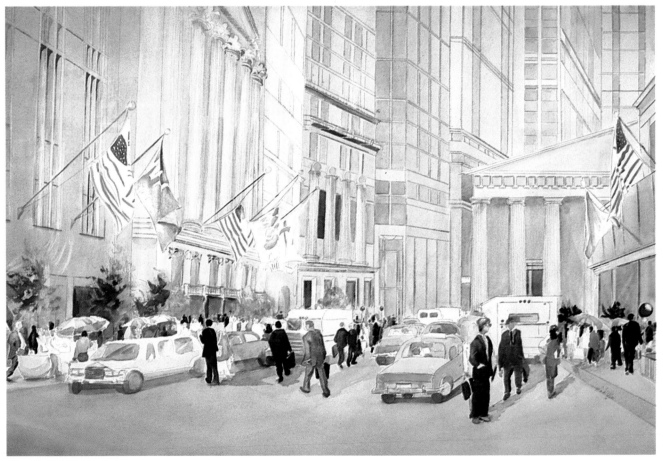

WALL STREET *Arches 260 lb., cold-pressed, 26″ × 40″ (66.0 × 101.6 cm)*

There was no question about area dominance in this painting. My busy area is the largest part of the painting with the smaller foreground area as the quiet resting place. This large busy area gave me the space I needed to paint all the elements (flags, cars, people, buildings) to create the

character of Wall Street. The distinguished space division in this painting gave me a sense of control of the subject. With so much description going on throughout the painting, I had to be sure that I left the foreground as quiet as possible, not only in texture but in color.

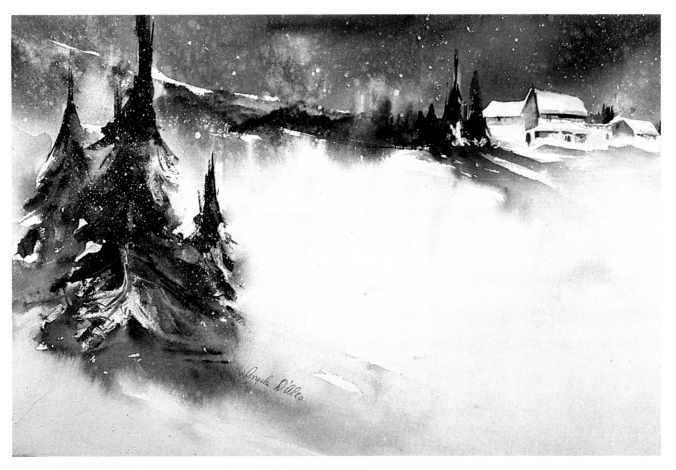

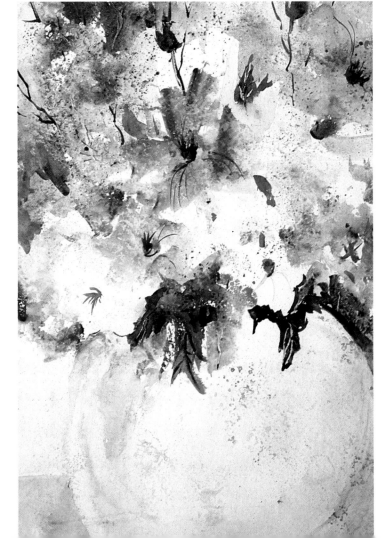

SNOW AT NIGHT *Arches 140 lb., cold-pressed, 15″ × 22″ (38.1 × 55.9 cm)*

To suggest the silence of snowfall at night, I arranged the area dominance in this composition so that my large part is the quiet snow area, and my busy area is the small part.

Although the snow reads as white *there are many color and temperature changes to keep the viewer entertained in this large area. The pine trees on the left not only balance the painting but interlock the foreground and background.*

This painting was painted wet-into-wet using bold washes of Prussian blue, cobalt blue, Winsor violet, burnt sienna, yellow ochre, alizarin crimson, and Hooker's green light. After the painting was dry, I spattered Chinese white on it to give the effect of falling snow.

TEXTURED BOUQUET
Morilla 1059, 24″ × 19″ (61.0 × 48.3 cm)

In this piece there is an area dominance of texture, but without a rest from all the texture, the painting would not work.

This painting of imaginary flowers was developed by using a press paint technique (demonstrated on pages 103–104).

The dunes take over the area dominance in this painting. Snow, fencing, and dune grass enliven this large area. I painted wet-into-wet using a triad of Naples yellow, Indian red, and Payne's gray.

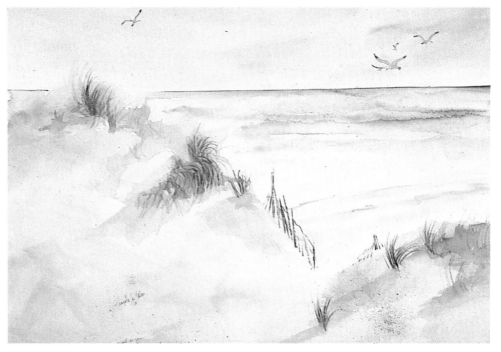

BIG DUNES *Arches 140 lb., cold-pressed, 22″ × 30″ (55.9 × 76.2 cm)*

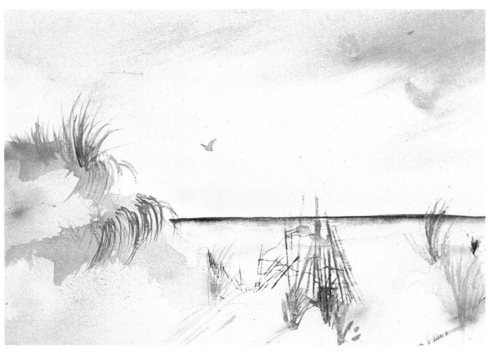

LITTLE DUNES *Arches 140 lb., cold-pressed, 11″ × 15″ (27.9 × 38.1 cm)*

The area dominance in this painting is the sky, but because it is quiet the dunes are the focal point, where the strongest value contrasts and embellishments are. By lowering the horizon line, I enable the viewers to get a different perspective of the subject; there is a feeling that the dunes are little.

Color Dominance

Organizing color so that it works for us is what having a color dominance means. It also gives us a way to take unrelated objects and shapes and design them into a pattern that can be read — saying what we want to express about the subject. It was mentioned before that if artists have nothing to say, they have nothing to paint. We could paint a scene, figure, or still life in its natural colors, but that is not projecting the personality of the artist. We would just be copying what anyone else could see for themselves or what a camera can reproduce (and probably better than we could paint it). Colors that interpret the feelings we have about a subject are what we want.

Subjects that attract us because of their special colors, as many flowers do, will have a color dominance we will want to use. There are other subjects on which we must impose a color dominance. For example, if we see a subject as soft and delicate, this may cause us to choose colors that suit these feelings regardless of what the local colors (true colors) are. There are times when we'll need to interpret a subject with a harsh attitude; then we must choose a dominating color scheme that will suggest that feeling. Other times, we may want to exaggerate the colors to express a personal emotion we feel about the subject.

Selecting a color dominance is not as simple or boring as picking one color and painting the whole picture with that color. When a dominance is established, it becomes the primary color and must be repeated. The repetition must be done by using variety; by adjusting the color's intensity, value, and temperature (all the elements are discussed in the chapter on color); and by adjusting the size of the colored area.

It is also necessary to add a subdominance, or conflict of the dominant color or colors, to avoid monotony and to dramatize the dominance. If the subject demands the use of many bright colors, they will become the color dominance, and the conflict will be to use some neutral colors to relieve the colorfulness. When painting with many colors, it is best to keep the values close in order to avoid confusion; this will also help to hold the subject together. And, if we decide on a neutral, or gray, dominance, then a touch of bright color will be our subdominance. This touch of color will enhance the neutral area. In this case, where there is little color in a painting, strong value contrasts may be used to create interest.

When a painting loses its color dominance during the painting process because a subject is being painted as it appears, then a subtle approach is necessary to ensure that the painting does not become a trite reproduction. After determining what the primary colors are, choose the one that best describes the subject and impose a very pale glaze of that color over the entire paper, let it dry, and continue painting. The pale underglaze will make that color dominant.

Underglazing can also be used when working with many colors. (When the surface dries, you can paint all the colors worked into the underglaze.) Keep in mind that when applying an underglaze using many colors, whether it is a pale underglaze or an intense one, the values must be kept close so that the underpainting does not compete with the subject to be painted on top of it. By painting the surface of the paper before painting the subject, you can make the colors dance throughout the paper. It is said that if we tore a great painting into shreds, each piece would be identified as belonging to that painting.

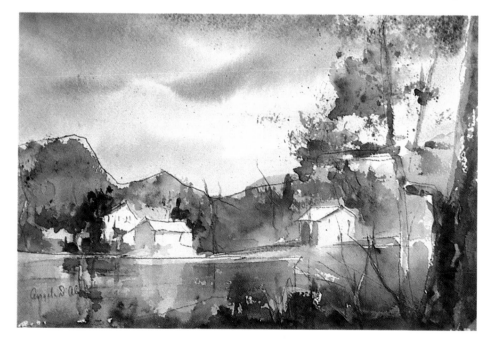

FALL FOLIAGE
Arches 140 lb., cold-pressed, 7½" × 11"
(19.1 × 27.9 cm)

I used the colors of the foliage (reddish browns and yellows) as my color dominance in this painting. I imposed a subdominance of gray (mixed from the foliage colors) in the sky and water to complement and exaggerate the colors of autumn.

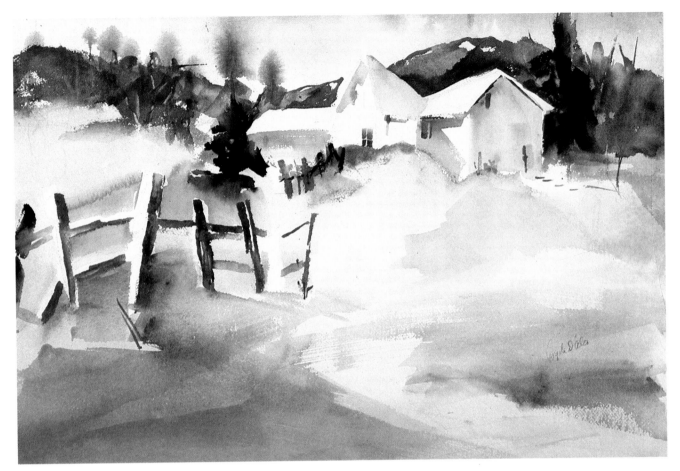

FRESH SNOW *Arches 140 lb., rough, 15″ × 22″ (38.1 × 55.9 cm)*

My color dominance is blue–green and it suggests the quiet and peaceful essence that I wanted to convey. The cool blue–green was contrasted with carefully placed touches of a warm yellow–orange. I repeated the warm with variation by using burnt sienna in the foreground snow. There is a hint of yellow (Naples yellow) in the sky to maintain unity throughout.

In the painting on the right, we could say color is my dominance with a neutral as the subdominance. This painting works, with its strong statement of color, because of the gray used in the background. All the flowers and vase shapes are enhanced by the gray background.

In order for the gray to work in this painting, it was necessary for me to carefully design the shapes and vary the temperatures of the gray. It is darker and warmer on the left and cooler and lighter on the right. The pattern guides the viewer through the painting.

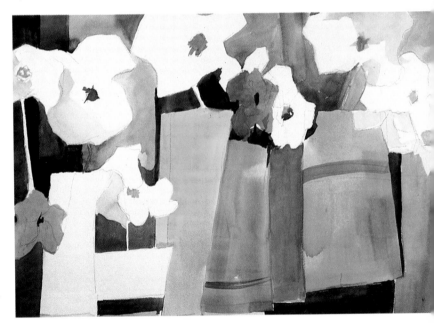

FLOWER FUN *Arches 140 lb., cold-pressed, 15″ × 22″ (38.1 × 55.9 cm)*

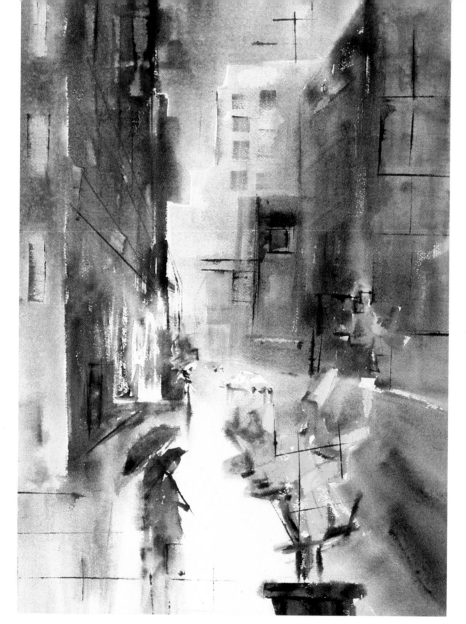

CITY IN THE RAIN
Arches 140 lb., cold-pressed, 22" × 15"
(55.9 × 38.1 cm)

*Gray is my dominance in this painting
with pure color as my subdominance. I
chose to use a multitude of colors to
create my grays; therefore, the values
in the buildings are close to prevent
confusion.*

*By mixing complementary colors on
the paper, rather than on the palette, I
allowed the colors to retain their own
identity and optically fuse together to
create the grays. If these complemen-
tary colors were mixed on the palette,
they would have neutralized one
another and a solid gray would have
been created. All the grays are comple-
mented, but not challenged, by the
bright, pure yellow, stylized shape in
the foreground.*

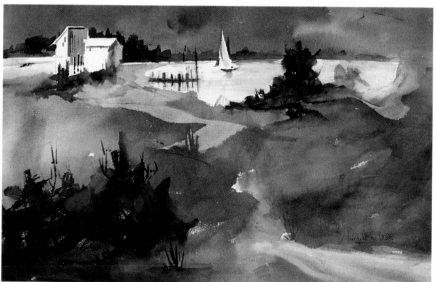

FIRE ISLAND DUSK
Arches 140 lb., cold-pressed, 15" × 22"
(38.1 × 55.9 cm)

*The color dominance in this piece is
gray with a subdominance of burnt
sienna and yellow. Where little color
was used, I created the drama with
great value contrast. The interest in
the gray lies in the value and the
temperature changes.*

*Notice how the light shape guides us
into the painting and leads us into the
focal point. When I was planning this
scene, I thought of the houses, water,
and sailboat as one shape, not as
separate things. They had to read
instantly to generate interest because
of the lack of color used.*

LILIES *Arches 140 lb., cold-pressed,*
15" × 22" (38.1 × 55.9 cm)

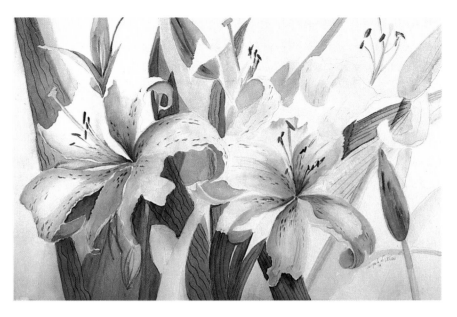

In this painting I imposed a pink color dominance throughout (a pink glaze was painted over the entire paper so that it would even show through the foliage). This enabled me to maintain unity and to avoid the painting from becoming half-green and half-pink (still remaining faithful to the local color). Using a peach color (rose madder genuine and Naples yellow), I painted a wash over the entire paper and added more pinks over the foliage area. When the greens of the foliage were added, after the initial wash dried, the pinks came through the greens and united the shapes. Greens were added to the pinks for the shadows of the flowers.

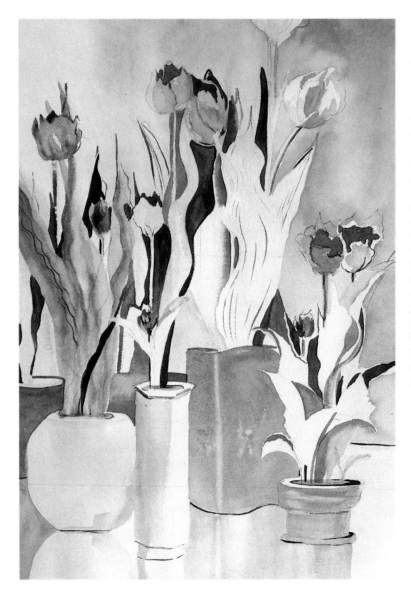

FLOWER GLAZE *Arches 140 lb., cold-pressed,*
22" × 15" (55.9 × 38.1 cm)

A color dominance of red, blue, and yellow was used in equal amounts to create harmony for this painting. The values of these three colors were kept close so that they would blend into one another. In this instance, the colors know no boundaries; they weave in and out of shapes and take us on a journey of continuous color.

I applied a pale underglaze of aureolin yellow, rose madder genuine, and cobalt blue. This is a popular triad of transparent, nonstaining, clean colors. Working on wet paper, I gently placed these colors down and allowed them to float and fuse together. When the paper was completely dry, I proceeded to draw my shapes (which were very carefully planned on a value/pattern sketch). The darks I used were made from Winsor violet and burnt sienna, and Thalo green and alizarin crimson.

Temperature Dominance

Deciding on a temperature dominance along with a color dominance is necessary if there is to be unity in the painting. When we choose a color dominance, we must always consider whether the color is a warm or a cool. We often think of color temperature when we decorate our homes. A familiar statement is "What a warm room this is." Hospitals are associated with cool atmospheres because of their fluorescent lighting and their cool green or blue painted walls. Selecting the proper temperature will change the impact a painting will have.

Every color, even black and white, can be warm or cool. It is its relationship and location to other colors that determine its warmth and coolness. We think of yellow as warm, but if we place lemon yellow next to cadmium yellow it becomes obvious how cool the lemon yellow is. The yellows that are near the blues on the color wheel will generally read cool; the yellows that are near the reds will be warmer.

Blues are usually thought of as cool, but the blues that lean toward the reds will be warmer, and the blues near the yellows will be cooler. Reds are warmer if they have yellows and oranges in them, and they are cooler if they are near the blues. Grays and dark colors must also be thought of as warm and cool. Burnt sienna and Winsor violet produce a rich, vibrant, warm dark. An intense, rich, and clean cool dark can be made from phthalo green and alizarin crimson.

When wondering what color to use in an area, you should ask, "Do I need a warm or a cool?" Always add a slight conflict of the opposite when deciding on the temperature dominance. A warm painting should be relieved by a cool, and a cool painting should be relieved by a warm. Many paintings have been pulled together by that one touch of temperature conflict.

Temperature dominance not only gives a painting character, but at times it can be the intriguing factor. When working with very close color chords, you can create an interchange of warms and cools that will have the same effect that is achieved by many color changes. Without temperature change, paintings that have little color change would be flat and boring.

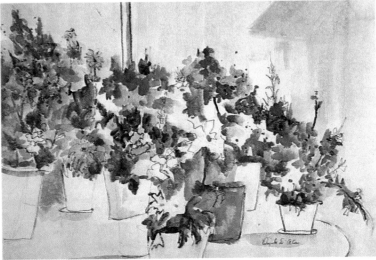

FLOWER STAND I AND II
Pittsfield, 18″ × 24″ (45.7 × 61.0 cm)

These paintings are examples of temperature dominance. The top piece has a warm temperature, and the bottom one has a cool temperature. The same hues (red, blue, green, yellow, and gray) were used for both paintings, but I intentionally changed their temperature by choosing the cool and warm of each hue. In each painting a subdominance of a warm or a cool was added to relieve the temperature dominance. The gray in the upper right (building silhouette) is a warm in one painting and a cool in the other.

In these paintings, which illustrate a temperature dominance, I used warm colors for the top painting and cool colors for the bottom one.

I chose to paint the subject unrealistically, so I complemented it with arbitrary colors (colors I chose rather than local colors). I love working with new color combinations, so in each painting I experimented.

Since one painting would be warm and the other cool, I needed my darks to support each dominance; the darks also had to be a warm and a cool. In the warm painting, with all the browns, yellows, and reds, I mixed Winsor violet with burnt sienna to develop a rich, warm dark. In the cool painting, with the blues and greens, I used Thalo green and alizarin crimson to develop a cool dark.

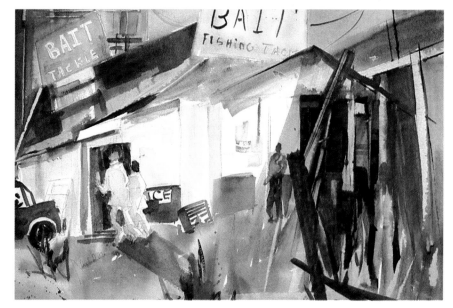

BAIT AND TACKLE I *Arches 140 lb., cold-pressed, 15" × 22" (38.1 × 55.9 cm)*

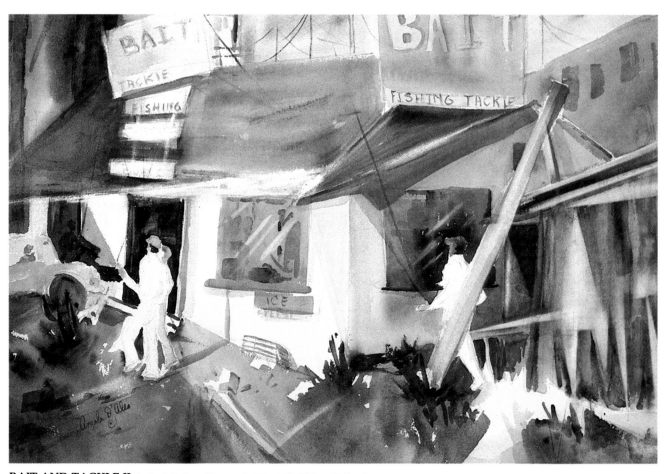

BAIT AND TACKLE II *Arches 140 lb., cold-pressed, 15" × 22" (38.1 × 55.9 cm)*

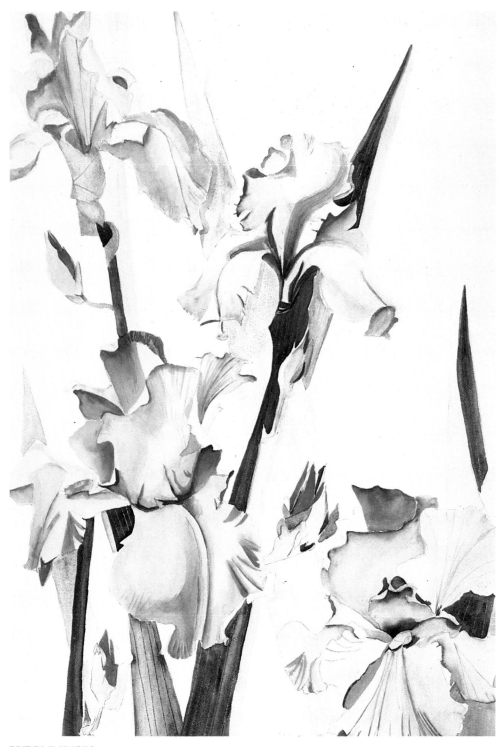

In this painting, with a cool temperature dominance, all the flowers were painted with purples and the leaves with greens. To make the painting more interesting than just describing their colors, I interchanged warms and cools of each color throughout the painting. I mixed the greens and purples together to create a silvery gray–green, which I used in the foliage.

The flowers were to be my point of interest, so I used pure, clean colors. I carefully played the warm violets against the cool violets to create a push-and-pull action in the flowers.

PURPLE IRISES *Arches 140 lb., cold-pressed, 30″ × 22″ (76.2 × 55.9 cm)*

Combining the Rules of Design

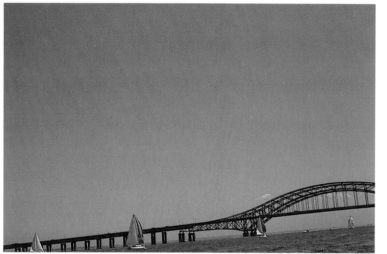

The photograph captured the way the scene looked, but not the feeling of excitement as I watched the boats race under the Robert Moses Bridge to round the mark on the other side. The illusion of the sails being too tall to fit under the bridge is something I wanted to capture in the painting. Using the photograph as my stepping stone, I then proceeded to create a hyperbolic statement.

Combining all the rules of design, the following breakdown helped me approach my purpose through the use of various dominances.

Directional dominance: triangles (everywhere we look there are positive and negative spaces in every direction).

Directional subdominance: curves (the bridge forms a large curve, and the triangles in the water slope form subtle curves).

Color dominance: blue–green (suggestive of water).

Color subdominance: yellow–violet (complement of the blue–green).

Area dominance: the largest part is also the busiest.

Area subdominance: smaller rest areas with nothing much happening in them (upper right is the largest area, where I added quiet symbols for sea gulls in a triangular shape).

Temperature dominance: cool.

Temperature subdominance: warm (the yellows are the warms).

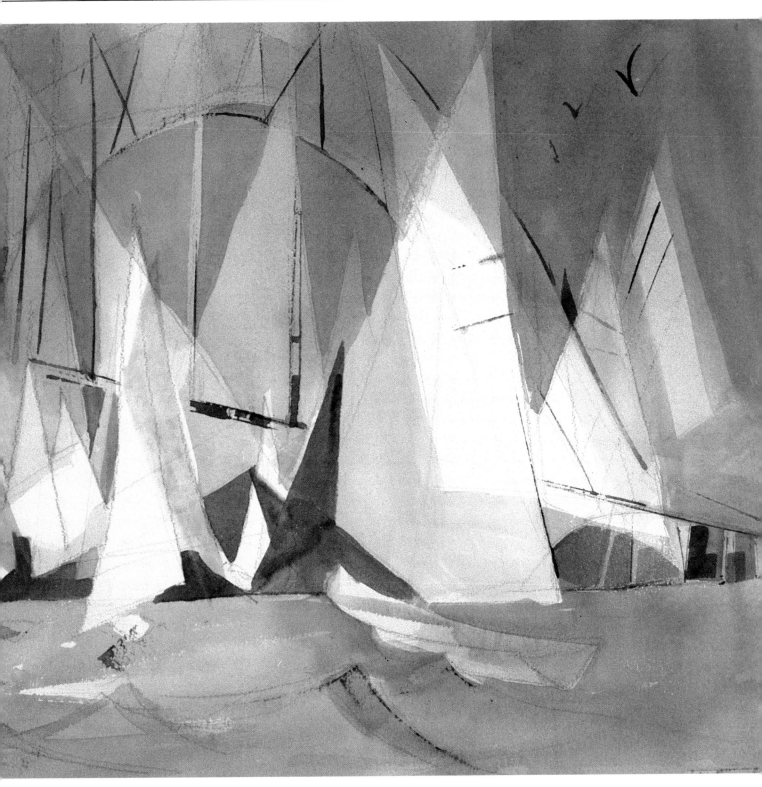

ABSTRACT SAILS *Arches 140 lb., cold-pressed, 15″ × 22″ (38.1 × 55.9 cm)*

4 DRAWING WITH A PURPOSE

rawing is like our signature. We all have an individual way in which we physically and emotionally translate a visual symbol onto paper. When writing, we can print, scribble, use calligraphy, or write in script. We use the style that is appropriate to the motive. We would not use calligraphy to jot down a phone message, nor would we scribble to write a business letter. Each style has its own place. There is no one way to draw; what we must do is choose the appropriate type of drawing to meet the needs of our particular idea.

When we draw with the purpose of structuring our subject, we must understand and use the different ways to draw and not fall into the habit of drawing instinctively without thought to its function. To begin, let us dispel the myth that if we cannot draw, we cannot paint. They are two separate art forms; one need not be combined with the other.

The most familiar drawing is the *representational drawing* — sometimes referred to as rendering. It is the drawing of things the way they look. Very little, if any, deviation is made from what is there. This takes careful observation and patience. It is a skill that can be learned and must be practiced, and it may come easier to some than to others.

On the other hand, *creative drawing* is the distilling of what we see and feel into a graphic art form. This type of drawing takes a great deal of thought, emotion, and imagination. Most of what we will be dealing with in this book is creative drawing. (We all possess this skill, but unfortunately, many of us try for the rendering.) Once we are comfortable with our subject and understand how it works, we can suggest, exaggerate, distort, or capture its essence — breaking away from what it looks like.

All creative arts require some degree of apprenticeship in technique. For example, we could not play a Beethoven sonata if we had to think about where the notes were on the piano. Yet there are many people who learn how to play notes, but only a few who really make music. It is only when we are past technique, past thinking about how to do it, that we can become part of what we are doing. When we reach this point, we will be able to master expression and interpretation.

The drawing in a watercolor must not be a separate entity but part of the whole composition. If we learn to draw a horse, a flower, or a person, it does not necessarily mean we can paint them successfully. A common error of many artists is to overemphasize individual objects at the expense of the total picture. For example, something we drew perfectly that doesn't work with or in the painting can detract and distract from the whole picture and purpose. The overall design must always be our primary concern. Every part of the drawing must work to support the total picture. Even the focal point or star of the show must complement the entire cast; every detail cannot be a star.

Many masters use a technique where they will intentionally leave areas vague and only do suggestive drawings of the object or objects. Thomas Eakins, John Singer Sargent, Claude Monet, and Paul Cézanne utilized this technique and understood how to use drawing and not be used by it.

As the creator, you get to choose the amount of drawing that is necessary to express your purpose in a painting. Academic drawing, or any formal study of drawing, is a wonderful tool that can aid you in your painting. But for those of us who are too rigidly trained, it can be more difficult to abstract, distill, or distort for the sake of expression. This can cause misplaced emphasis on what a painting looks like and result in a tight, self-conscious painting that lacks spirit. As the American painter Albert Pinkham Ryder once stated, "The artist should fear to become the slave of detail. He should strive to express his thought and not the surface of it."

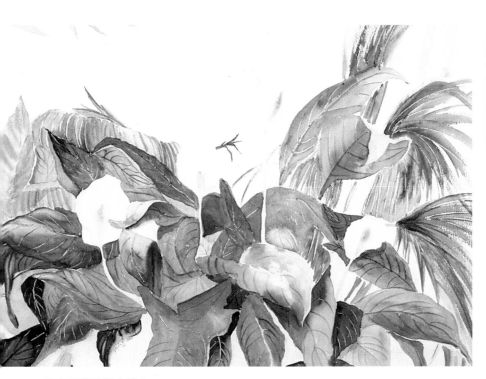

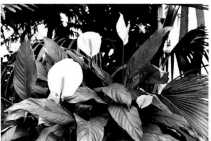

SPATHIPHYLLUM *Whatman 140 lb., rough, 22″ × 30″ (55.9 × 76.2 cm)*

In this painting a representational drawing was needed to ensure an accurate depiction of the subject. It is representational because I did not deviate from the way the plant looks to incorporate any creative design.

Working in my studio from the above photograph I took of the spathiphyllum plant, I wanted to see how many greens I could work with and still keep the painting interesting. To do this, I decided to draw the plant as realistically as possible and to concentrate on color. It had an area dominance of a large busy part, a color dominance of greens, and a curvilinear directional dominance with just enough straights for the subdominance.

In this painting I took my knowledge of flowers and had fun with their shapes. I did no representational drawing for this painting; it is a creative drawing. It suggests the flowers, stems, and leaves rather than depicting the details of each. I worked this painting wet-into-wet and used negative painting, calligraphy, spatter, and a little stamping with the sponge to create texture. With such a busy painting I made sure I kept my color chords close to avoid confusion.

FLOWER FANTASY II *Arches 140 lb., cold-pressed, 11″ × 15″ (27.9 × 38.1 cm)*

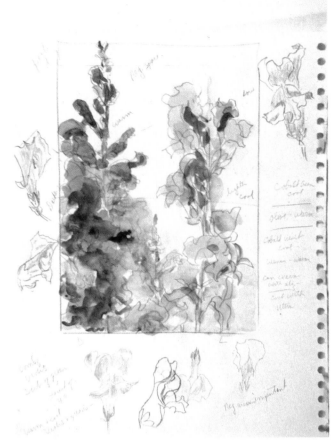

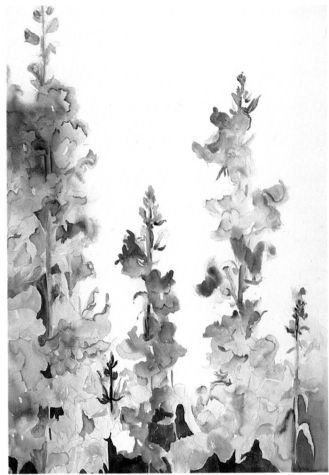

SNAPDRAGONS SKETCH *drawing paper, 14" × 11"*
(35.6 × 27.9 cm)

*After carefully studying the snapdragon, I made little
information drawings of the individual flowers and a
composition sketch of the entire spray. Initially, I became
too involved in drawing every little detail and lost sight of
my original purpose. I had to remind myself what it was
that made me want to paint the flowers in the first place—
their pattern of growth, colors, peek-a-boo foliage, and the
buds poking out here and there. Then I quickly developed a
color study, and that is what helped me keep my painting
loose.*

SNAPDRAGONS *Arches 140 lb., cold-pressed, 30" × 22"*
(76.2 × 55.9 cm)

*My purpose in this painting was fulfilled because I
restrained from not drawing all the intricate details and
emphasized the essence of the snapdragons.*

*I used maskoid in the centers of the flowers, where I later
applied color; this allowed me complete freedom to apply a
rich, loose wash of cobalt violet and Winsor violet for the
flower shapes. When the paint was dry, I removed the
maskoid and added cadmium orange and yellow to the
centers. This created a subdominance to the violets. The
greens are a mixture of cobalt green, viridian mixed with
Winsor violet, and olive green that contrast the interplay
between the warms and cools.*

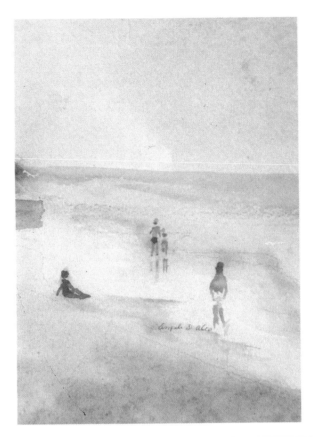

FOUR ON A BEACH
Arches 140 lb., cold-pressed, 6" × 4½" (15.2 × 11.4 cm)

This little painting was done while I was sitting on the beach. Originally I intended it to be only a sketch. It may lack description and detail, but it captures the essence of the setting and becomes a universal statement for all to enjoy.

No drawing was done for the painting below. I applied a series of glazes on wet paper and used warm and cool colors. Maskoid was used to keep the rocks, pebbles, and ripples light (the maskoid was applied after the first glaze was put in and allowed to dry). These areas read as light but not stark white. Knowing these masked areas were protected, I continued to add the remaining glazes.

When the paper was dry, I sponged out the sun and the reflection and modified the rocks and ripples in the water by adding shadows. The sea gulls were stenciled out and modified, and the horizon line was strengthened. A darker glaze in the lower left and the upper right corners were added to accentuate the lights.

SUNRISE *Arches 140 lb., cold-pressed, 15" × 22" (38.1 × 55.9 cm)*

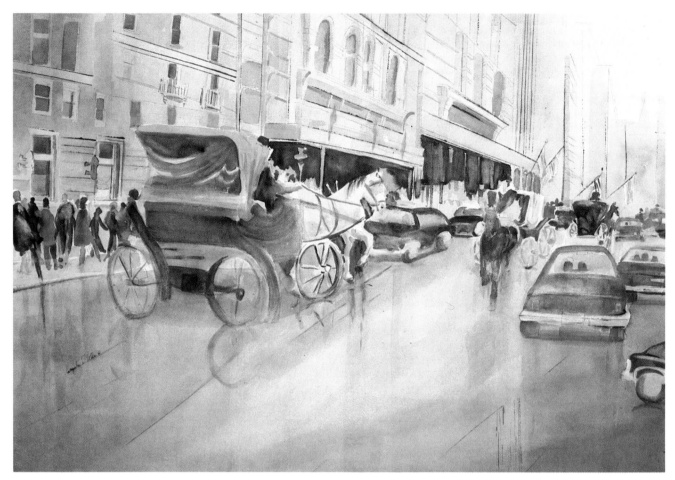

THE PLAZA *Arches 140 lb., cold-pressed,*
22" × 30" (55.9 × 76.2 cm)

*In this painting a thorough knowledge of my subject
was necessary. Careful study and many drawings were
made to manipulate the contents to satisfy my needs.
The actual drawing for the final composition was done
on drawing paper the size of my watercolor paper (a
master drawing).*

*In the painting I used only three colors for
everything except the darks (rose madder genuine,
cobalt blue, and aureolin yellow). The darks were
made from Winsor violet and burnt sienna, and Thalo
green and alizarin crimson. My primary concern here
was to develop a pattern. The trap was not to get
caught up in detail, but to express the special flavor of
this part of Manhattan.*

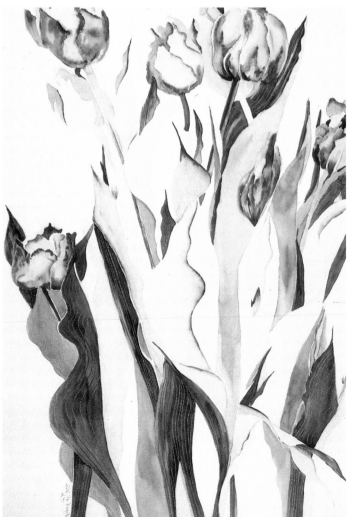

BLUE TULIPS
Arches 140 lb., cold-pressed, 30" × 22" (76.2 × 55.9 cm)

*After learning how to draw tulips and understanding
their structure, I felt comfortable extracting their design
to suit my needs for this decorative painting. I was
careful to capture the rhythm I wanted to express of
the foliage rather than an accurate description of the
tulips.*

Information Drawing

This is a specific type of drawing that must be clarified and put in its proper place. The purpose of the information drawing is to gather detail, all usable information, without worrying about composition, color, or dominance. All we want to know is what the subject looks like and how it works. Information drawing is a separate function from all other design elements in preparing for a painting.

Information drawings can be done by drawing the subject from all angles until you are comfortable with it; drawing it in different sizes and in different lighting; taking the subject apart and concentrating on small areas; and looking for negative and positive shapes. In addition, you can draw things around the subject for background fillers and repetition of its shape.

There are various reasons why we make information drawings. Some we do right before painting a subject because we realize we do not know enough about it. Other times, the subject finds us — we see something and sketch it because we find it interesting. For planned drawings, we seek out the subject and study it for future reference.

Sometimes an accurate rendering may be necessary to establish relationships as well as details. This distinction of the information drawing became quite apparent to me when I visited a rock quarry in Vermont during a watercolor workshop. Having never been to a quarry before, I was amazed and overwhelmed by what I saw. We were expected to work up a sketch for a watercolor painting that would be done back at our lodgings. Up until then, a composition sketch was all I had ever needed to complete a painting, but here I had to learn about how a quarry worked before I could paint it. I was very distracted by all the noise, commotion, and curiosity. All I could accomplish were isolated representational drawings of different things I spotted — cranes, ladders, rock shapes, people working, little work sheds, and other details — but I was not sure how I would use them. Back at the studio, I tried to make some sense out of what I saw and drew. Working with the information drawings, using the rules of design, and establishing my purpose, I worked up a composition/value sketch and did a painting. Since then, I have done several quarry paintings. There are three of these paintings illustrated in this chapter.

It is important to keep in mind that these information drawings are for personal reference. Do not pretty them up as finished work; this wastes energy, and usually prevents us from putting in all the necessary information. We must not worry about what people will think of our drawings. Think in terms of getting to know the subject. Take notes about the subject's different characteristics that may be helpful when painting. Do not spend time arranging them in a composition (that will be discussed next). Information drawings should be a perpetual process. Artists who draw constantly will sharpen their eyes as well as add other sources to their painting vocabulary. Painting from inspiration can only be successful when we possess an accumulation of knowledge and practical skill to be used spontaneously. We cannot paint successfully what we do not know.

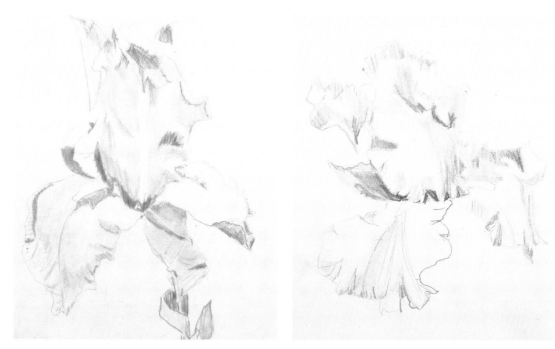

These are only two of many iris information drawings I used to prepare for the iris paintings. I made no attempt to design the irises into any type of composition, and no colors were worked out. I was only interested in learning about the flower.

IRIS INFORMATION DRAWINGS *pencil on drawing paper, 11" × 8½" (27.9 × 21.6 cm)*

This study of individual leaves was done in preparation for the spathiphyllum painting. Using color in this sketch was part of the information I needed.

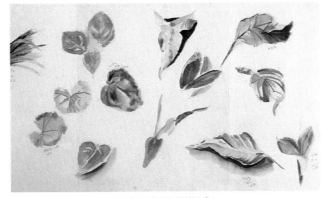

LEAVES INFORMATION DRAWING *Whatman 90 lb., cold-pressed, watercolor and pencil, 7½ × 22" (19.1 × 55.9 cm)*

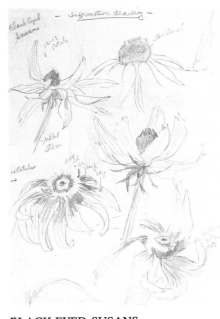

BLACK-EYED SUSANS INFORMATION DRAWING *pencil on drawing paper, 14" × 11" (35.6 × 27.9 cm)*

I drew these flowers in all different directions and wrote notes to myself about the specific details that will be useful to me when I refer back to my sketchbook.

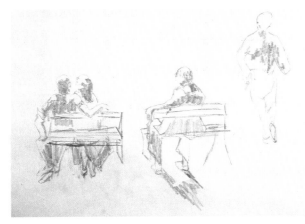

PEOPLE IN THE PARK INFORMATION DRAWING *pencil on drawing paper, 11" × 14" (27.9 × 35.6 cm)*

These are isolated drawings of people in a park that I sketched on location. I made no attempt to develop a composition out of these drawings. I will keep these drawings in my sketchbook for reference material.

DAISIES INFORMATION DRAWING *watercolor and pencil on drawing paper, 14" × 11" (35.6 × 27.9 cm)*

Although I am familiar with daisies, I practice drawing and painting them whenever they are around. It is said that when we draw from life that information is ours forever.

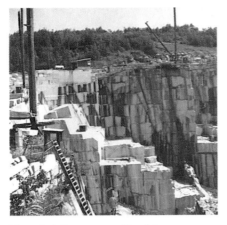

To paint the quarry, I had to understand the function of the things in it (cranes, ladders, buildings, and the way the rocks were cut). The photograph was a source of reference. It refreshed my memory of what I saw and sketched.

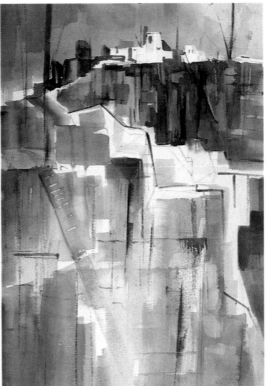

This was my first interpretation of the quarry. It was difficult to gain the textural effects I wanted (that was why I worked on rough paper in my next painting). To make up for the lack of texture, I used dry brush-strokes and added symbols to represent the rocks. Working from my information drawing, I established the location of all the various quarry equipment, such as ladders, booms, cranes, and work stations.

QUARRY I *Arches 140 lb., cold-pressed, 22" × 15" (55.9 × 38.1 cm)*

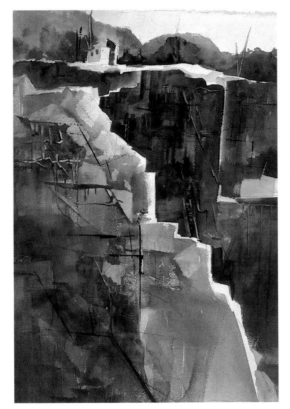

QUARRY II *Arches 140 lb., rough paper, 22" × 15" (55.9 × 38.1 cm)*

In this second painting I wanted to achieve more texture. I worked with the same composition sketch, changing only a few shapes. I kept the oblique dominance strong by stamping dark lines (made with a credit card dipped in pigment) to accentuate that direction. The subdominances to the oblique are the horizontal and vertical straights imposed across the top and upper right.

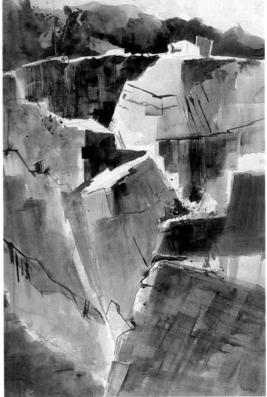

By now I was very comfortable with my subject and with only one surface left to paint on, I decided to paint another quarry. This time I changed the composition. When paint was applied on the dry surface of this smooth paper, a mottled effect was achieved. This pattern expressed the rocks. The calligraphy was done with pen and ink and worked beautifully on hot-pressed paper.

QUARRY III *Arches 140 lb., hot-pressed, 22" × 15" (55.9 × 38.1 cm)*

Composition

Organizing our information drawings in a logical, expressive, and carefully planned manner is what composition is all about. Everything in a painting can be perfect (technique, color, proportion, and subject), but if the composition does not succeed the painting will fail.

Composition is the instrument the artist uses to direct the viewer's eye to key areas of a painting. It allows viewers to quickly pass through some areas while slowly scrutinizing others. There is always a purpose that dictates how we plan the composition of shapes, colors, values, and lines. It is the most important tool we have and probably the most overlooked.

By using composition properly, we can reorganize the chaotic material of the real world into the orderly design of the art world. There are volumes of information that deal specifically with different approaches to composition. My purpose here is not to condense and oversimplify that valuable information, but to remind the artist of its importance and to show through illustrations how they are used.

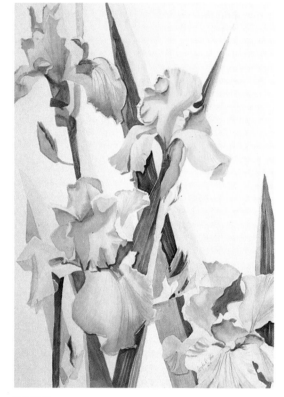

IRISES *Arches 140 lb., cold-pressed, 30" × 22" (76.2 × 55.9 cm)*

To achieve the fresh, clean, uncluttered appearance of this painting, I had to work very hard with the composition. I wanted the flowers to be my focal point, bold but delicate. It was to have a light, airy appearance (that was why I left the background white) that looked unlabored. To accomplish this I planned all my strokes carefully. There is something going on throughout this painting. The viewers have a path to follow and are never confused as to where they should look.

the cool leaf directs us toward the left iris

iris has a good shape and a warm temperature

pale wash decreases the value contrast

iris is cooler and less decorative than the others

flower bud has a sharp value contrast that guides us up

pale wash decreases the value contrast of the stem

the cool leaf on the right stops us from leaving the painting and directs us inward

iris is decorative and interesting in its shape, color, and detail

pale wash

triangle points us into the painting

note all shapes near an edge are pale and less noticeable so that they do not compete with the focal point

Compositional Motif

Some artists may want their compositions to deliver a message (as in advertising). Others may design their works to tell a story. Then there are some artists who need to use decorative art to depict a subject or design (calendar art, greeting cards, and posters). But most of us involved in fine art desire the viewer to do more than just glance at our work. We want them to contemplate on what they see.

One way to engage the viewer is to create a compositional motif that will direct the eye to the focal point of the painting. Letters such as Z, S, L, and T can be used to create a motif. The letters Z and S have a natural rhythm that makes it easy for the eye to follow their angles and curves. The lines that form the letters L and T run horizontal and vertical, and can be inverted or turned sideways to guide the viewer through the painting. The pattern these letters form becomes a connecting path that the eye will follow and can be used to direct the viewer to the focal point.

One-point perspective is another method of directing the viewer. It is similar to an arrow pointing to where we should look. This motif is very popular in landscape painting to give the illusion of depth and distance. When using one-point perspective, you need to establish a single vanishing point. All the objects in the painting will recede to that point. We cannot exaggerate the size of the diminishing objects in recession. Proper and constant evaluation of each object's relationship to the vanishing point is required for this motif to be effective.

The last compositional motif, or strategy, is the *vignette*. It is the most dramatic and eye-catching compositional device there is. We are forced to look at the positive shape surrounded by white. Though it may appear unlabored in execution, it requires tremendous planning to be done correctly.

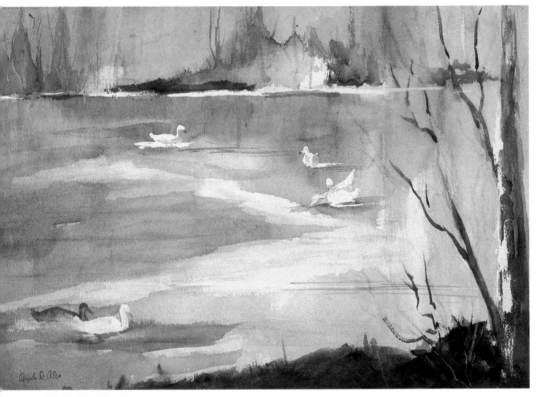

*I used the letter **Z** to direct the viewers through the painting. The cat paws in the water create a light pattern that is reinforced by the ducks. We are directed into the **Z** path by the duck in the dark triangular foreground. The light glint on the water's edge carries us across the painting, and the large dark tree on the right stops us from leaving the painting.*

I used a limited amount of colors (rose madder genuine, raw umber, yellow ochre, and ultramarine) and relied on my strong composition to create the interest in this painting.

ROSLYN POND *Arches 140 lb., cold-pressed, 15" × 22" (38.1 × 55.9 cm)*

WINDOWSILL
Arches 140 lb., cold-pressed, 15" × 22" (38.1 × 55.9 cm)

*The motif in this painting is the letter **L**. Not only is the dark shape an **L** but so is the negative shape (the white of the paper). The busy pattern of the plants and pots is offset by the simplicity of the background. The background is a variety of repeats of the **L** motif.*

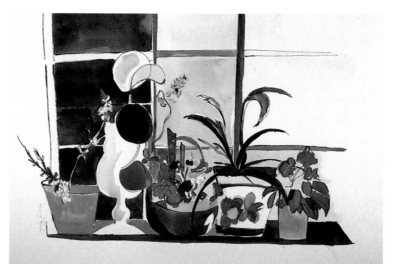

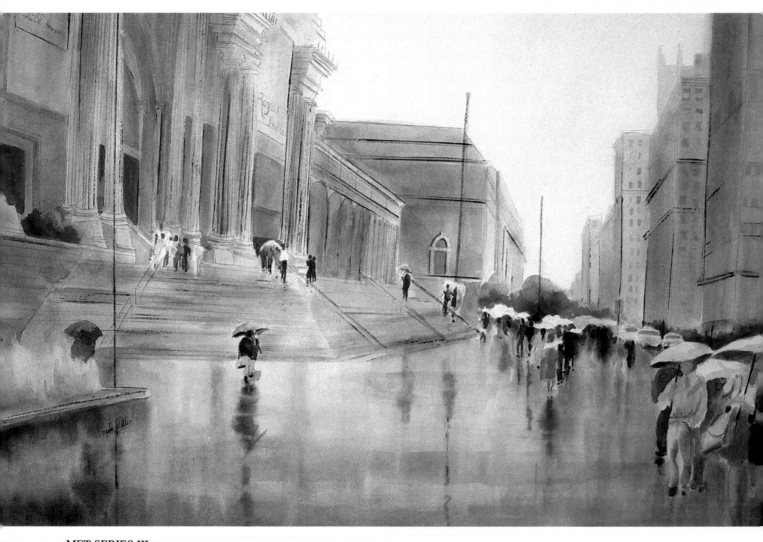

MET SERIES III *Arches 140 lb., cold-pressed, 26" × 40" (66.0 × 101.6 cm)*

To capture the feeling of depth needed for this painting of the Metropolitan Museum of Art in New York City, I used one-point perspective or the illusion of diminishing recession. I reinforced this motif by working in strong obliques to direct us toward the point of interest.

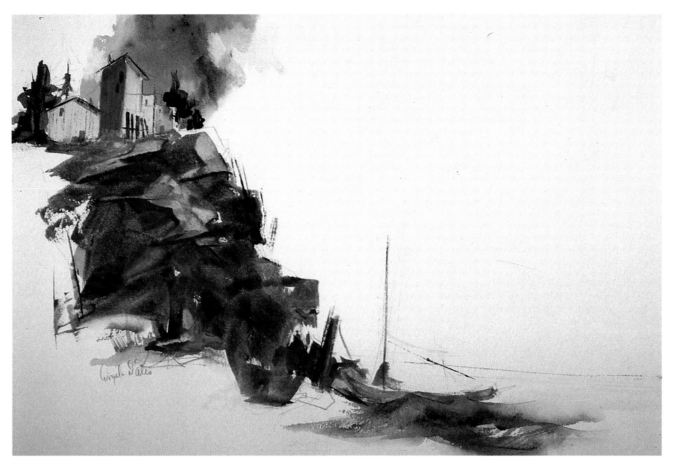

VIGNETTE *Arches 140 lb., cold-pressed, 15" × 22" (38.1 × 55.9 cm)*

In order for a vignette to be successful, there are several compositional details to think about. First, it should be a good shape *that is situated in different measures from all the edges. As this painting shows, the four white corners must be a different size and shape (avoid equilateral triangles). The shape must touch each side of the paper at a good location (preferably not in the corner or in the middle) without running along an edge for too long. A small part of the shape can be amorphous, and the rest of the shape can have varied edges (rough, blended, or hard).*

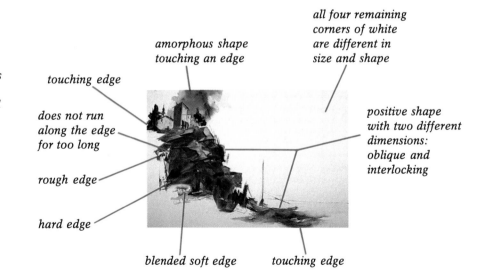

touching edge

amorphous shape touching an edge

all four remaining corners of white are different in size and shape

does not run along the edge for too long

rough edge

hard edge

positive shape with two different dimensions: oblique and interlocking

blended soft edge

touching edge

Value Sketch

My intention in discussing value sketches is not to show you how to sketch but to clarify the purpose of sketching. It is important to understand the difference between drawing and sketching, so to speed things up a bit, let me give you the dictionary definition of a sketch.

 1. a simple, rough drawing or design, done rapidly and without much detail.

 2. a brief plan or description of major parts or points; outline.

The intention of a value sketch is to serve as a road map to tell us how to get where we want to go. Any unnecessary details not related to fulfilling this purpose will be distracting, annoying, and a waste of time. Like a map, some sketches have to be specific to tell us about the unfamiliar areas to be traveled; others may be simple — even a few scribbled lines may be all we need. Each painting has different needs that must be worked out in a sketch.

Sketches are *not* where we draw a detailed rendering of our subject, or learn *how* to draw something (that is why we do an information drawing). It is where we decide on the arrangement of the components of our subject to express our purpose. The sketches must be customized to fit the specific needs for each individual painting.

My typical sketches consist of a very simple outline *allocating* shapes, and establishing the three values — lights, midtones, and darks. Notes are written all over my sketches to remind me of my dominances and colors. I include some type of information drawing, either on a separate page or right on the sketch itself, if necessary. These information drawings are done separately, in thought and action, from the value sketches. In paintings that will require a great amount of detail, it is best to design the overall shape first, and then on a separate piece of paper draw an enlarged detail for easy reading.

The objective of sketching is to quickly put down only as much information as we will need to begin painting. Don't expend excessive energy on the sketch and become exhausted when it comes time to paint.

Sketching involves planning composition as well as value patterns. Usually they are worked up in the same sketch, but sometimes it takes two sketches. This may be the case when drawing a technical subject, where it is necessary to keep the drawing clean for easy reference when transferring it to the watercolor. On the other hand, there may be times when it is easier to develop a value sketch and work from that; this may simplify a subject that is complex. Details and rendering of the subject may be done separately, after the value pattern is worked out.

I have often painted without using lines, but never without values. In developing values, you should begin with the three basics: light, midtone, and dark. They must read clearly and be distinguished from one another at a glance. A pattern will develop from these values. Once the midtone values are put in (that is usually everything in the painting that is not to be left white), then the darks go in (make sure that they are not spotty or scattered all over the sketch) as connecting, interlocking shapes. By placing the darkest dark next to the lightest light, you will establish the focal point.

Developing a sketch by using a neutral watercolor wash to work out values and the development of the overall pattern is very helpful when you are approaching a large complex painting. This type of planning takes less time than filling in large areas with a pencil — it is also cleaner, and there's no smudging.

Value pattern sketches are the most difficult sketches to develop. Sometimes squinting will help to eliminate the nuances in value changes, and it will accentuate the most dominant value. Manipulating these values to suit our needs is why we plan them out in a value sketch.

MONTPELIER SKETCH *pencil on drawing paper,*
11" × 14" (27.9 × 35.6 cm)

This drawing is typical of my sketches. A very simple outline allocates the shapes; my values are established and notes are written. On the outer edges there are some information drawings that enlarge the details.

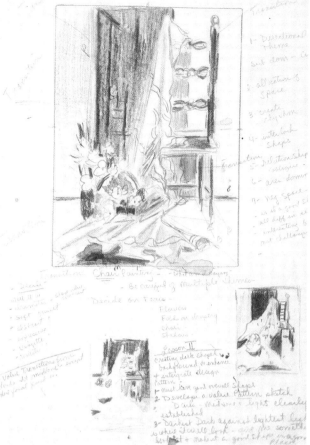

CHAIR I SKETCH *pencil on drawing paper, 14" × 11"*
(35.6 × 27.9 cm)

CHAIR II SKETCH *pencil on drawing paper, 14" × 11"*
(35.6 × 27.9 cm)

In this illustration a very simple sketch was done. Since the painting was to follow the actual setup, I only needed to allocate the shapes. The smaller sketch, below, is my contour drawing of the overall shape I wanted to establish. I then drew a rectangle in the proportionate size of my watercolor paper and proceeded to correctly allocate the placement of the subject.

I worked in the values, wrote a few reminders on the side of the sketch, and then I began painting. The grid marks on the outer edges of the sketch helped to guide me when I transferred the drawing to watercolor paper.

Even though I was familiar with the drawing and composition of the chair, it was necessary for me to develop this second sketch to plan the execution of the new painting.

Although the basic composition remained the same, a new value pattern was worked out. I also established all my design rules and confronted other potential problems.

The allocation of my main shapes and my light patterns were established in these sketches. I then worked on some drawings of the flowers that could be used for the painting. It would have been futile to try to put these detailed drawings into my tiny sketch.

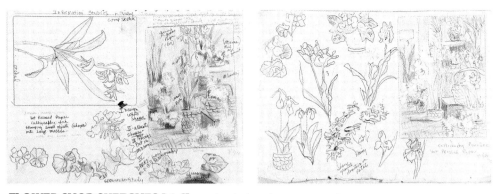

FLOWER SHOP SKETCHES I & II *pencil and ink on drawing paper, 8″ × 11″ (20.3 × 27.9 cm)*

STRAW MARKET SKETCH *pencil on drawing paper, 14″ × 11″ (35.6 × 27.9 cm)*

The only way I could have painted this scene was not to be in front of it. The details were too distracting. I had to simplify the design and work from this sketch.

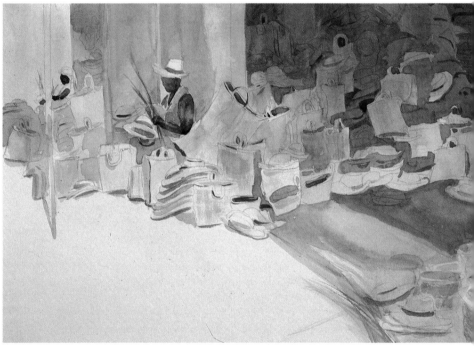

STRAW MARKET *Arches 140 lb., cold-pressed, 15″ × 22″ (38.1 × 55.9 cm)*

Some paintings, once they begin, develop into something entirely different from the well-planned sketch. Not so in this case. I worked closely with the sketch to keep me on track so I would not become involved in describing too many things and lose my pattern.

The colors were kept to a minimum and the values were accentuated. An underglaze of cadmium orange was used to give the painting a warm, sunny character. The strongest colors are in the focal point.

I wanted to keep my original placement sketch as an easy reading reference to use to transfer onto my watercolor paper. Another sketch was developed under this line drawing for the placement of my values. Again, note the writing on the outer edges.

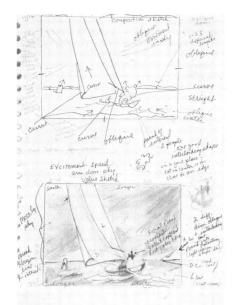

STORMY SAIL SKETCH *pencil on drawing paper, 11″ × 8″ (27.9 × 20.3 cm)*

NEW YORK STOCK EXCHANGE SKETCH *pencil on paper, 14″ × 11″ (35.6 × 27.9 cm)*

With such a complicated subject, it was necessary for me to simplify the subject into an easy-to-read pattern of values. The top sketch established my three values (mostly midtones with some darks and lights) and allocated the basic shapes. In the lower sketch I refined my shapes; it shows some of the details I wanted to suggest.

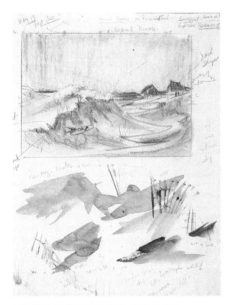

PINK SAND DUNES SKETCH
pencil, ink, and watercolor on paper, 14″ × 11″ (35.6 × 27.9 cm)

The values in this sketch are more important than the lines. The light, midtone, and dark values create the form as well as the focal point.

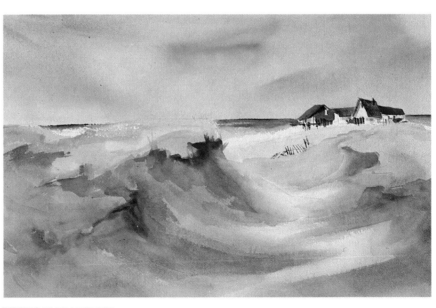

PINK SAND DUNES *Arches 140 lb., rough paper, 15″ × 22″ (38.1 × 55.9 cm)*

Working very closely with my sketch, I executed this painting very quickly. I depended on values to create the forms and shapes. I used exaggerated colors to gain the effect of the sunset: cadmium orange, permanent magenta, viridian green, and Winsor violet. The darks are Winsor violet and burnt sienna. It was worked wet-into-wet with almost no drawing.

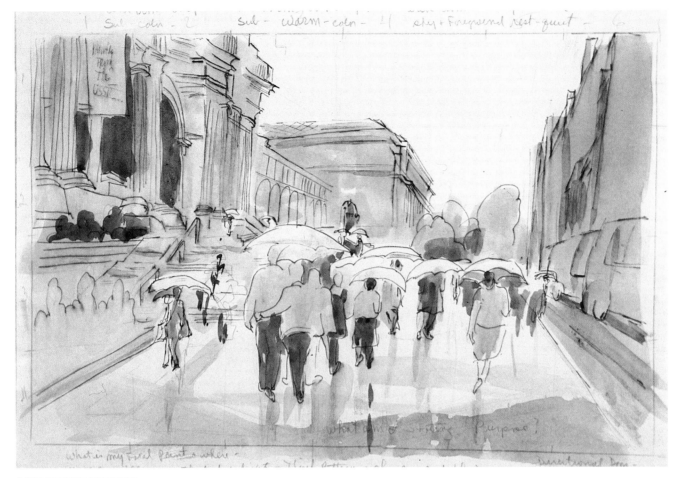

MET SERIES SKETCH *watercolor wash and pen on drawing paper, 11" × 14" (27.9 × 35.6 cm)*

Developing this value pattern sketch using a neutral watercolor wash, I was able to work quickly to cover all the areas I did not want to leave white. Using only three values, I can easily read where my lights, darks, and midtones are. But I decided not to use this value plan because it did not have a good dark pattern. The darks are scattered (this becomes obvious if we squint). They pop out because of the sharp value contrast with the whites. That kind of pulling power must be put into the focal point and not scattered all over the painting. Recognizing this, I quickly developed another sketch to resolve these potential problems. (The completed painting of the Met is in the beginning of this book.)

SUNSET SKETCH *pencil on drawing paper, 14" × 11" (35.6 × 27.9 cm)*

In these sketches I worked up two value patterns to distinguish my lights, midtones, and darks. In the lower sketch I made decisions concerning my colors that are written on the sketch itself. The execution of this painting went very quickly because of all the prior planning.

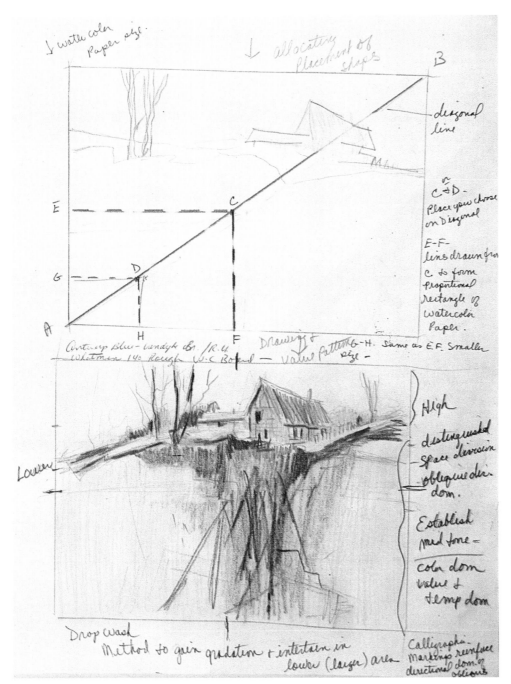

The handwritten annotations on the sketch read:

↓ water color paper size.

↓ allocating placement of shapes

— diagonal line

C & D -
Place you choose
on Diagonal

E-F -
lines drawn from
C to form
proportional
rectangle of
watercolor
paper.

B

E

C

G

D

A

H

F

Antwerp Blue - Vandyke Br. / R.U.
Whatman 140 Rough W.C. Board — Value Pattern

Drawing ↓
G-H. Same as E.F. Smaller size -

High

distinguished
space division
oblique dir.
dom.

Establish
med tone -

color dom
value &
temp dom

Lower

Drop wash

Method to gain gradation + interest in
lower (larger) area

Calligraphic
markings reinforce
directional dom. of
obliques

PROPORTIONS SKETCH *pencil on drawing paper, 14″ × 11″ (35.6 × 27.9 cm)*

It is imperative that our sketches (no matter how large or small we like to work) are in proper proportion to the watercolor paper. It is the only way to ensure that the location of shapes in our sketch will be the same when we transfer them to the watercolor paper.

This illustration demonstrates how to find the proportions of the watercolor paper (use the back of the paper or an old painting). The top rectangle represents the watercolor paper; the lower rectangle represents the sketch.

First, you must draw a diagonal line (A–B) to divide the watercolor paper in half; it will form two triangles. Then drop a vertical line (C–F or D–H) from any point on the diagonal line; this is the approximate size of the sketch paper. A horizontal line should be drawn to connect the vertical line (E–C or G–D). The rectangle that is formed (AE–EC–CF–FA or AG–GD–DH–HA) is proportionate in size to the watercolor paper.

Any size can be made to suit our sketching purposes. Templates in various sizes of the most commonly used watercolor papers are helpful to keep in a sketchbook. I have several templates in different sizes: full sheet, half sheet, quarter sheet, and Arches 260 lb. These are made from old mat boards for durability.

Color Sketch

The motive for a color sketch is to work out color problems — usually working in flat colors to judge relationships. (Save the color nuances for the completed painting.) Most times the sketch will not be necessary, but when it is desired, do it on the back of an old painting, mat board, or sketch paper to avoid the temptation of making it a finished work. Color sketches should be kept simple and not be labored.

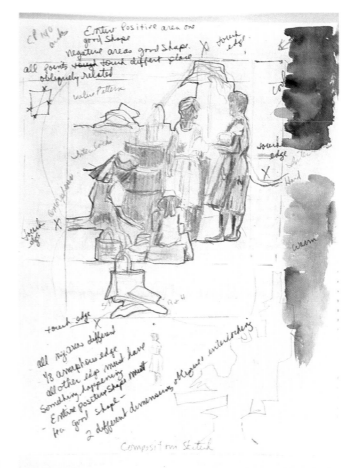

ISLAND LADIES SKETCH *pencil and watercolor on drawing paper, 14" × 11" (35.6 × 27.9 cm)*

This vignette originated from a painting that was later put in the discard pile. The discarded painting had about twelve different points of interest and no composition. Out of all this chaos, one small piece caught my eye—this group of island ladies.

To ensure unity, I worked up this sketch. Undecided about color, I tested out some temperature combinations.

ISLAND LADIES COLOR SKETCHES *watercolor and pencil on mat board, 11" × 14" (27.9 × 35.6 cm)*

With these two color sketches I was able to compare the warm and cool temperature dominances.

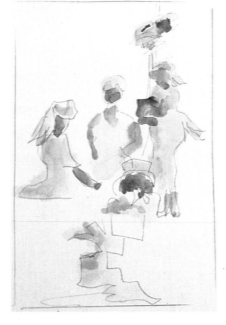
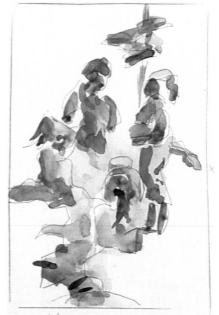

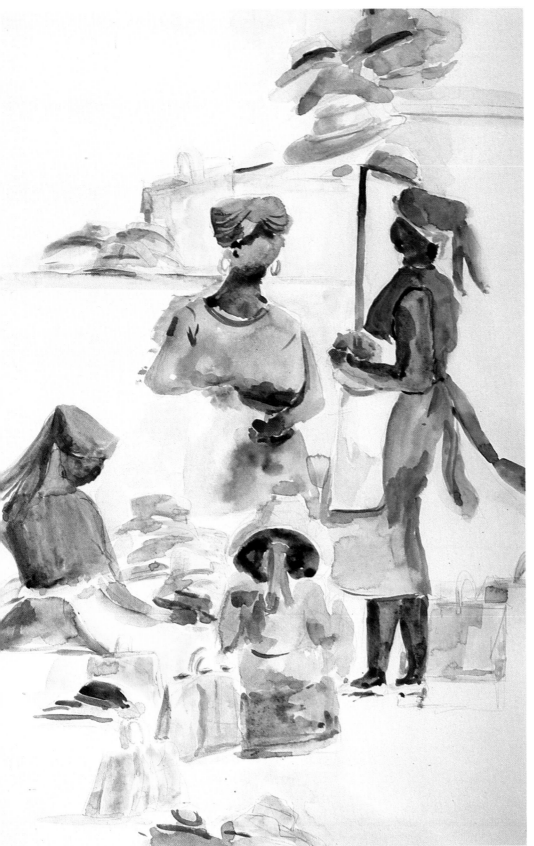

This painting composed as a vignette was worked dry. All the shapes were interlocked to create one large shape with varied edges. There is a curvilinear directional dominance here, which is accentuated by the **S** pattern of the compositional motif. It is counteracted by the straights. The painting has a cool temperature dominance of blues and violets with a subdominance of warm yellows and oranges.

ISLAND LADIES *Arches 140 lb., hot-pressed, 22″ × 15″ (55.9 × 38.1 cm)*

Master Drawing

After all the information drawings are compiled and the value sketch is completed, we are ready to make our final drawing onto watercolor paper. There are times when we may want to work up a *master drawing* (which is the same size as the watercolor paper), and then transfer it onto the watercolor paper.

There are many reasons for using this extra step before painting. First, if the painting involves intricate drawing, where erasing is inevitable, this will spare the painting surface from excessive wear. Additionally, when working very large, you will find it difficult to judge the placement of shapes from the sketch in relation to the new enlarged size of the painting surface. (In technical drawings, small details may be worked out in actual size to ensure correctness.) And finally, my favorite reason, the drawing can be used over and over again. The painting can be redone using another technique, new colors, or repeated for any number of reasons.

Transferring

Tape the completed drawing to a window during daylight hours, then place and tape over the drawing the watercolor paper you intend to use. The light coming through will enable the drawing to be seen, and it can be traced onto the watercolor paper. (If a 300-lb. or heavier paper is used, it may be necessary to darken the lines on the master drawing.)

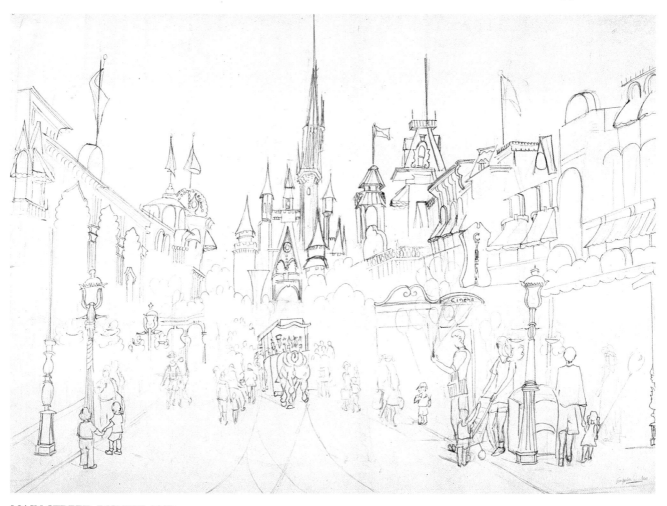

MAIN STREET, DISNEYLAND *pencil and ink on drawing paper, 22" × 30" (55.9 × 76.2 cm)*

After careful planning on sketch paper to allocate the shapes, I drew this intricate drawing of Main Street in Disneyland. I worked from sketches I made on location and from photographs I took. This drawing took several ses-sions and many hours. To have drawn directly onto my watercolor paper would have been detrimental to the paper; whereas, in this drawing, I felt free to make all the necessary corrections.

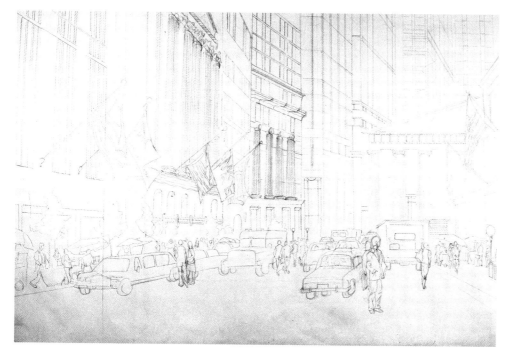

Although I made several sketches of this drawing, I knew because of the large size of the watercolor paper that my relationships would be exaggerated and may not work. This turned out to be the case here, where the foreground seemed to have tripled from that of my sketch. It was necessary for me to add more people and cars to create more interest in this large area. I studied this drawing for weeks, making many corrections and adjustments before I did any transferring and painting.

WALL STREET *pencil and ink on drawing paper, 25″ × 40″ (63.5 × 101.6 cm)*

This drawing involved technical rendering to get the rigging and positions of the sails correct. Although many of my sailing paintings were painted loosely, the drawings of the boats and their rigging had to be precise. In order to accomplish this, I needed to have the drawing the actual size of the painting. Working up a master drawing, I could clearly figure out all the necessary details (actually my husband is my technical adviser on boats).

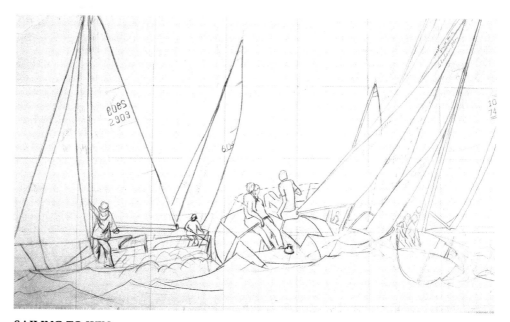

SAILING TO WIN *pencil and ink on drawing paper, 16″ × 30″ (40.6 × 76.2 cm)*

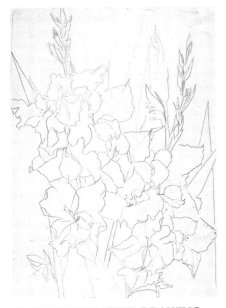

GLADIOLUS MASTER DRAWING
pencil on tracing paper, 30″ × 22″
(76.2 × 55.9 cm)

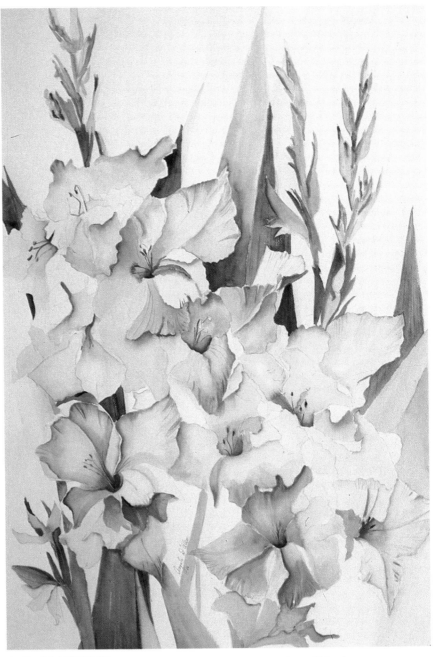

PINK GLADIOLUS *Arches 140 lb., cold-pressed, 30″ × 22″ (76.2 × 55.9 cm)*

The same master drawing was used to work up these gladiolus paintings. I also used the same colors for both paintings, only in different proportions: Winsor violet, rose madder genuine, Naples yellow, burnt sienna, and olive green. For both paintings I used a dry glazing technique (see the demonstration on pages 101–102). In this process very thin glazes were applied and then allowed to dry before adding another glaze. I repeated this process until the desired effect was achieved.

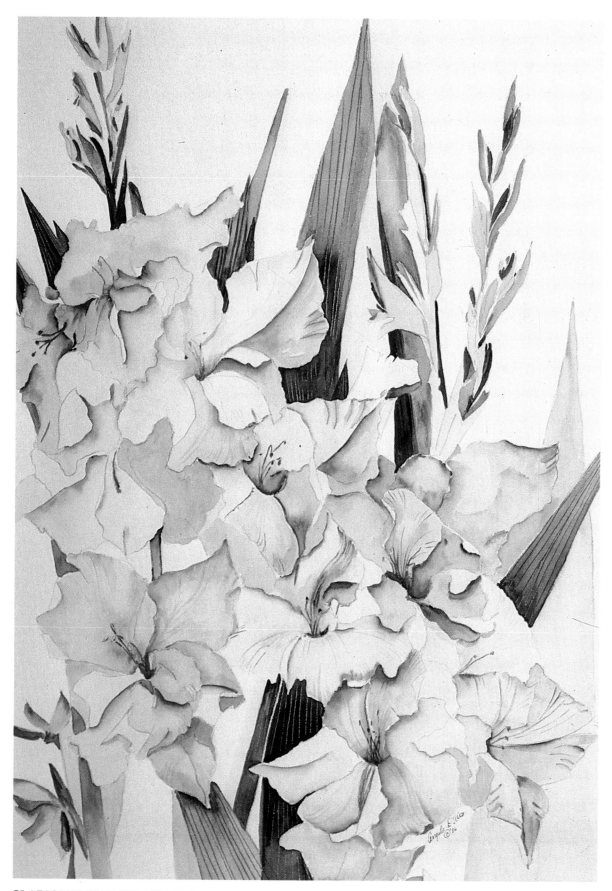

GLADIOLUS IN PINKS AND VIOLETS *Arches 140 lb., cold-pressed, 30" × 22" (76.2 × 55.9 cm)*

5 SHAPES

It is said that artists paint *shapes* and colors. No matter what the subject is, it is always a shape first, then the object — boat, house, flower, people, or whatever. The negative and positive spaces in a painting are shapes. We must not assume the object to be painted is a good shape because we like what it is. We must know it is a good shape or rearrange it so it forms one.

As defined by Edgar A. Whitney, a good shape is "two different dimensions — oblique and interlocking." For years I heard this definition of a good shape, and it meant nothing until I started to analyze what it was about certain subjects that made them appealing. I discovered that it was their shape or the combined shape of many objects. Then I began noticing good shapes in other art forms, such as ballet. Each time dancers strike a pose, it is never a static or scattered position. Choreographers make sure that there is a strong shape for the audience to focus on, it is usually oblique and interlocking. This holds true for most art forms; if a shape is interesting, we will look at it and explore its nature.

If you begin a painting by isolating the subject, you will have trouble achieving unity. In order to unify the subject, we must identify it as a shape before we describe it as a thing — person, flower, house, animal, and such. We can make a subject into a good shape by interlocking it with other shapes. The merging of forms creates a rhythm that also unifies a subject. There are times we can connect objects by relating their colors or values to make them good shapes. All these optical illusions set up a viewer participation, which is a desirable feature in any work of art. Let the viewers feel good about being part of the artist's plan, and they will not get tired of looking at the painting.

Try to avoid drawing the individual objects; this places too much emphasis on "what it is" and not enough on establishing the overall "good shape." We read shapes in a painting before we read objects. Things must not be thought of as a separate part of the picture; they must be drawn as part of the total picture.

To view *things* as *shapes* is a difficult concept to grasp in art. The brain identifies shapes, and then a specific preconditioned image appears that frequently prevents us from seeing objects from a fresh point of view. We assume we know what it looks like. For example, when we see an apple, we automatically associate it with a picture we have of it in our heads. But this apple may

be special in some way. Unless we take the time to examine it and identify all its characteristics, we will only see *an* apple, not *the* apple. When this happens, it becomes difficult to distinguish the shapes from the objects.

Redesigning objects into shapes calls for an acute understanding of what objects do and how they function. Using this knowledge, we can change them into strong shapes. It is necessary to look at all individual objects and study *their* shapes. The positive areas as well as the negative areas are shapes in a painting. Every part of the painting must be a good shape in order for the painting to work. A sky is boring if it is just a rectangle, but by interlocking a tree or a mountain it becomes a better shape. The most commonplace object can be made interesting by imposing a good shape onto the object.

When a complicated scene is before us with a great deal of small and large shapes, it is best to simplify it by designing a contour drawing to establish the overall large positive shape. The contour drawing will reveal the negative shapes, which will show us if it is, in fact, a good shape. (Many times a contour drawing can be made by using tracing paper. Just place the tracing paper over the drawing, trace the main shapes, and eliminate all the details.)

SITTING ON THE BEACH *watercolor and pencil on drawing paper,*
5½" × 9" (14.0 × 22.9 cm)

This little color sketch is a good shape. It has two different dimensions: it is oblique and interlocking.

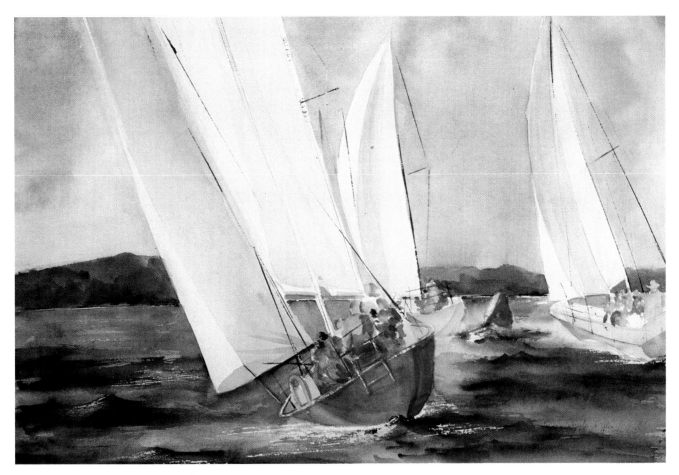

SUNDAY SAILING *Arches 140 lb , cold-pressed, 22" × 30" (55.9 × 76.2 cm)*

With this traditional subject, I was still able to be faithful to the definition of a good shape and portray the boats and sails realistically. It was a matter of designing first and drawing second.

I tilted and connected the boats and sails to make a good shape. The people in the boats are only shapes that suggest figures.

SHOES *pen on vellum, 12" × 19" (30.5 × 48.3 cm)*

In this drawing there was too much emphasis placed on the description of the subject and not enough placed on establishing the overall "good shape." Each shoe was drawn as an isolated object trying to capture its identity, because of this I lost the shape of the pattern that I wanted to paint. No attention was given to the negative areas in regard to making it a good shape; here they are simply empty spaces between shoes.

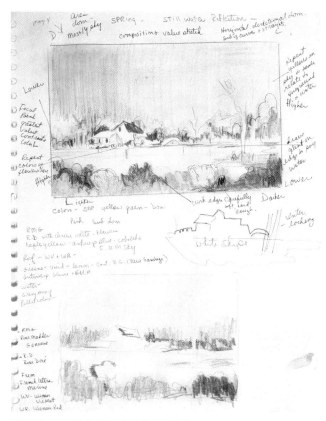

SPRING REFLECTIONS SKETCH *pencil on drawing paper,*
11″ × 8″ (27.9 × 20.3 cm)

*Designing this sketch from the actual scene, I took what
was there and connected the elements to create a good
positive shape (outlined in the bottom sketch). Beginning on
the left, the light shape of the land and water lead us in.
The white birches become a part of the overall shape that
leads us into the house shape. From there the house shape
connects with the shape of the bridge and continues on to
the right side of the painting. Here we are stopped by the
white interlocking shape of the birches.*

CONTOUR DRAWINGS *pen on vellum, 11″ × 8″ (27.9 × 20.3 cm)*

*This illustration shows the contours of three paintings: Barn
Vignette, Anemones, and Garlic (the paintings follow). In
each of these paintings the shape is the most important
feature. All the well-drawn details will not make a painting
great if the overall shape is poor or invisible. Once a good
shape is established, then we can fill in the shape with
details to describe and decorate it.*

GARLIC *Arches 140 lb., cold-pressed,*
11″ × 15″ (27.9 × 38.1 cm)

*All the abstract shapes I used in this
painting are there to enhance the
bulbous shape of the garlic. The
vertical and horizontal wash on the
left adds a conflict to the otherwise
curvilinear directional dominance.*

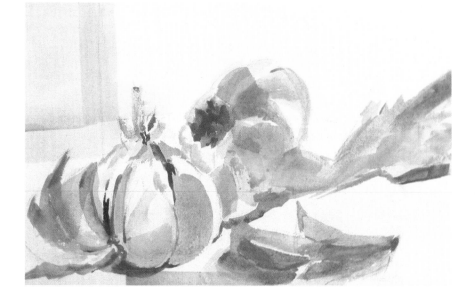

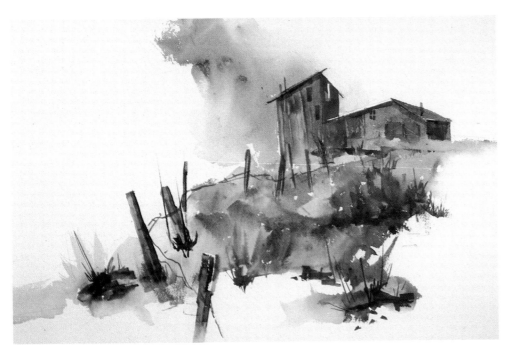

Because of the vignette style I used in the composition of this painting, it was imperative for me to establish the overall shape and then fill in the details later.

All details in a painting must have a purpose. The wire fence posts direct the viewers into the painting and connect the shapes. I made them different widths; they are all staggered and obliquely tilted at various angles, and they interlock the foreground and background to the middle shape.

BARN VIGNETTE *Arches 140 lb., cold-pressed, 15" × 22" (38.1 × 55.9 cm)*

By turning the flowers in all different directions, I was able to interlock them and create shapes rather than have isolated flowers. The filigree of foliage under the petals creates interesting shapes. The stems connect the shapes and are the conflict to my curvilinear dominance.

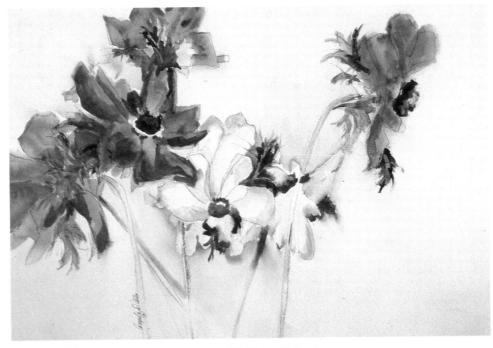

ANEMONES *Arches 140 lb., cold-pressed, 15" × 22" (38.1 × 55.9 cm)*

In order to paint this scene, it was necessary for me to simplify and unify the subject matter into simple shapes.

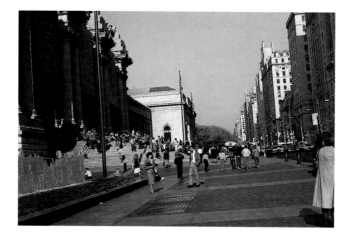

CONTOUR DRAWING *15" × 22" (38.1 × 55.9 cm)*

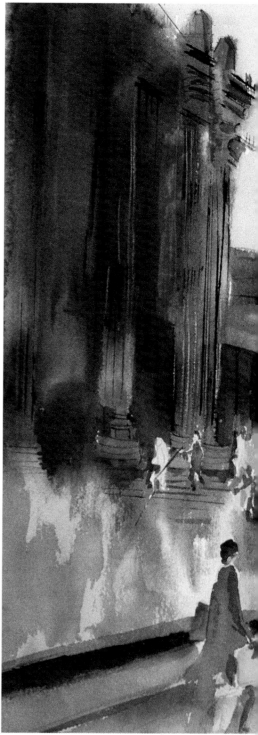

Once I established my overall shape, I had to choose which details I would incorporate into the painting to describe the area. Never try to say it all in one painting. I usually work interesting scenes like this in a series and characterize different parts of the location.

The positive shape (the gray area in the contour sketch) has all the detail, but that is not what makes the painting work; this shape is a good one in its entirety. The negative shapes (the white areas on the contour drawing) are also good shapes and relate to one another (to do this I interlocked the figures in the foreground and the flags in the sky area).

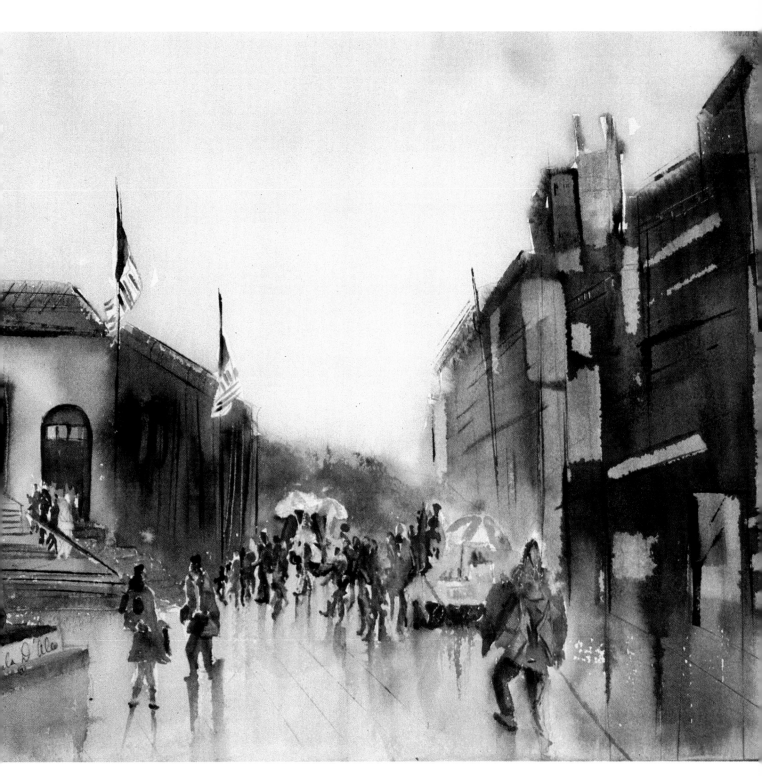

THE MET *Arches 140 lb., cold-pressed, 15″ × 22″ (38.1 × 55.9 cm)*

Shape Relationships

Throughout the text I emphasize how important it is to repeat the various elements: color, line, shape, and value. Repetition is easy, but to do it with variety takes a conscious effort. Certain variations are easy. For example, if we have many curves in a painting, we can use circles, dots, and wavy lines. When arranging variations, I think of them in terms of a family: *mama*, *papa*, and *baby*. The reason I have chosen to use this silly sounding analogy is because it has worked for me and many others to think of size relationships this way.

The main shape or color, the largest part of the painting (it could be a sea gull or a group of sea gulls, or a flower or a group of flowers), is the papa shape. Repeat the papa shape by making a smaller group, or individual, shape — this is the mama shape. Then we need one or more smaller group shapes — the baby. Every element that is to be repeated can be divided up this way (darks, lights, lines, shapes, colors, rest areas). A horizon line can be broken into papa, mama, and baby lengths. Not only does this system repeat the element, but it allows for variation of the element through size.

After working out the size of the elements, you must know where you want to place them in the painting. You should place the elements with thought as to how they will affect the viewer's reaction to the painting. For instance, by placing the elements in their varied sizes in a straight line across the paper, you will create a soothing effect that gives the feeling of comfort and support. To arrange the shapes obliquely you will create movement, and enable the viewer to follow the related shapes or colors through the painting. There is also the triangular placement, which is helpful when you are planning a floral arrangement.

In order to organize the placement of elements while painting, we must train ourselves to see where we will be able to place a repeated element and be aware of the areas where it has already been placed. Remember, the amateur paints a stroke, then asks if it is right; the pro asks if it is right, then paints a stroke.

ROCKS AND SURF SKETCH *pencil on drawing paper, 14" × 11" (35.6 × 27.9 cm)*

It is no accident that there is repetition with variety in the painting developed from this sketch. As simple as the shapes are, the size and placement of every rock, the surf, and the sea gulls was planned.

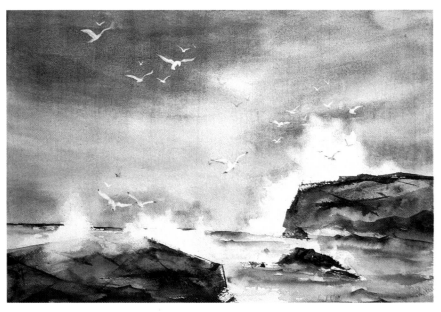

ROCKS AND SURF *Fabriano 140 lb., rough paper, 22" × 30" (55.9 × 76.2 cm)*

Everything in this painting I thought of in terms of relationship to their size and placement. All the colors, shapes, and lines were repeated with variation. The birds were painted in a large group, a middle size group, and several smaller groups. The rocks, horizon line, and surf were also worked this way.

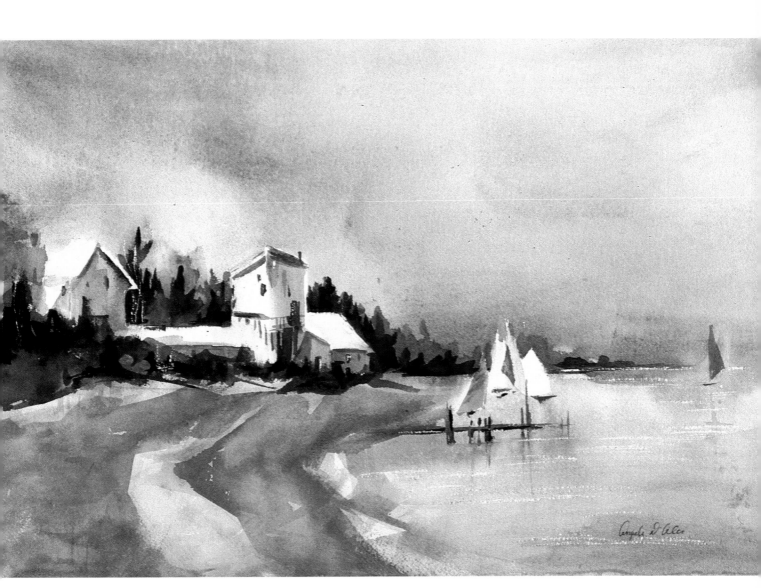

DUNE WOOD *Arches 140 lb., cold-pressed, 15" × 22" (38.1 × 55.9 cm)*

Nothing in this scene was painted as an individual shape to stand alone. I connected everything to make good shapes out of all the elements (sand, boats, foliage, sky, water, and houses). The values, colors, and lines do all the connecting. All the shapes, colors, and values were repeated with variation. These repeats have good relationships in their size and positioning.

6 THE PURPOSE OF COLOR

Color influences the attitude of the viewer more than any other factor. Therefore, we must always be careful in our choice of colors and how we use them to suit our purpose. There are two ways in which color can be used in a painting. We may use the subject's *local* color which refers to its true color — red apple, yellow banana, blue sky, green grass. This is known as the objective color. Then there is *arbitrary*, or subjective, color. In other words, the *artist* chooses what colors to use for the subject. Painting with arbitrary colors can help you create a personal statement. Color can show feelings

and say things that cannot be said any other way. The artist has the choice to decide on what colors to use and how to use them.

We all have prejudices toward certain colors, but in reality there is no wrong or right color and no beautiful or ugly color. It is how colors are used that causes certain reactions. Through the use of color, we have the means to create a happy feeling, convey sadness, or show anger. All we need to understand is how to work the properties of color. This means isolating each property to allow its character to come through and function in the painting.

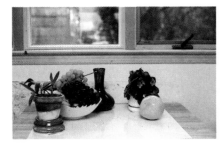

In this painting I made no attempt to alter the colors of the objects I painted. I was faithful to the description of the objects in order to maintain unity. Care was taken to follow the rules of design (taking it out of the realm of the camera and into the artist's world).

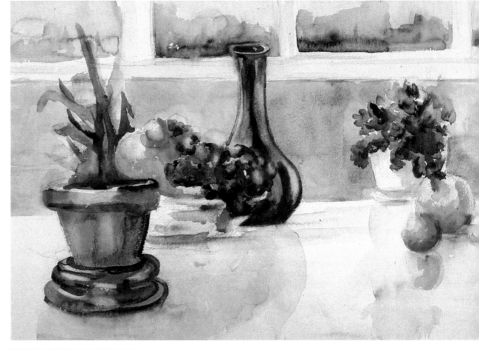

STILL LIFE WITH FRUIT *Fabriano 140 lb., rough, 15" × 22" (38.1 × 55.9 cm)*

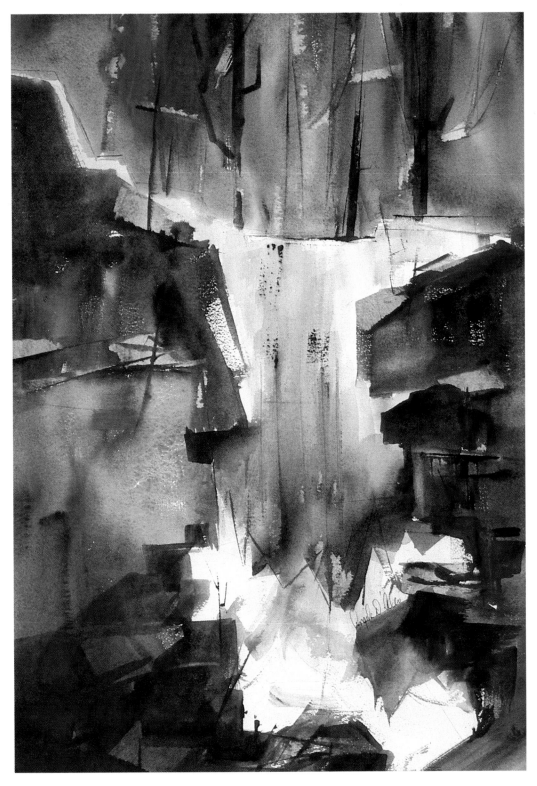

FANTASY FALLS *Arches 140 lb., cold-pressed, 22" × 15" (55.9 × 38.1 cm)*

I chose the colors for the rocks, water, and trees in this painting for the purpose of expression. No attempt was made to capture any realism through color. The stylized handling of the subject complements the abstract quality of the colors. The arbitrary colors add to the agitated and aggressive feeling evoked by the subject. By selecting to use a triad (three tertiary colors: red–orange, blue–purple, yellow–green), I ensured unity in a painting that has sharp value contrast.

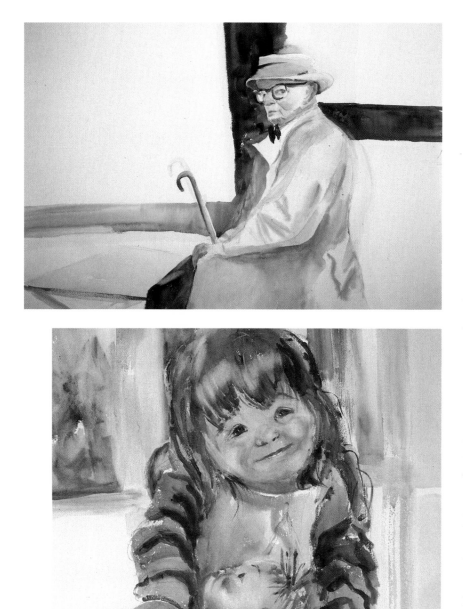

EDGAR A. WHITNEY
Arches 140 lb., cold-pressed,
22″ × 30″ (55.9 × 76.2 cm)

The character of the subject is suggested by the way I used color. For my painting of Whitney, the artist and teacher, I needed sharp value contrasts to suggest his assertive, aggressive, and decisive character. Few colors were used because of the great value contrast; this ensured clarity in understanding the composition.

The sketch for this painting was drawn while he was giving a watercolor demonstration. Whitney was serious about his teaching and demanded everyone's attention. In this painting, which is done in a vignette style, I made him the star with his features creating a pulling power.

Whitney's glasses, bow tie, cane, and hat were his trademarks. The darks in these objects fuse with the background and unify the entire shape. The background darks are both warm and cool; cool near the edge of the paper and grading to warm as they come closer to the figure. The darks are very warm around Whitney's features.

The warm reds are all placed obliquely from one another (top of hand, nose, feather in hat, ear, and under forearm). They each form a triangle, which is small, medium, and large in size.

ERICA
Arches 140 lb., cold-pressed,
30″ × 22″ (76.2 × 55.9 cm)

The colors and the way they were used in this painting suggest the feeling of youth and gaiety. I chose to use intense colors to complement the subject; in order to do this, I had to keep the values close to avoid confusion. By using little value contrast, I suggest an easy, carefree subject. The warmth of the colors used in this composition brings the subject forward and closer to the viewer.

Value

Value refers to light and dark. Color is a value in itself; it is a color and value simultaneously. Yellow in its pure state is a light value; red is more of a midtone value; and blue, green, and purple are basically dark values. When working from our value pattern sketch, we must take into consideration the way a color will translate onto the paper. The colors that appear dark in their pure state, as they come out of the tube, will most often be dark on paper. The reverse is also true; light colors straight from a tube will be light on paper. An exception to this rule is cobalt blue, which will not make a good dark even when mixed with other colors.

When judging the value in a color, it will be affected by the surrounding colors. Colors have a spreading effect where their values are changed by the adjacent hues. Black surrounding a color makes it appear richer — the value increases. In contrast, white restricts the spreading effect in the color it surrounds. The color will appear less rich — the value diminishes. (This is helpful to know when choosing the color of a mat for a painting.)

Value Contrast

The relationship between dark and light areas is called value contrast. To avoid confusion in a painting where many colors are used, you should use close value contrasts. In a painting where few colors are used, there can be a greater value contrast. When the colors with the greatest value contrast are placed next to one another, it becomes the focal point. The manipulation of value contrast can also create form, imply depth, and express a feeling.

In order to create form, we need to paint value contrasts to show the dimensional quality of a thing. If we take a light color and place it next to a dark color, a dimensional quality is achieved. Darker values will come forward, and the paler values will recede (affecting this will be the coolness and warmth of a color). Changing the value of a single hue will create a form. Painting all areas in the same value will result in a flat painting — even if we use different colors.

Value contrasts can also express a wide range of emotions. For instance, a sharp value contrast will suggest tension, assertiveness, aggression, and decisiveness; while a subtle or small value contrast will suggest calmness, ease, and relaxation.

Low-key paintings work the values 5–10 (using a scale of 1–10, 1 is the lightest value and 10 is the darkest value). The lightest color in a low-key painting is the midtone and the darkest is black. Using only dark values in a painting, you can create a somber or mysterious mood, give the feeling of heaviness and weight, or suggest eerie and secretive sensations. In watercolor painting it can be difficult to work low-key because of the nature of the paints. There's a tendency to make mud while trying to obtain rich darks — overmixing and overstroking lead to this problem. Working with clean colors can produce a luminous dark painting. Clean colors are composed with the least amount of sediment and other colors. The primary colors of pure red, yellow, and blue are the purest. Secondary colors are the next purest; they are made from the primary colors and consist of orange, green, and purple. The last set of colors are the tertiary colors, and they are the least pure. They are colors that are mixed from a primary and an adjacent secondary: blue–green, blue–purple; yellow–green, yellow–orange; red–orange, red–purple. Information can be obtained from various paint manufacturers to find out what the tube colors are composed of.

High-key paintings work with the values 1–5 (1 is the white of the paper, and 5 is the midtone). No intense darks are added (intense colors such as vibrant yellow, purple, red, or green can be used as long as they are not made into a dark). The midtone is the darkest value. Using high-key colors will create a happy, light, fresh, and delicate painting. A great deal of restraint is needed to avoid overworking this type of painting. When the commitment is made to work high-key, avoid the temptation to put in more color. High-key paintings may have the tendency to look unfinished. The artist is the one who decides when the painting is finished.

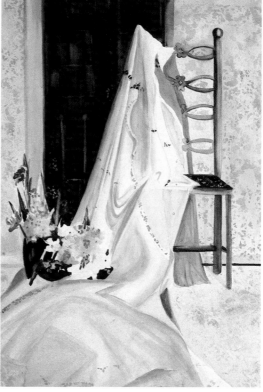

CHAIR STILL LIFE *Arches 140 lb., cold-pressed,*
30" × 22" (76.2 × 55.9 cm)

By using close and high-key values, I suggest a
peaceful, delicate, and fresh feeling. I painted
from the same still life as the dramatic chair
painting, but the visual effect is different because
of the way I handled the values.

I chose not to work with a full palette of colors
and saved the colorful part for a small portion of
the painting (the trail of the floral print lace of
the drapery). The values were also kept close in
the flowers. The greatest value contrast is the
focal point of the flower basket.

DRAMATIC CHAIR *Arches 140 lb., cold-pressed,*
30" × 22" (76.20 × 55.9 cm)

Value contrast plays the major role in creating
the visual impact of this painting. The greatest
value contrast is in the flowers. We look there
first, before being pulled by other aggressive
areas. To ease the transition of one value change
to another, I added texture to the background
and foreground. The texture had to be subtle and
interesting, yet not overpower the focal point.

Value contrast gives form to the drapery.
Where there is no value change, only color
change, the shapes appear flat.

Here is a detail of Dramatic Chair. *On*
the left, I stenciled in the shapes by
pushing paint through the holes of a
doily. (This was repeated on the right
and the foreground area.) To keep
unity, I also developed some of the
flower shapes using the doily.

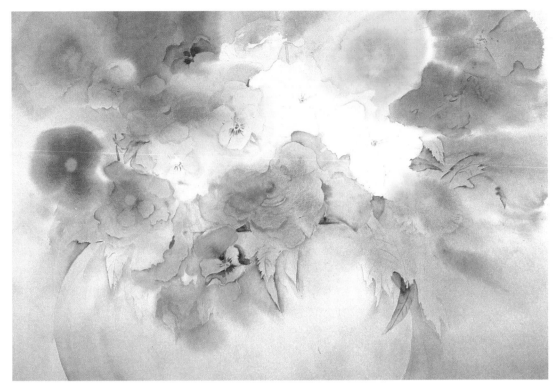

Working with light values and no darks (high-key 1–5), I expressed the soft, delicate side of these flowers. The intense yellows and the vibrant colors create the interest in the flowers.

SPRING ANNUALS *Arches 140 lb., cold-pressed, 22″ × 30″ (55.9 × 76.2 cm)*

When working with low-key colors (values of 5–10), the feeling of volume, heaviness, and bulk can be suggested. The small light flower on the right is the lightest light. It is actually a midtone value that appears almost white because of the darks that surround it. In this painting I used the exploding colors technique.

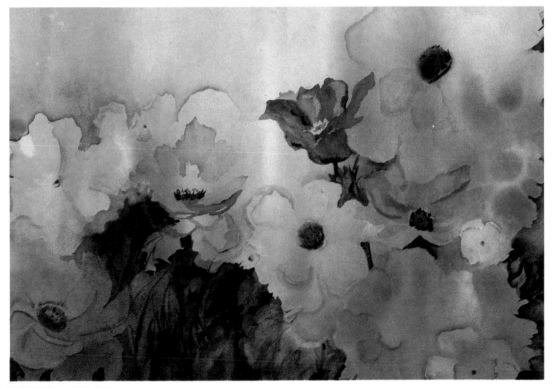

MAGENTA MAGIC *Arches 300 lb., cold-pressed, 22″ × 30″ (55.9 × 76.2 cm)*

Demonstration on Arches 300 lb.
EXPLODING COLORS TECHNIQUE

Purpose: to apply pigment without the use of brushstrokes to establish loose, unstructured, soft shapes. In this demonstration I used this technique to suggest the essence of flowers.

Tools: Robert Simmons #36 Goliath brush, spray bottle for water, watercolor paper (various papers can be used, yielding different results), watercolor paints — such as permanent magenta and Winsor red. (Certain pigments have tremendous spreading power when dropped onto wet paper. Other pigments like Naples yellow just sit there. Each color has a different spreading power and can vary with different brands.)

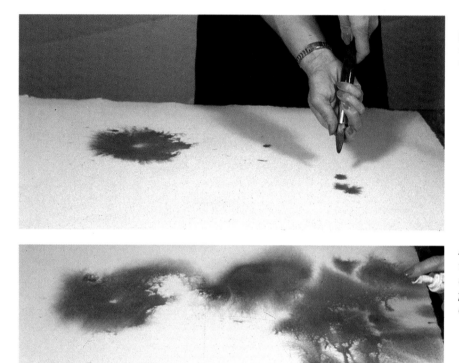

On a wet sheet of Arches 300 lb. paper, I dropped permanent magenta on my paper by squeezing it from my Goliath brush.

After I dropped more pigment, using related colors, I sprayed the colored areas with water to spread the pigment further and to soften the edges.

When flower shapes began to form, I dropped in some color for the centers (here I used Naples yellow which just sits where it is dropped without spreading).

74 THE PURPOSE OF PAINTING

Gradation

A gradual change is called gradation. It is one of the greatest assets of painting in watercolors. No other medium can create the nuances of grading like watercolor. There can be gradation of *value*, *temperature*, and *color*.

Gradation of values is what suggests volume. By gradually decreasing or increasing the value of a color, an artist may be able to avoid monotony. The eye is able to discern an average of forty value variations; with this capability visual effects are unlimited. (*Chiaroscuro* is the Italian word coined during the Renaissance that is associated with the artistic device of implying depth and volume in a painting.)

Value gradation can also create drama, giving depth to an otherwise flat surface. There are many techniques that can be used to achieve a graded value wash. The two methods demonstrated in this section are the initial wash for a working wet glaze and the more advanced drop wash technique.

One of the most valuable tools we have to create varied effects in a watercolor painting is the *gradation of temperature*. This type of gradation tends to be the most exciting because it is so subtle that the viewers aren't even aware that they are being manipulated by the artist. I use temperature gradation in almost all my paintings (the gradual transition of color from warm to cool and from cool to warm). A graded wash of a warm and a cool will create a quiet push and pull. It will also produce a rhythm that will make the painting dance.

With the wide selection of paints on the market today, a palette consisting of a warm and a cool of each primary color will serve the artist well. If warms and cools of each color are not available, then add a warm or a cool hue to the primary color. This will create the same effect (to warm a red add a touch of yellow; to cool a red add a touch of blue).

Gradating the temperature of gray can also create an interesting effect. A gray mixed from colors used in a painting (as long as it is not overmixed and loses its identity) will allow the other colors in the painting to sing and become more vibrant. It can be a warm or a cool gray depending on the colors used to mix the gray.

The purpose of the gradation of color is to set a mood. One way of obtaining a gradual change of colors is by using the working wet glaze technique. This technique will give a painting the greatest amount of luminosity. It allows the colors to fuse and sparkle in a way no other medium can produce. Often, when this method is used on the entire paper, a low-key painting is produced. All the whites become the midtone values and the darker values are then added over the glazed paper to complete the painting.

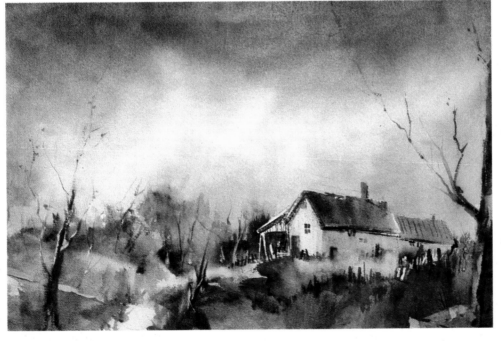

The sky grades from dark to light and sets the stage for this eerie scene. The value gradation suggests a voluminous sky ready to burst on the land below.

I used the drop wash technique with the colors raw sienna and cobalt blue to create this effect.

STORMY *Arches 140 lb., rough, 15" × 22" (38.1 × 55.9 cm)*

Demonstration on Whatman rough watercolor board
DROP WASH TECHNIQUE

Purpose: to achieve a value gradation of color without the use of a brush after the initial application.

Tools: Whatman rough watercolor board or any firm, rough, durable 100% rag surface; spray bottle; paints and brushes (optional: masking tape/maskoid).

After lightly sketching in my shapes on the dry Whatman, I protected all the areas that I wanted white with masking tape and maskoid.

I slightly dampened the board and then painted a wide band of cobalt blue and raw umber across the top edge; I made sure the brush was loaded with enough paint so that a bead formed when the board was held on a slight angle.

Working very quickly, I sprayed the bottom of the bead straight across the paper and tilted the board to let the paint run.

It was important that the spray was directed just under the falling wash and not into it.

When the spraying was completed (the wash dropped to its destination—in this case the horizon line), I lifted the board and maneuvered the flow of paint in different directions.

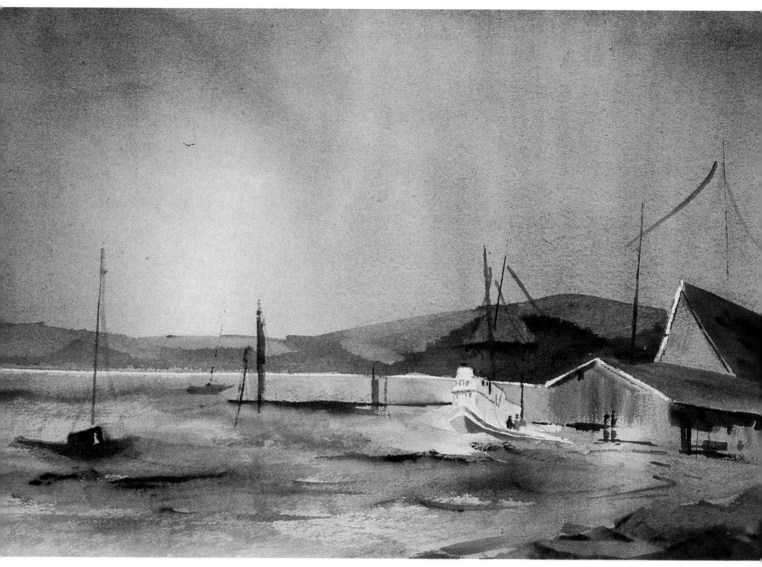

The masking material was removed, and the painting was completed with a brush.

Demonstration on Arches 140 lb., cold-pressed
WORKING WET GLAZE TECHNIQUE

Purpose: to achieve gradation of *color* and *value*.

Tools: watercolor paints. With this technique it is important to choose the brush carefully. The hairs on the brush should be soft so they do not disturb the underwash by pushing the paint and leaving a brush mark, and it should hold a good amount of water. I used a #8 onion-shaped, squirrel mop brush, manufactured by Isabey. Any 100% rag cold-pressed paper that weighs at least 140 lb. will work for this technique. Watercolor boards can be used but the extra expense is not necessary. Usually ¼ sheet is a good size. (Working small with this technique will guarantee that the wash will be carried across the entire paper before it dries.)

The paper was wetted on both sides with a sponge. Working with one pure color (that was not mixed with another color), I applied a band of color (cobalt blue was used here) going across one side of the paper. The board was lifted and tilted to allow a bead of wash to form (enough water and pigment must be used in the initial wash to allow a bead to form or this technique will not work). I then picked up the bead with my brush and worked it across the paper (using horizontal strokes). After each complete run, I dipped my brush in clean water.

I repeated dipping the brush in clean water and working the bead across (always allow a new bead to form). This was done until the entire paper was covered with a graded glaze of the color (sometimes the bottom of the paper will be just clean water).

I started the process over again by using a new color that was applied over the wet glaze I had just put on. (The paper can be turned any way to begin the new color.) Turning the paper upside down, I put a band of yellow ochre on the opposite end and continued with the color all the way down to the bottom of the paper.

In this painting I added a third color (three is usually the recommended maximum; more than that and the luminosity begins to diminish). I turned the paper on its side and began applying an alizarin crimson glaze right across the paper and over the other two glazes that were still glistening wet.

78 THE PURPOSE OF PAINTING

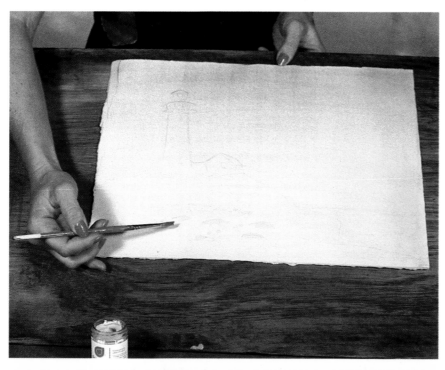

(optional) If masking is to be used in the painting, it is applied when the glazes are dry. Here I applied maskoid to create rocks. It protected the area over which a wash would later be applied during the final stages.

I completed the painting by putting in shapes using the glaze colors. When the wash was dry, the masking was removed and the light shapes of the rocks were modified.

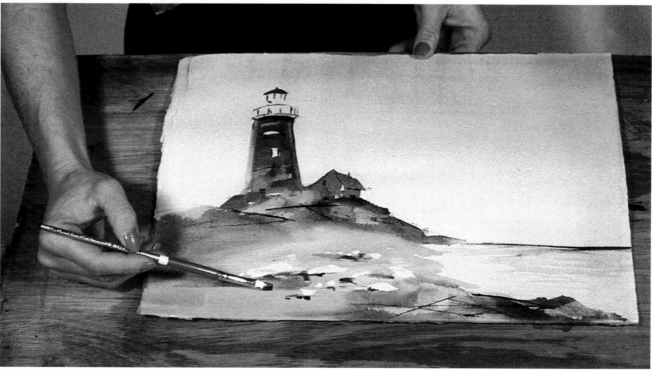

A few helpful hints:

▷ The tilt of the board is very important to control the bead.

▷ On damp days, wet only one side of the paper.

▷ Never push the paint into the paper; you should only apply enough pressure to pick up the bead and guide it across the paper.

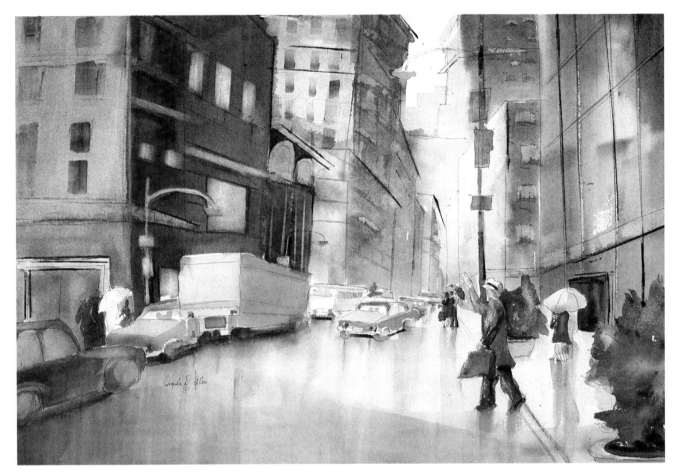

CITY SCENE *Arches 140 lb., cold-pressed, 15" × 22" (38.1 × 55.9 cm)*

When I think of New York City, I think of gray. But not all grays are the same temperature. The grays I used in this painting were warm and cool. I graded with cool grays on the left to warm grays on the right. The gradation created a depth that pushes the left side of the painting back and brings the right side forward.

Color gradation was achieved in this small painting by using a working wet glaze technique. I wanted the glaze to suggest the mood of the painting (which is often the case when working with wet glazes). Gradation with colors can alleviate the necessity of having to paint a background or foreground.

 I drew this sketch of my daughter onto the glazed watercolor paper (after it dried) and began painting the figure in terms of the negative and positive shapes.

KRISTEN ON THE BEACH *Arches 140 lb., cold-pressed, 7½" × 11" (19.1 × 27.9 cm)*

Intensity

Another property of color that will be vital in determining the outcome of our painting is intensity. This refers to the brightness of a color, and though intensity is related to value it is not the same. Two tints, or shades, of a color can be the same value but have different intensities. Intensity is determined by the degree of freedom a color has from white and gray and from the amount it is diluted. The intensity of a color is greatly influenced by temperature, hue (what color it is), and its surrounding colors.

What does all this mean in a watercolor painting? Understanding how to decrease or increase the intensity of a color will give the artist the power to create the necessary effects to communicate his or her ideas and feelings.

I mentioned that the warmth or coolness of a color affects the intensity. Warm colors tend to be more intense than cool colors — a yellow or red will be brighter than a blue or green of the same purity. There are also psychological effects that warm and cool colors have on viewers. Warm colors tend to advance and make objects appear closer. Depending on the intensity used, you can create a lighthearted, fiery, or intense statement. Cool colors recede objects (pushing them back), they evoke calm and relaxed emotions. Dust in the earth's atmosphere breaks up the color rays in distant objects and makes them appear bluish. As a result, when objects recede they lose their intensity and become more neutral.

A way of decreasing the intensity of a color is to add its complement to it. Complements are colors that are opposite one another on the color wheel (red–green, orange–blue, yellow–violet, and all their variations). This method is especially helpful if we have a color that becomes too intense in our painting (an unwanted aggressive color). We can lower a color's intensity by adding a wash of that color's complement to it. For example, an aggressive yellow can be toned down with a purple wash. An intense orange can be subdued with a blue wash, and a red can be toned with a green wash. In all cases, the color used for toning down must be a clean color. The opposite can also be accomplished. To intensify a color to its maximum (making it appear brighter than in any other context), we can put its complement next to it. This type of effect is called *simultaneous contrast*. If there is a focal point we want to develop, we can intensify the colors in that area by using this method.

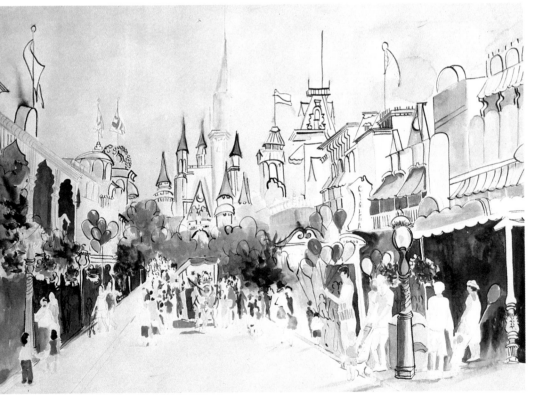

I felt free to experiment in this painting because I had worked up a master drawing for it.

I used Chinese white to lower the intensity of the colors in the parts of the painting that were not key areas. This was mostly the upper portion of the painting. Pen and ink calligraphy was added to strengthen the decorative structure of the buildings and to connect the shapes. I used the visual effect of simultaneous contrast to increase the intensity of the castle's yellow tower (center) by painting the area around it violet (its complement).

DISNEYLAND *Arches 140 lb., hot-pressed, 22″ × 30″ (55.9 × 76.2 cm)*

GIRL IN A FLOWER STAND
Arches 140 lb., cold-pressed, 11½″ × 16″
(29.2 × 40.6 cm)

By using high-intensity colors with discretion for accenting or creating a focal point, you can obtain desirable effects. The same colors were used throughout this painting with their intensities lowered, except in the flowers; this is where I wanted the viewers to look. Notice how my darks and the shapes of flowers were designed in small, medium, and large groups. Even the background was divided this way.

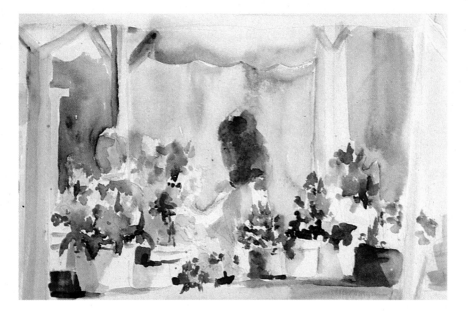

VERMONT MIST *Whatman rough, 15″ × 22″ (38.1 × 55.9 cm)*

Dust in the earth's atmosphere breaks up the color rays in distant objects and makes them appear bluish. So as objects recede they lose their intensity and become more neutral. I used this fact to create the illusion of the unforgettable early morning Vermont mist that settles in the valleys. I kept the entire painting very soft edged and relatively high key. I made sure that all my colors were subdued as well as clean and clear (low-intensity).

This piece was painted wet-into-wet with no drawing so that the boundaries were created by the free-flowing paint. Using an exceptional amount of water on wet paper, I was able to dilute the pigment to create the illusion of mist. The glint on the water's edge was lifted using a stiff chiseled-edged brush as the paper was drying.

Working with pure pigment and very little water, I created this high-intensity painting. I used violet, the complement of yellow, to lower the intensity in the mountains, foreground, and water. Green and purple were repeated in the sky for the sake of unity.

Because of the high chroma (intensity) in this painting, it screams to be looked at. By using extreme exaggeration of intense colors, I felt the sunset could be fully expressed.

YELLOW SUNSET *Arches 140 lb., cold-pressed, 15″ × 22″ (38.1 × 55.9 cm)*

The high intensity of the colors of the flowers, complemented by the low intensity of the background, makes the pattern of flowers the focal point.

The intensity of the flowers was achieved by painting complementary colors side by side (simultaneous contrast), using the colors in almost their pure state. The value of these intense colors were kept close so that they would read as a group of flowers and not as individuals.

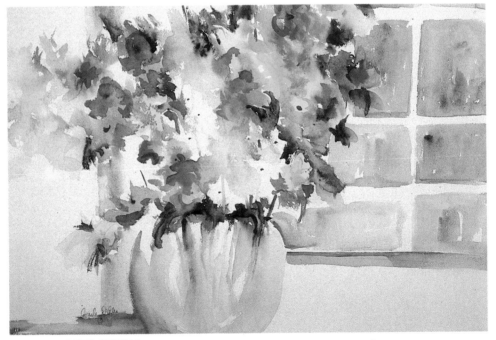

ESSENCE OF FLOWERS *Arches 140 lb., cold-pressed, 15″ × 22″ (38.1 × 55.9 cm)*

CLAM BOAT GLAZE
Arches 140 lb., cold-pressed, 7½" × 11"
(19.1 × 27.9 cm)

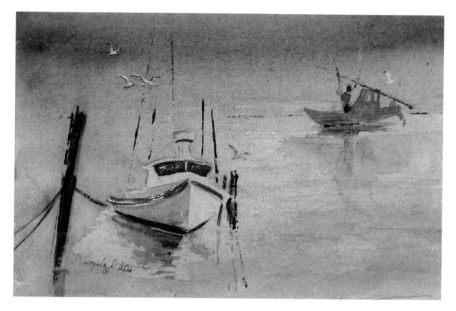

By mixing two complements together, you can produce a gray. But by placing one complement on top of another, you can neutralize the colors as well as allow them to keep their identity. Only the intensity is lowered.

I used a working wet glaze in this piece to create an atmospheric effect. When the glaze was dry, I drew the light boat shape in and added another glaze, this time working around the light boat shape and the light areas of the water. The sea gulls were stenciled in after the painting was completed.

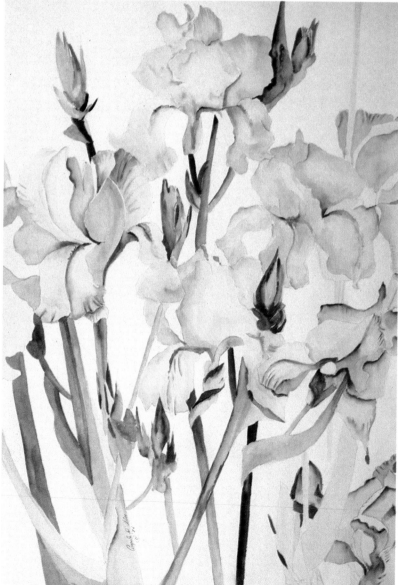

IRISES IN PEACH AND YELLOW
Arches 140 lb., cold-pressed, 30" × 22"
(76.2 × 55.9 cm)

By lowering the intensity and using simultaneous contrast, I was able to create depth and form in the design and keep the painting soft (suggestive of its delicate subject).

There is a constant exchange of violets and yellows, and oranges and blues. The colors weave their way through the flowers and foliage. Adding even more interest are the exchange of warms and cools of each color; they push and pull the viewers in and out of the shapes.

Color Schemes

In this section we will look at four color schemes (specific color combinations or harmonies) that can be used to fulfill our purpose. For those of us who enjoy working with a limited palette, you will find that any of these color schemes will work in creating a unified painting. Select the best one to express what it is you want to say and begin painting.

Monochromatic
This color scheme involves the use of painting with only one hue (color) — pure white and black may be added to it. The *value*, *temperature*, and *intensity* should vary to generate interest. This scheme produces harmony, calmness, and ease; color unity is always guaranteed. When a complex subject is to be painted, one with many shapes and values, the use of only one color can work to our advantage. Monochromatic paintings are also effective with the press paint technique (demonstration on pages 103–104), where there is a great deal of texture involved. The use of one color is only as limiting as the imagination.

Analogous
The analogous color scheme combines several colors that sit next to each other on the color wheel (blue: blue–green, blue–violet; yellow: yellow–orange, yellow–green; red: red–orange, red–violet). This color scheme is not as limiting as the monochromatic scheme, but it still restricts us from using a full palette. Because of the harmony achieved by using analogous colors, it is to the artist's advantage to understand how to work with these colors. There are many possibilities available with this limited palette, and unity is always ensured.

Complementary
Complementary colors are not new to us, but in this color scheme we will use them in a limited palette. This means painting with two colors opposite one another on the color wheel: orange and blue, yellow and violet, or red and green. Utilizing this color scheme can create extreme effects — a vibrant, dramatic, and colorful painting or a subtle, moody, and gray painting.

Triadic
The last color scheme is the triad. This method utilizes three hues that are equally spaced on the color wheel. It is the most widely used color scheme, and it has the greatest amount of possibilities: red–yellow–blue or orange–violet–green. Any number of variations from these color combinations will work to ensure color unity (examples: burnt sienna [red], yellow ochre [yellow], Paynes gray [blue]; burnt sienna [red], raw sienna [yellow], cobalt blue [blue]; cadmium orange [orange], Winsor violet [violet], olive green [green]).

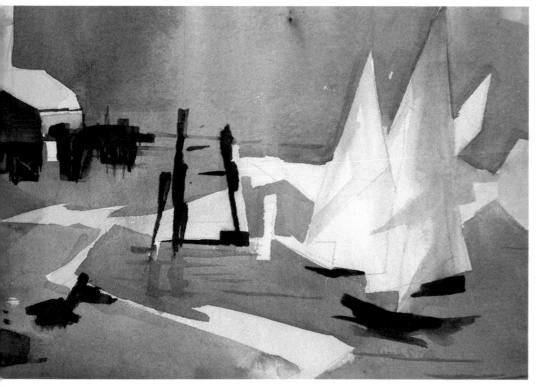

In this monochromatic painting I used one hue, blue, to express the subjects (water and boat). I created an interesting composition with the pattern and also by varying the values and temperatures of the different blues (cerulean, French ultramarine, cobalt, and indigo).

SAILING THE BLUES AWAY *Arches 140 lb., cold-pressed, 11" × 15" (27.9 × 38.1 cm)*

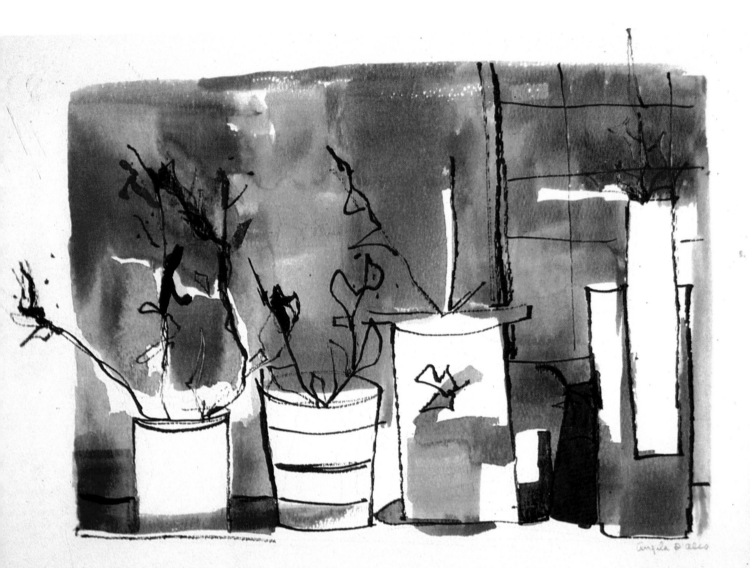

I DON'T HAVE A GREEN THUMB *unknown watercolor pad paper, 11″ × 14″ (27.9 × 35.6 cm)*

By making this a monochromatic painting, I was able to emphasize the design quality of the subject. My windowsill, lined with containers of forgotten plants, was the inspiration. I did not dare make it green to suggest the live foliage. Instead, I chose to use reds. I worked with warm and cool reds—Winsor red, cadmium red, alizarin crimson, and bright red. What interested me was the light pattern of the different size containers and the foliage poking out of them. These wiry protrusions were an interesting contrast against the geometric shapes of the vases. I added pen and ink calligraphy to connect the shapes and to outline the subject.

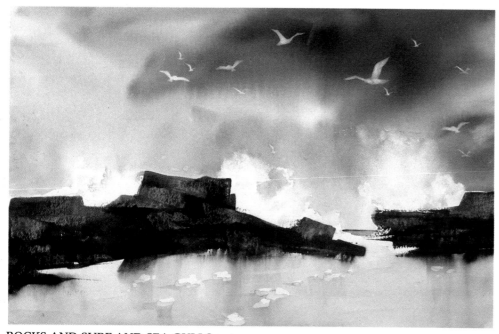

This analogous painting was easy to create since my colors were limited to blue, green–blue, and blue–violet. The initial washes were painted wet-into-wet to ensure blending of my midtone colors and to develop soft edges around the surf. The stones on the beach were masked out after an initial glaze of color was put in, and the dark rocks were painted with an underglaze.

ROCKS AND SURF AND SEA GULLS *Arches 140 lb., cold-pressed, 15" × 22" (38.1 × 55.9 cm)*

Yellow–orange and yellow–green were the analogous colors I used in this painting of a house on Fire Island. By placing the orange and green side by side, I produced a vibrant mood. I used the same colors for the background, but I mixed them together to lower their intensity.

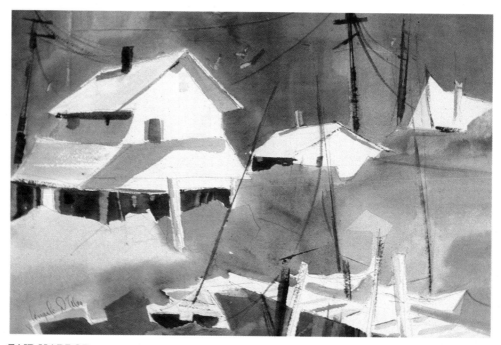

FAIR HARBOR *Arches 140 lb., cold-pressed, 11" × 15" (27.9 × 38.1 cm)*

This piece was painted in the analogous colors of red—orange and red—violet. The high-intensity colors and the sharp value contrasts work together to create a strong statement.

By making the white pattern a good shape, I give the viewers something to focus on. Some of the flowers were softened when I stenciled out some of the shapes. They offer a rapid transition from stark whites to extreme darks. Because reds and violets are staining colors, the scrubbed-out areas are not pure white. This saved me the trouble of having to modify them later.

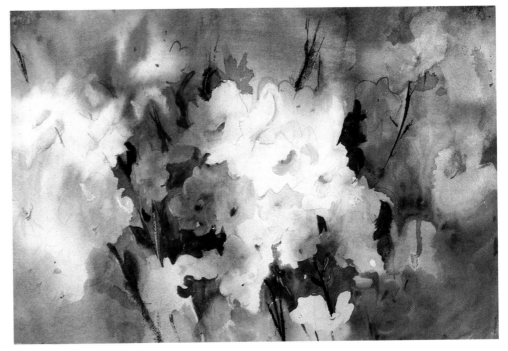

HOT HOUSE FLOWERS *Arches 140 lb., cold-pressed, 15″ × 22″ (38.1 × 55.9 cm)*

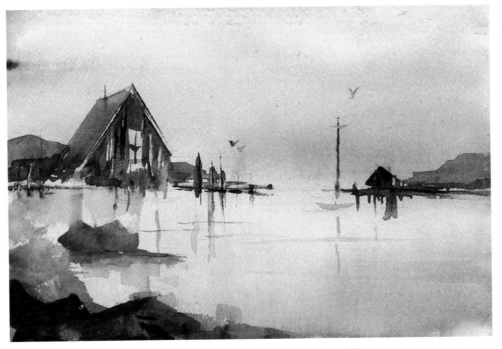

BEST TIME TO FISH *Arches 140 lb., cold-pressed, 7½″ × 11″ (19.1 × 27.9 cm)*

In this complementary painting I used a working wet glaze technique with the colors cadmium orange and indigo (orange and blue). These two complementary colors worked well to create the restful feeling that suggests this scene. After the initial glaze dried, I used the same two colors in the dark shapes of the rocks and buildings.

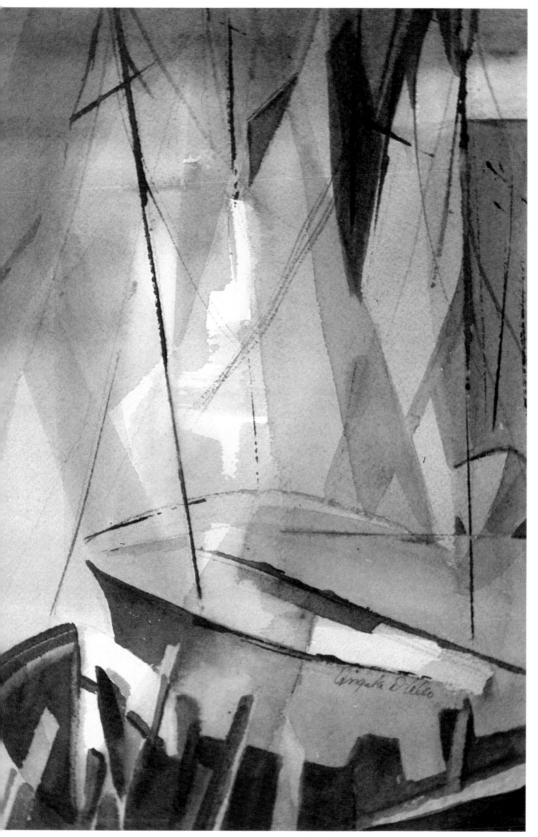

The sharp obliques and the vibrancy produced by the complementary colors I used in this piece evoke the feeling of disorder commonly found in a boat yard. I applied a working wet glaze using new gamboge and Winsor violet, and I left some areas white.

WINTER STORAGE *Arches 140 lb., cold-pressed, 11″ × 7½″ (27.9 × 19.1 cm)*

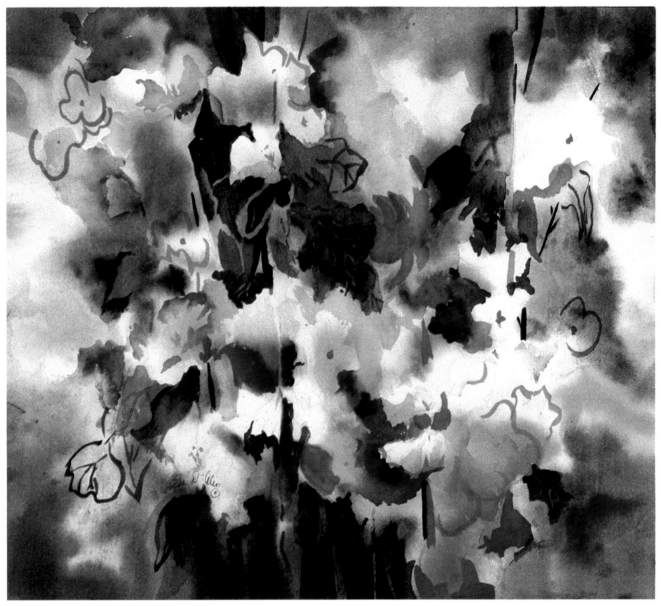

UBIQUITOUS FLOWERS *Arches 140 lb., cold-pressed, 11" × 15" (27.9 × 38.1 cm)*

This complementary painting was developed from my desire to express the lush growth of flowers in my garden. To lessen the confusion, I decided to work with a limited palette. I selected the complementary colors of red and green and used them everywhere. The edges are soft in most areas to fuse the two colors. This creates a neutralizing effect that complements and accentuates the pure color. The bits of white and light areas give the painting a much needed relief from all the colors and shapes.

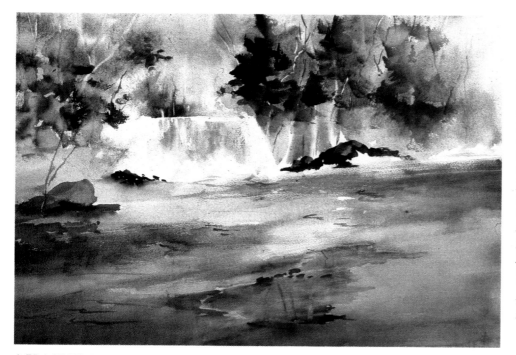

Through the use of a triadic color scheme and design, I re-created my memory of this scene. Using a limited palette of burnt sienna, Winsor violet, and viridian green (orange, purple, and green), I worked wet-into-wet putting all my midtone shapes in the background and foreground. Masking fluid was used in some areas to allow total freedom when I applied the initial wash. As the sky was drying, I painted in the background foliage and I scratched out the lights with a knife tip. When the paper was dry, my darks were put in and the lights were modified.

A PLACE TO THINK *Whatman 140 lb., cold-pressed, 15″ × 22″ (38.1 × 55.9 cm)*

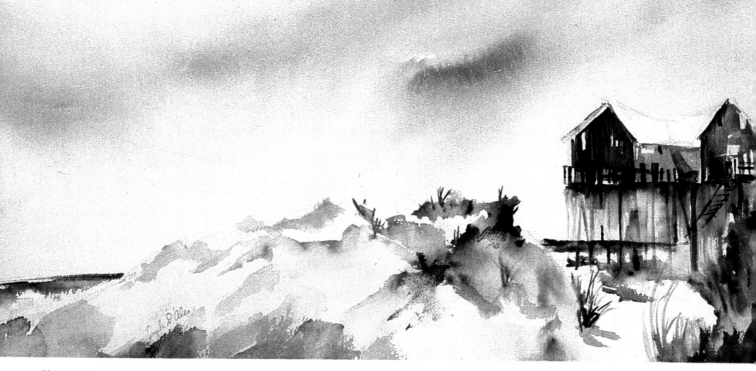

HAMPTONS HOUSE *Fabriano 140 lb., rough, 11″ × 24″ (27.9 × 61.0 cm)*

Whenever I am at a loss for what colors to use, I know I can always depend on a triadic color scheme. In this painting I used burnt sienna, Naples yellow, and indigo (red–yellow–blue). Another variation of this triad is Indian red, yellow ochre, and Payne's gray. A feeling of unity was immediately established.

Naples yellow is the only yellow that will not turn green when mixed with blue. This is why I was able to have a warm glow in the sky without a green cast from the indigo fusing with my yellow.

HOUSE ON A HILL
Arches 140 lb., hot-pressed, 15″ × 22″
(38.1 × 55.9 cm)

This vignette is a composition I have painted before, but this time I expressed the subject using a triad of unusual colors (purple, green, and orange). These colors were used almost full strength with little mixing.

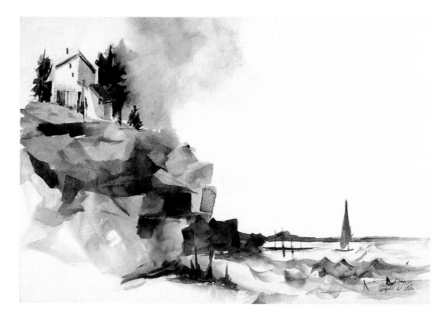

DAISIES
Whatman 140 lb., hot-pressed, 22″ × 15″
(55.9 × 38.1 cm)

This triadic painting illustrates the effect of mixing three transparent, nonstaining colors (rose madder genuine, aureolin yellow, and cobalt blue) to create a luminous gray. By not overmixing, I allowed each color to show through.

The Whatman paper is a brilliant white and more absorbent than Arches and can create a glow, especially with the colors I used.

7 PAPERS

Throughout this book, I identify the type of paper I used for each illustration. With so much to say about the paintings, I saved the discussion relating to paper for this chapter. This is by no means a complete list of papers; nor is it a complete description of each paper. My intention here is to make you more aware of the papers that are available. I hope this will entice the artist to experiment with many different papers and develop a sensibility toward each paper's special characteristics.

If we have a paper we like and are comfortable with, why look for other types of paper? The answer is, some papers won't work for certain techniques. We are being limited by our tools. Once we decide on our purpose for painting a subject and find a technique to express it, then we must select the paper that will allow us to work in that technique. If we wanted to express the texture in a lush forest, a hot-pressed paper with its smooth surface is not the paper to work on; a paper with a rough surface would be more suitable. The paper must be chosen with a purpose, and each paper has its own inherent qualities that will allow you to attain certain effects. Some characteristics of the different papers cannot be described; the nuances are so subtle that they must be felt by the artist to understand how it responds to his or her needs.

Characteristics of Various Papers

Arches

Arches produces rough, cold-pressed, and hot-pressed watercolor papers. They are available in rolls, sheets, and blocks of various weights and sizes. The Arches watercolor papers that are discussed in this book are mouldmade (this means the sheets have very little grain direction), which helps to make them one of the most popular watercolor papers on the market. The paper is tub sized rather than vat sized; this produces a more durable painting surface. (Vat sizing is the process where the sizing is added to the furnish before the sheet of paper is made. The furnish consists of cotton fibers and water. In tub sizing the sheet is formed on a machine or by hand, then it is run through a tub of sizing, and finally the sheet is coated.) Since tub sizing is an expensive method, most paper companies vat size. The reason for this technical information is so that we can understand why we like or do not like working on various surfaces, and what it is about a paper that makes it special.

The *140 lb. cold-pressed* surface is neither too smooth nor too rough. The 140 lb. weight of this off-white paper is heavy enough to work wet-into-wet without much buckling, and it can withstand a great deal of abuse. When working wet-into-wet stretching is not necessary, but can be done if desired. Scratching, scraping, sponging out, scrubbing, spattering, salting, and many other harsh techniques can be used showing very little wear on this paper. It responds well to soft edges or hard edges as well as rough or dry brushwork. We can work both wet and dry with little or no buckling. Almost all of the techniques used in this book can be done on this paper.

The *140 lb. hot-pressed* paper has a smooth surface that works well with pen and ink calligraphy. This paper is worked dry; therefore it is difficult to achieve soft edges (not impossible, just difficult). When paint is applied to this surface, it creates a mottled effect.

Brushstrokes remain dominant. Because the paint sits on the surface, it can be easily disturbed. Painting in a more direct method is suggested. Layering or glazing colors may make them look dull.

The *140 lb. rough* paper can help you create instant texture with dry brushing. It has all the qualities of the Arches cold-pressed and can be worked the same way. But the results will differ because the paper's textured surface becomes part of the finished painting.

The *260 lb.* paper comes in rough, hot-pressed, and cold-pressed. Its weight is not really 260 lb. but actually the 140 lb. weight. The unique quality of this paper is its size — 25¾" × 40". It is a convenience to have the paper precut. I purchase rolls of watercolor paper where I have to cut the size, so the paper is not always ready when I am. Just standing in front of this vast area of white paper stimulates the imagination. Any watercolor paper larger than a full sheet, 22" × 30", is difficult to work wet-into-wet using the traditional method. When the paper is too large, areas will begin to dry before all the initial washes are put in and undesirable hard edges will be the result. The following adjustments must be made to accommodate the larger painting surface:

- Work with a large brush when applying the washes onto wet paper.

- Make sure you have plenty of paint ready. (This is the most common problem of working large.) Mixing washes in jars may be necessary or you may need to use large pans.

- Plan all areas carefully so that execution can be quick.

- The edges of the paper will dry faster, so work this area first or add extra water here.

- Work the painting in such a way that the areas which dry first can be rewet.

With the demand for larger watercolor paintings and the paper manufacturers accommodating this need, the extra effort required from artists to use oversized paper is worth it.

The *300 lb.* paper comes in rough and cold-pressed. Because of the thickness of this paper, it will hold excessive moisture. Washes can spread uncontrollably and create fuzzy edges. The paint you apply to this surface will diffuse and lighten the value considerably when it has dried (washes dry about 40% lighter than under normal wetting conditions; with the extra water this paper holds, this percentage will increase). To compensate for this lightening, use less water and more pigment when you are painting. The thickness of this paper will give you the ability to work with surface wetting of areas to obtain soft edges and diffused washes without buckling. It should be noted that when the surface of a watercolor paper is not reclaimed (excess water removed after wetting in the traditional manner of wet-into-wet), the sizing remains undisturbed. This reduces the absorbency rate when paint is applied. This paper works well when you are pouring inks — it is able to absorb all the liquid without creating puddles and running off. The paper is also stiff enough to be manipulated while you pour the inks to direct the flow.

There are some techniques that need the support of a stiff heavy paper. When this is the case, a 300 lb. or heavier 400 lb. paper should be considered. Arches and Waterford manufacture a 555 lb. and a 1,114 lb. watercolor paper. These papers are 300 lb. in thickness but come in oversized sheets — the 555 lb. measures 29½" × 41" and the 1,114 lb. measures 40" × 60".

Fabriano Artistico
Similar to Arches in its high quality, Fabriano Artistico is a top grade watercolor paper that comes in three surfaces: cold-pressed, hot-pressed, and rough. The cold-pressed is smoother and slightly softer than Arches, and the rough is not as textured. The softer surface is more absorbent than Arches, and it has a different feel while painting. This paper does not take a great deal of abuse, but it does yield nice results.

Whatman
A unique quality about this paper is the fact that it is pure white. When glazing on this surface, a luminosity is achieved because the paper is more absorbent than most. When paint is applied to this paper, it is drawn deeply into the paper rather than sitting on the surface. This creates vibrancy and is useful when adding many layers of paint. Lifting the paint off the paper is not easy since the surface is fragile. Similar to other quality papers, it is 100% rag and acid-free.

Grumbacher Society
This paper is not acid-free and only contains some rag. You should work dry when using this paper. The colors sit on the surface and remain fairly brilliant. Pen and ink calligraphy and ink pouring work well on this surface. The press paint technique can be used as well as experimental techniques such as gaining texture with waxed paper, plastic wrap, or plastic acetate. It should be noted that this paper will not withstand excessive scrubbing. This paper is available in various size pads.

Morilla 1059
The Morilla 1059 is similar to the Grumbacher Society. It is widely used because of its hard, heavily-sized, textured surface that will support many techniques. The added bonus of this paper is that it is inexpensive. It comes in rolls, blocks, and pads.

Pittsfield
This paper has the characteristics of smooth rice paper. It is inexpensive and takes paint the way no other paper does. This paper is used dry, and colors must be put on almost full strength. When paint is applied it is absorbed into the paper, similar to a staining effect. The paper fibers show through the painted areas and result in an unusual muted, textured appearance. Calligraphy with pen and ink works well with this surface. Since lifting is almost impossible, this makes correcting difficult even though the paper is durable and does not buckle.

Strathmore Excalibur
This is a 80 lb. rough paper. It is made of 70% cotton and 30% fiberglass (which may cause skin irritation if improperly handled). Excalibur replaces the old Aquarius paper which had more glass and less cotton (not to be confused with the Aquarius II which contains synthetic fibers and does not react the same way). Excalibur will not buckle when wet. Painting is done dry. The unique characteristic of this paper is that colors retain their brilliance when applied to this surface. The soft surface can be scratched with a knife tip to produce dark lines where paint was applied. Paraffin acts as a resist when it is applied to the dry areas of this paper. Stampings and imprints made on this paper with textured items such as sponges, fabrics, corrugated cardboard, netting from vegetable bags, and lace are well received on this surface. The paper absorbs paint without allowing it to spread. Layering or glazing is difficult. Corrections are almost impossible, and no scrubbing out or lifting can be done.

The Strathmore Excalibur can be coated with polymer matte medium. This will create a slick, nonporous surface that reacts much like painting on glass. Paint is applied to a dry surface and lifting becomes possible.

Combining Papers
You can alter the surface of the paper by adding other elements such as gesso, sizing, or polymer matte medium. This will also make the paper less absorbent — paint will sit on the surface. By collaging rice paper, lace paper, mat board, or any other flat, textured materials, you will add a new dimension to your watercolor paintings. These methods can achieve the effects you may need to fully communicate your feelings and ideas.

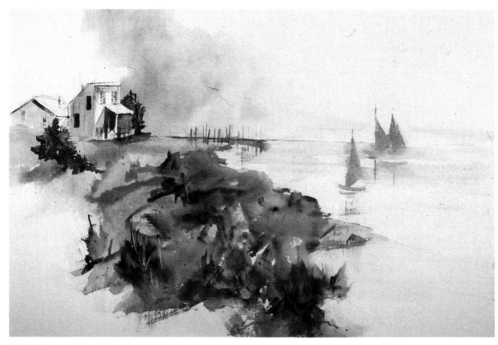

FIRE ISLAND *Arches 140 lb., cold-pressed, 15″ × 22″ (38.1 × 55.9 cm)*

Soft edges, hard edges, rough brushing, scraping, scratching, sponging, and spattering are some of the effects I used in this painting. I worked wet-into-wet, laying in all my large washes and used a scraper to push the paint and create the lights on the hill. I painted in wet the amorphous gray sky shape to allow the edges to fade into the white. Controlling the edges is important when you're painting. Always plan them to be soft, hard, or rough; never leave edges to chance or forget them. I used rough brushing to give sparkle to the water. The grass was scratched out with the point of a knife. The paper contributed to the ease of working all these techniques into this painting.

The smooth, hard, and flat surface of this paper helped me to achieve the effect of muted colors. I used the hot-pressed, knowing I would add calligraphy—this paper accepts it better than others. I worked dry, laying in all my midtone shapes and painted around the areas I wanted white. After the paint was dry, I added the darker values and refined my shapes. I used calligraphy to connect, decorate, define, and create shapes. I lifted the oblique lights from the glass window with a clean, damp brush.

PARIS CAFÉ *Arches 140 lb., hot-pressed, 15″ × 22″ (38.1 × 55.9 cm)*

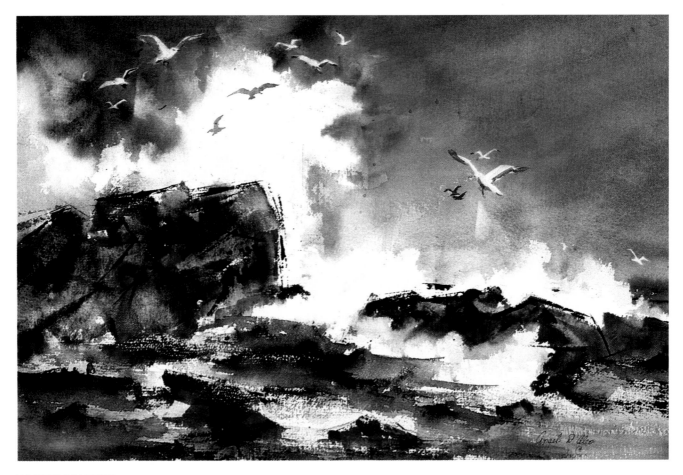

ROUGH WATERS *Arches 140 lb., rough, 15″ × 22″ (38.1 × 55.9 cm)*

Rough brushing in the surf, sand, and texture of the rocks were all easy to accomplish on this rough paper. Fabriano rough would have worked as well in achieving the desired effects, but the Arches withstood the abuse of the scrubbing, sponging, and scraping that I did in this painting.

The initial washes were applied wet-into-wet. Careful attention had to be given to the edges of the surf; I softened them with a clean tissue when necessary. By dry brushing, I created sparkle in the water, texture in the rocks, and life in the surf.

In the detail at the right, you can see the subtle effects of the underglazing of darks in the rocks.

UNDERGLAZING OF DARKS TECHNIQUE

Purpose: to achieve colorful, interesting darks; to establish color unity; and to add a textured look by allowing the undercolor to show through the dark overpainting.

Tools: most cold-pressed and rough 100% rag watercolor papers that will take some scraping can be used for this technique. A smooth scraping tool (hard, plastic kitchen spatula), paints, brushes, and a credit card or any other similar plastic card.

Intense and sometimes garish-looking colors are usually used for this type of underglazing (cadmium orange and alizarin crimson were used here). The colors I chose relate to the rest of the painting so I applied them to the rock shapes. When it was dry, I painted the area with a rich dark (alizarin crimson and Thalo green). While the paint was damp, I used a plastic spatula to push the dark pigment beyond the rock area (press the edge of the spatula firmly against the paper when pushing the pigment). This revealed the underglaze of colors and the darks left their stain.

When I was satisfied with the design of the rocks, the paint was left to dry. To clean up all the edges of the scraping (it left irregular edges not expressive of rocks), I reinforced the rock crevices by painting them in with a credit card that had been dipped into the dark paint. These strokes created oblique lines that express the essence of the rocks.

When deciding on the paper for this scene, I knew the subject matter would demand a large area. The techniques I wanted to use would also require a durable paper. If you look at the illustration next to the completed painting, it shows the initial washes I used. Notice that the lower portion of the composition had changed; the entire foreground was scrubbed out and repainted. In order to accomplish all this, I relied on the Arches to be soaked, scratched, scraped, scrubbed, rewetted several times, and to accept many layers of paint.

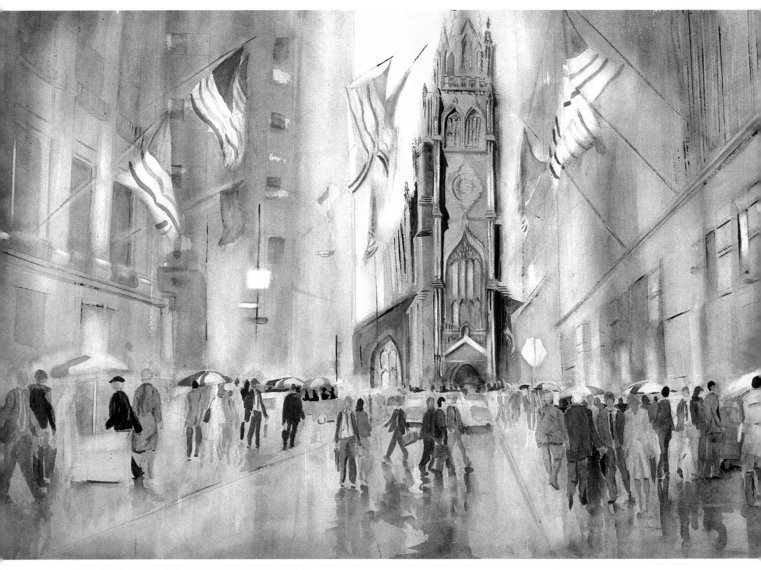

TRINITY CHURCH, WALL STREET SERIES *Arches 260 lb., cold-pressed, 25¾″ × 40″ (65.4 × 101.6 cm)*

WINTER WONDERLAND *Arches 300 lb., cold-pressed, 22" × 30" (55.9 × 76.2 cm)*

Snow is always a challenge to paint. Trying new ways of dealing with this challenge gave me a fresh way to look at an old subject.

Without the sturdy structure of this paper, I could not have accomplished this painting. FW Steig waterproof inks were poured onto the partially wet surface of this paper; then I lifted and tilted the paper to maneuver the flow of the ink in the direction I wanted it to go. The paper was stiff enough to manipulate and absorbent enough to hold all the liquid. When the ink was dry, I added fine lines by using a hypodermic oiler filled with ink (this implement can draw a very fine line). White ink was spattered to give the effect of snow.

This technique of exploding colors has been illustrated several times in this book. For each painting, I worked on a different paper, weight, or surface. The Fabriano Artistico has more spreading power because of its soft surface. The paint also soaks into the paper quicker. In some areas this worked to my advantage (foliage, lower right), creating a soft, fuzzy edge. I was not able to scrub out without losing the freshness of the flowers (this paper cannot take the abuse that Arches can), so whatever areas were not left light/white I worked into the composition, rather than sacrificing the essence of the flowers.

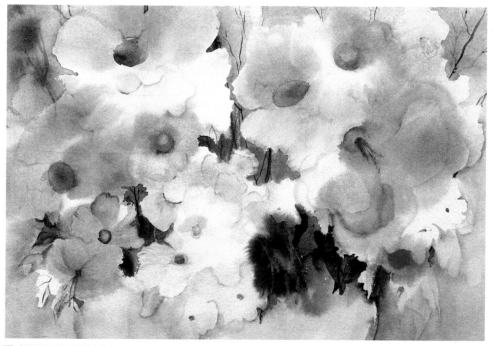

FLOWER FANTASY *Fabriano Artistico 140 lb., cold-pressed, 22" × 30" (55.9 × 76.2 cm)*

This paper is similar to the Morilla, but it has slightly more texture. I used the press paint technique, which is the method of flipping paint to develop texture. This type of paint application cannot be produced by using a brush.

In this watercolor there is a structured design, which meant I had to plan the placement of the paper every time it was turned over and pressed. No masking was used; I consciously avoided getting pigment on the areas that were light or white. To strengthen the drawing, I had to do some brush painting afterwards. It is important to leave some areas with no texture.

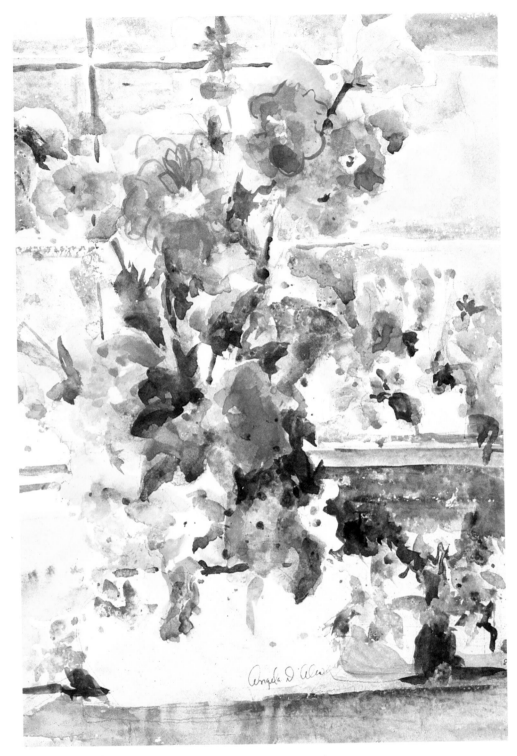

SUNNY WINDOW *Grumbacher Society, 18" × 15" (45.7 × 38.1 cm)*

DRY GLAZING TECHNIQUE

Purpose: to gain a clean, transparent, luminous glazing of colors; to express the subtle nuances of a form.

Tools: watercolor paints, pointed brushes, and any 100% rag, cold-pressed paper. This technique is not limited to Whatman paper. The Whatman is well-suited for this technique because it is very white and intensifies the glaze. In this piece the paint was drawn deeply into the paper (accepting many layers of paint without hiding one another). The fact that this paper is not able to take punishment did not affect me here. The glazes were pale, and the painting was done slowly. It is a safe way to paint; errors are few.

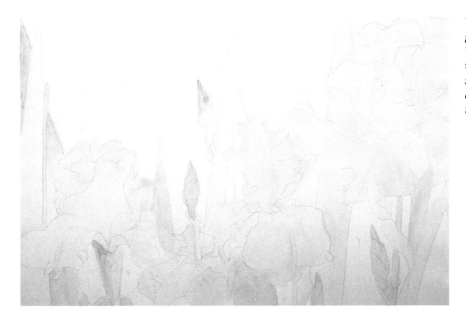

This picture indicates how pale the glazing was applied in the initial wash. The entire flower and foliage area were covered with colors that did not stay within the structure of the drawing. The colors interweave throughout the design.

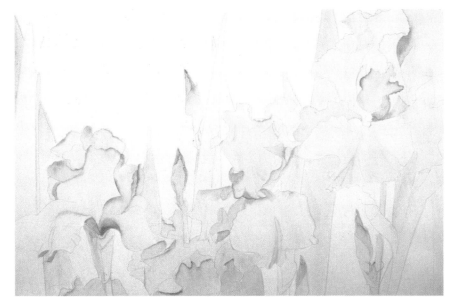

I continued to glaze slowly and waited for each layer to dry before applying the next glaze. The colors were gently placed onto the surface rather than brushed into it so that the colors underneath were not disturbed.

The flowers were near completion in this picture. The darks were beginning to appear, and form was developing in the flowers.

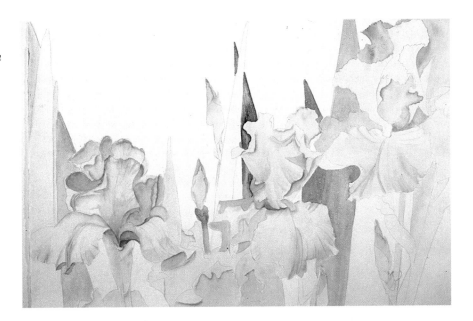

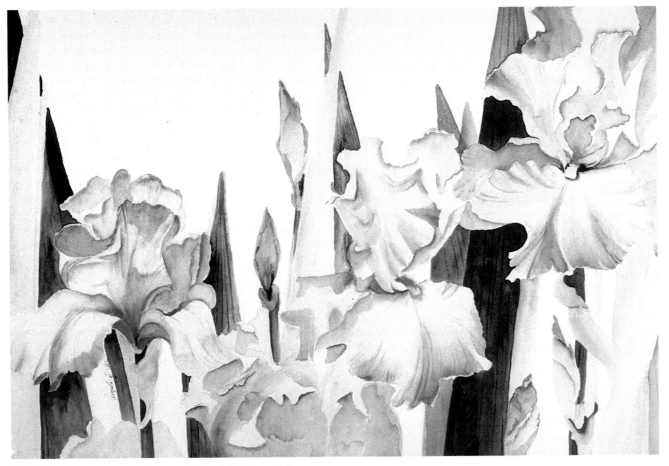

IRISES II *Whatman 140 lb., cold-pressed, 22" × 30" (55.9 × 76.2 cm)*

By exaggerating the size and structure of the irises, I force the viewer to stop and look at them. The flowers were developed by glazing countless layers of colors. The colors I used were rose doré, rose madder genuine, permanent magenta, Naples yellow, Winsor violet, viridian green, new gamboge, and cadmium orange. The quality of this paper enabled the colors to remain clean, translucent, and bright.

PRESS PAINT TECHNIQUE

Purpose: to get texture without the use of a brush.

Tools: a smooth, flat, hard, and nonporous surface that is slightly larger than your paper (glass or formica); watercolor paints; brushes; any rough, hard, heavily sized paper — Morilla and Grumbacher Society are two such papers. (Optional: masking tape, pen and ink, stencils.)

On dry Morilla paper, I applied torn strips of masking tape. These were the areas I wanted to keep white.

I applied paint to the dry paper with a loaded brush (there was more pigment than water).

Next, I turned the paper onto a nonporous surface (glass or formica) and used my hand to lightly burnish the back of the paper. (This action allows the paint to spread.) Then I turned the paper right side up and repeated the process of painting, turning, and pressing until I achieved the texture I wanted.

When I was satisfied with the amount of texture, I stopped, removed the tape, and proceeded to complete the painting using a brush.

FALL *Morilla 1059, 16″ × 12″ (40.6 × 30.5 cm)*

To complete this painting, I modified the white birch trees and added pen and ink to define the shapes. A glaze was added to some areas to tone the whites.

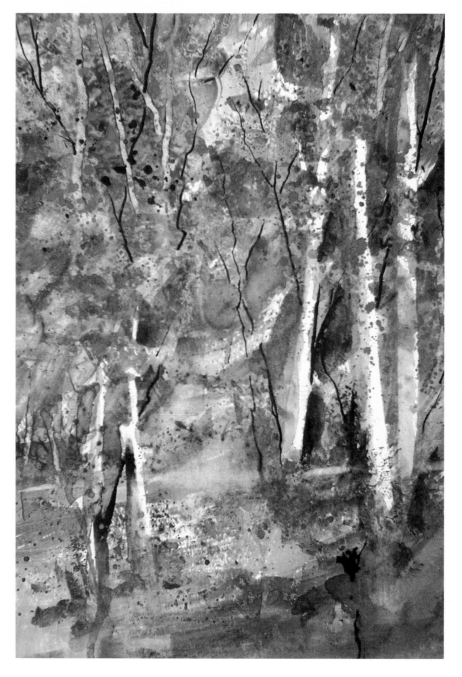

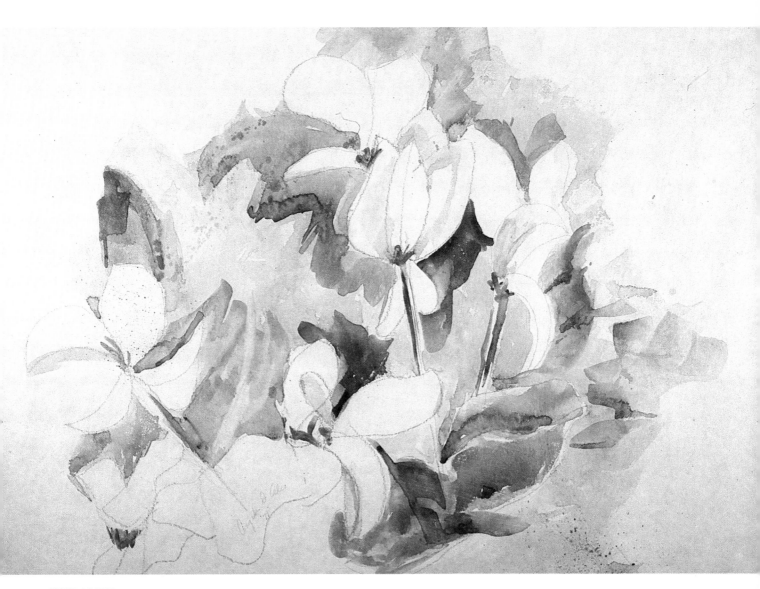

CYCLAMEN *Pittsfield, 18″ × 24″ (45.7 × 61.0 cm)*

This painting was created almost spontaneously on location. After a full day of painting cyclamen on Arches in a structured way, this painting was a release for me. I tried to capture the spirit of the plant using as few strokes as possible and with little detail. The paper's off-white color and ricelike quality required little modifying.

This was the perfect paper to use to express the vibrant colors I needed to show my enthusiasm brought about by a sailing race.

I prepared the paper by carefully drawing in my shapes. Then on dry paper, I rubbed paraffin onto the surface to act as a resist where I wanted unstructured whites. I scratched the paper in various oblique directions using a pointed knife to create drama in the sky. The paint was applied full strength to stress the movement I wanted to convey. Aquarius paper absorbs paint like a blotter, yet the artist still has control.

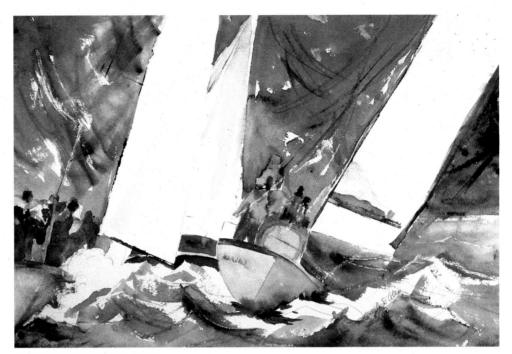

ROUNDING THE MARK II *Aquarius, 15" × 22" (38.1 × 55.9 cm)*

In this painting the matte medium and paper are part of the design. The procedure is simple. Polymer matte medium is painted on Aquarius paper and allowed to dry. The polymer causes the paint to bead on the surface, acting almost like a resist (the more coats of polymer applied, the more beading). Brushstrokes from the painting of the polymer can be revealed, or you can apply the polymer on smoothly and hide the brushstrokes.

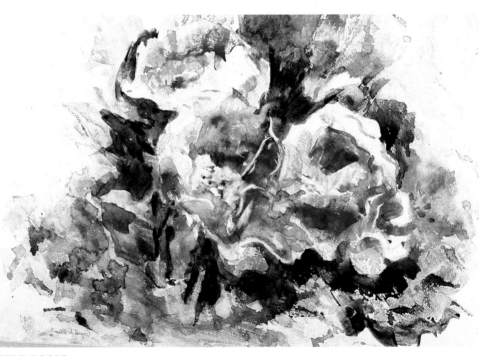

WILD ROSES *Aquarius coated with polymer matte medium, 15" × 22" (38.1 × 55.9 cm)*

KRISTEN'S DOLLS
Arches 140 lb., hot-pressed on mat board,
30" × 22" (76.2 × 55.9 cm)

My purpose with this piece was to create a painting for my daughter. The subjects are two dolls that have become a part of her room. After completing the watercolor on Arches paper, I was not satisfied with the effect. The dolls looked too structured and formal. I decided to cut them out and place them on mat board (raising them from the surface by inserting separators behind the cut-out figures). This collage created a lighthearted watercolor painting more suitable for Kristen's room. It may never hang in a museum, but it does make my little girl happy.

FOREST REFLECTIONS
Rice paper on mat board, 13" × 17"
(33.0 × 43.2 cm)

Some things are described better in paintings than in words. By working with rice paper and mat board separately and then together, I was able to create an imaginary forest. This painting has shapes, colors, and textures that give it a three-dimensional look. To do this painting, I used a new method of applying paint and texture. The rice paper was torn into irregular shapes, painted, and placed on the mat board. Then the mat board was also painted, and in some areas rice paper stampings were added. The colors I used were a triad of yellow ochre, burnt sienna, and cobalt blue.

Watercolor Boards

Basically, a watercolor board is watercolor paper adhered to a support. When selecting a board, you must take into consideration the paper surface (rough, hot-pressed, or cold-pressed) and the thickness of the support that will suit your technique. Some are very rigid, and others are thin and will curl if excessive water is applied.

Arches, Whatman, Crescent, and Bainbridge all make watercolor boards. The more expensive boards will have an acid-free barrier paper between the board and the watercolor paper to protect it from the cardboard support.

Whatman

This board is composed of Whatman watercolor paper mounted by hand on buffered, acid-free, three-ply boards. They come in two sizes (20″ × 30″ and 30″ × 40″) and in three surfaces (rough, cold-pressed, or hot-pressed). The support is very rigid. You can hold the board upright and spray pigment without having the board warp. The board can also be maneuvered to direct the dropping of a wash. The tissue paper technique (demonstration on pages 109–110), the pouring of inks, and many other watercolor painting methods (except wet-into-wet) can be used on this board. Arches and Crescent also make watercolor boards that can be interchanged with the Whatman, depending on your personal preference for the painting surface.

Illustration Boards

These boards are generally less expensive than watercolor boards. Strathmore has a 100% cotton fiber paper mounted on both sides of their board — this will prevent the board from warping. Bainbridge and Crescent illustration boards have a high rag content and can warp when wet, but will flatten when dry. The smooth surface boards work well for the tissue paper technique. By applying Saran Wrap and wax paper on a smooth surface, you will gain some interesting effects. These boards also come in a textured surface.

There are many interesting ways of applying paint to different surfaces. I did not require the use of a brush for most of this painting. Instead, I maneuvered the paint to spread across the board by tilting it.

In developing this composition, I created a distinguished space division and worked gradation into the large foreground area. I achieved the gradation by using the drop wash technique. Whatman rough watercolor board is a valuable asset in obtaining the desired effects of this technique because of its good painting surface and stiff backing.

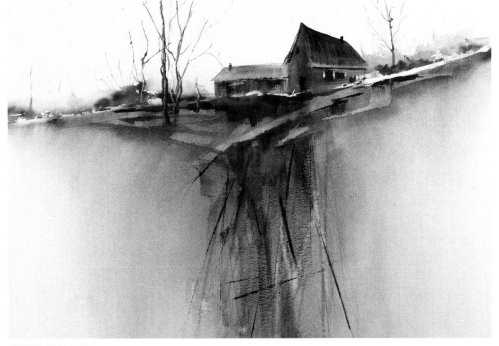

CLIFF-HANGER *Whatman rough watercolor board, 15″ × 22″ (38.1 × 55.9 cm)*

TEXTURE WITH TISSUE PAPER TECHNIQUE

Purpose: to gain texture without the use of a brush. (Although the purpose is the same as in press paint, the method used here is different and yields different results.)

Tools: Bainbridge #80 illustration board, tissue paper (ordinary gift box tissue), watercolors, and brushes. This technique works on many papers and boards. I find the firmness, surface texture, and sizing of the Bainbridge works for me in gaining the necessary texture.

After lightly wetting the surface of the board, I crumpled up the tissue paper and laid it over the wet area. (Note: Where there is excessive bunching of the tissue there will be more protection from the paint, and whites will result; to keep the whites from the edges of the painting, you should smooth out the corners.)

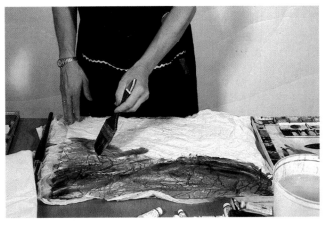

When I was satisfied with the placement of tissue paper on the board, I dampened the surface lightly, trying not to disturb the paper.

With a brush loaded with paint, I began pushing the color onto the tissue paper, allowing it to penetrate through to the board underneath. I painted in a monochromatic color scheme using all my blues (French ultramarine, cerulean, cobalt, Prussian, and some indigo).

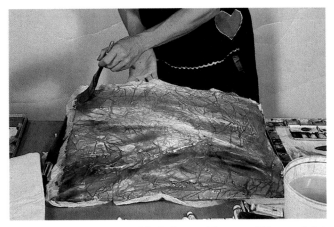

Cadmium orange was added along with some Winsor violet, yellow ochre, and viridian green (these colors were discreetly placed).

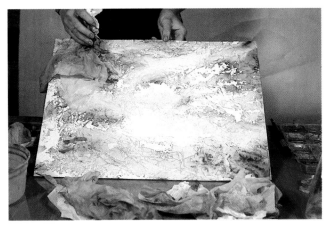

When the board was completely dry, the tissue paper was removed. Glazes were applied to modify certain areas where the whites popped out.

On the dry surface, the birds were stenciled out and painted in using stencils that I had cut from acetate.

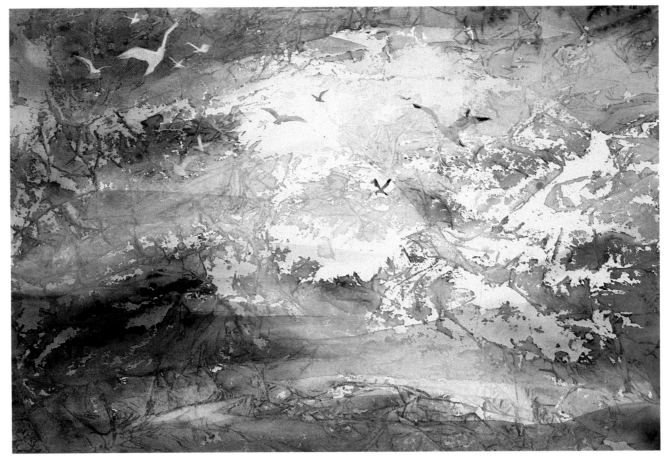

GRACEFUL GLIDERS *Bainbridge #80 illustration board, 15″ × 20″ (38.1 × 50.8 cm)*

8 DECIDING WHAT TO PAINT

With all the information I have discussed so far, anything and everything could lend itself to a painting, but we know it's not that easy. You must *want* to paint a subject. It has to appeal to you.

Many artists have difficulty in following their natural impressions of a subject. For example, there is often a search for an arrangement in nature we have seen in another painting that has been accepted and approved. As a result, we overlook what we really would have enjoyed painting.

If we were to visit Kuerners Farm in Chadds Ford, Pennsylvania, and Olsons Farm in Cushing, Maine, without having ever seen Andrew Wyeth's paintings of these places, we would probably not think of them as painterly subjects. Wyeth transposed the ordinary and seemingly unimportant into monumental works of art. The simple commonplace farm objects such as buckets, knots on ropes, oil lamps, porches, windblown curtains, seed corn, bags of grain, and the portraits of the farm people were made important because they were important to Wyeth. He gave his subjects character and beauty that went beyond the surface appearance and into their spirit.

The following story is one that I heard in an art class many years ago that I often contemplate on:

It was in England in 1840 that a man riding a railway train kept putting his head out the window of the fast-moving train. He asked the girl seated next to him to do the same in order to "see what I see."

Some time later, a viewer looking at a painting in a gallery remarked to that same girl who was on the train, "Who ever saw anything like that?" The girl replied, "I did."

The man on the train was J. M. W. Turner, and the painting is *Rain, Steam and Speed — the Great Western Railway*.

A painting is a visual expression of your ideas and feelings. It is rarely the subject itself that is interesting; it is how the artist interprets it. We must be ready to trust and recognize our feelings, and be able to seize the right moment. That is the answer to what to paint. We all know what we like and do not like. Problems arise when you do not pinpoint the reasons why you thought the subject was a worthwhile one to paint, and when you wait too long after you see the subject to think about painting it.

Finding a subject matter can come from varying motivations, and it can happen anywhere. You may see a photograph in a magazine where the design or its colors are so appealing that you may want to use it as a subject matter in a future painting. If possible, tear the page out; if that can't be done, think about it for a while and sketch it. Likewise, when you see a flower you like, think about what intrigues you to want to paint that flower. Is it the color? If so, try to make mental notes about the colors and transpose them into the colors on your palette. Or maybe it's the way the flower grows that is interesting. It could be the size or shape that you like. Only you know what it is that you want to paint, and if you do not identify your feelings about the subject immediately, you will lose it. A sensitivity must be developed to see and think like an artist at all times so that it becomes a part of you.

There is a tendency for people to point out to artists what they assume we should be painting; it could be a landscape, still life, or figures. We may see these subjects as beautiful and fascinating, but unless it is something that we have a purpose for wanting to paint, the subject has no meaning for us. We should not feel obligated to paint what others see. Sometimes the most unlikely subjects become paintings. For example, tubes of paint were always in front of me when I painted. But one day instead of seeing squeezed-out tubes of paint, I saw shapes, colors, and designs. Originally I had intended to only do a little color sketch, but before I knew it one painting led to another and soon I had six little paintings.

It is usually the everyday situation that influences what we paint. Once I saw a scene of bridges and cranes that really caught my attention. Ordinarily I have no interest in these subjects, but when I saw this scene with all the obliques and repetition of shapes, I found it exciting and wanted to paint it. Another similar situation developed from my reaction to a scene of a straw market, in the Bahamas. Hats and bags were piled up on a table, and I knew it would be a painting. On both occasions I was not out looking for things to paint. Since we never know when a subject will inspire us, we need to sharpen our senses and follow up on our feelings. Even if we do not produce a painting, it always helps to make some kind of note or sketch to rekindle the sensation of a specific scene.

Sometimes I rely on the paint itself to be the impetus — painting inspires a painting. Covering a giant piece of paper with loads of color can help you stimulate many ideas. This is what I call *spontaneous painting*. There is no drawing or sketching involved. Decisions on design and composition are made on the spot. This type of painting requires a great deal of

concentration and a thorough understanding of the medium.

Experimenting with the physical properties of color can be your starting point. The following is a list of the characteristics of a color that may influence the outcome of your painting.

• the amount of sediment it contains

• its opaqueness

• how transparent it is

• the way it spreads onto the paper

• how it sits on the paper

• how colors with different properties react to one another when they are mixed together (such as an opaque, a transparent sediment, and clean colors)

These characteristics can lead you to do a series of paintings. They may also help to create a new way to paint an old subject.

One of my favorite ways of working out the problem of what to paint is to do a series of working wet glazes (demonstration on pages 78–79). Afterwards, I hang them up around the room. As I look over the glazes,

I also flip through my sketchbook for ideas. The combination of the two never fails to stimulate the imagination.

Here are some other ways I try to spark my imagination:

• look through my reference files, sketchbooks, and photographs

• take a subject I like and paint a series of it

• paint some fresh flowers

• go on an outing

• set up a still life

• buy a new brush, color, or paper

• read a book or magazine on watercolors

• read about the masters

• look at some of my old paintings

• go to a workshop

• mat some of my work

• go to a museum

PAINT TUBES I
Arches 140 lb., cold-pressed, 5″ × 9″ (12.7 × 22.9 cm)

I began this series of sketches by working on dry paper and painting the squeezed-out tubes of paint realistically. The dramatic lighting created shadows that give the tubes depth.

PAINT TUBES II
unknown watercolor paper, 7½″ × 11″ (19.1 × 27.9 cm)

While I was studying the paint tubes for my first painting, other ideas came to mind. In this piece I painted on dry, crumpled paper with watercolor. I also used pen and ink calligraphy to create the outline of the paint tubes.

PAINT TUBES III
*Arches 140 lb., cold-pressed, 4½″ × 7½″
(11.4 × 19.1 cm)*

*Flat washes, intense colors,
and shapes were my
primary concerns in this
sketch.*

PAINT TUBES IV
Arches 140 lb., cold-pressed, 7½″ × 10″ (19.1 × 25.4 cm)

*I wanted to work with the
white of the paper as well
as with the shapes, flat
washes, and the intensity of
colors.*

PAINT TUBES V
Arches 140 lb., cold-pressed, 7″ × 10½″ (17.8 × 26.7 cm)

*In this sketch I worked with
negative painting (painting
around the shapes) and
glazing.*

PAINT TUBES VI
Aquarius, 11″ × 15″ (27.9 × 38.1 cm)

*After finishing five
paintings, I developed
personalities for each of
these paint tubes. Using pen
and ink, I tried to capture
the character of each tube.*

Looking at this sketch, I know what I want to paint. It was seizing the right moment that makes this sketch suitable material for a watercolor painting. Although I have many photos of my dear friend Helen, they could not capture the memory I had of her on the day I did this sketch. I will paint that memory using this rough sketch as my reference.

SKETCH OF HELEN *pencil on drawing paper, 11" × 14" (27.9 × 35.6 cm)*

Being an artist means collecting bits of information that may be used for a painting one day. The colors I used in this painting I initially saw in a magazine. Because they were utilized in a striking way, I ripped the page out and stored it in my reference folder, not knowing when I would use them. One day upon seeing a dramatic sunset on Fire Island, I saw the same colors. I took an old subject (one that I had painted many times) and transformed it into a new statement. The artist should never give the viewers something they could see for themselves or what they expect—surprise them.

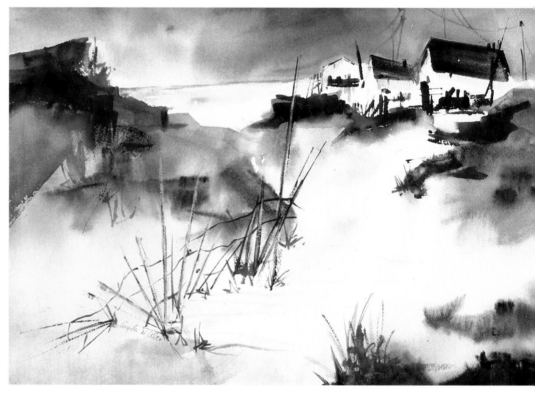

FIRE ISLAND SUNSET *Arches 140 lb., cold-pressed, 15" × 22" (38.1 × 55.9 cm)*

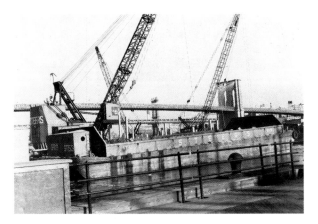

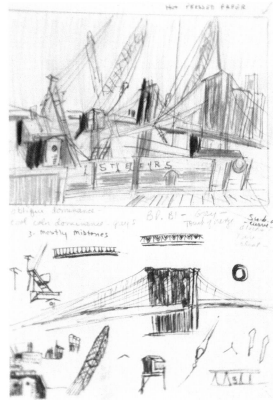

When I saw this sight at the South Street Seaport in New York City, I was immediately inspired to paint this scene. It is not something I thought I would ever paint; nor was I looking for something to paint that day. While I was out with family and friends, I stood there staring at the cranes and bridges. There were obliques all over the place. The arch of the bridge was a subdominance of all the straights.

I also did a quick sketch on location to capture the thrust of what appealed to me. Under the composition/value sketch are some rough information drawings of things I saw that I thought might need clarification for my painting. I was trying to understand my subject without getting too caught up in details.

BRIDGES AND CRANES SKETCH
pencil and pen on drawing paper, 11″ × 18½″ (27.9 × 21.6 cm)

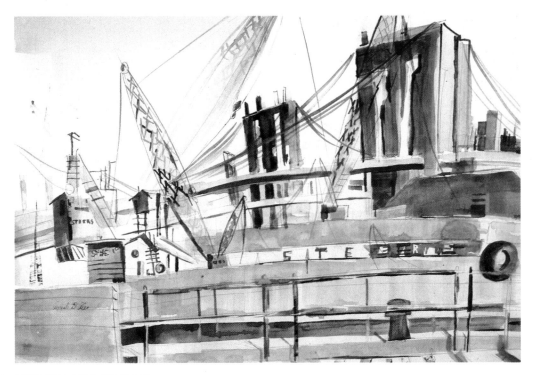

BRIDGES AND CRANES *Arches 140 lb., hot-pressed, 15″ × 22″ (38.1 × 55.9 cm)*

In my studio I worked from my information drawings and the photograph to capture just what I wanted to say. I played up all the obliques and dramatized the feeling of confusion without making the painting confusing. I simplified the shapes and worked with a limited palette. This kept the emphasis on the design.

With so many things to paint in this straw market, my attention was drawn toward the sun reflecting on the straw hats and bags. As I studied the scene, I realized all the necessary elements of design, color, and shape were before me. All I had to do was eliminate the extraneous details around the subject.

STRAW HATS AND BAGS
Arches 140 lb., cold-pressed, 15″ × 11″
(38.1 × 27.9 cm)

After drawing the overall shapes of the hats and bags, I proceeded to work wet-into-wet to establish my light midtone pattern. I was careful not to paint each individual hat and bag but thought of them as connecting shapes. The dark pattern running through the negative spaces in the painting is what leads the viewer from one hat to the next. My intention was to present the illusion of hats everywhere with some bags to be found elsewhere.

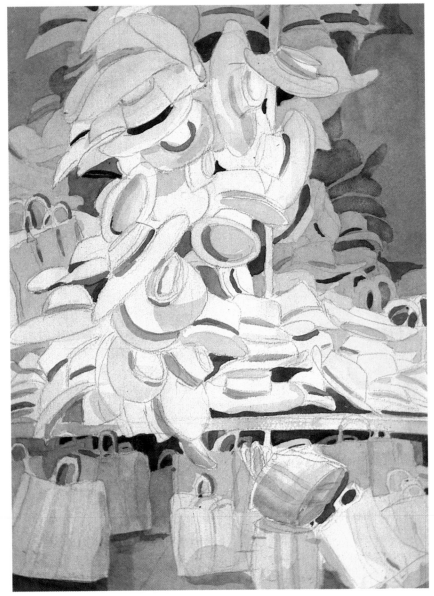

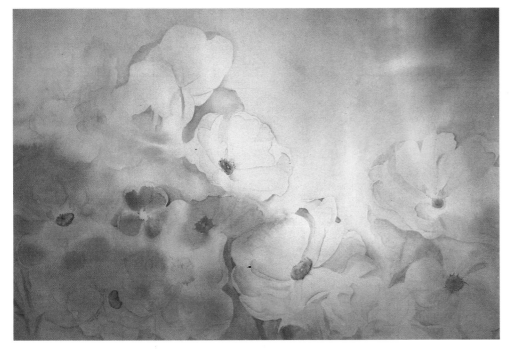

With such a large area before me, I knew I had to do something bold and daring. So I forged ahead and put tremendous amounts of paint on the wet surface, maneuvered the board that the paper was clipped to, and let the watercolor paints do their thing. I knew I was going to paint some kind of floral design, but that was the only preliminary planning I did. I worked with the subtle nuances of shapes created by the initial dumping of paint (I literally threw paint onto the surface). It was important to keep whatever lights I had, so I painted around the flower shapes.

GIANT BLOOM *Arches 140 lb., cold-pressed, 40″ × 60″ (101.6 × 152.4 cm)*

Initially, this painting had no preconceived subject. I worked with sedimentary, opaque, and transparent colors by dropping them onto wet paper. All the dark specks are the paint droppings left just as they fell. Each combination of colors, according to the chemical properties of each color, will create a different pattern. This was what I worked my design around.

I am not sure how the sweet peas came out of this confusion of color, but at the time that was what I saw emerging from the negative spaces. I used a stencil to scrub out some flower shapes in the center and painted around the rest. Some stems were lifted and others I painted around.

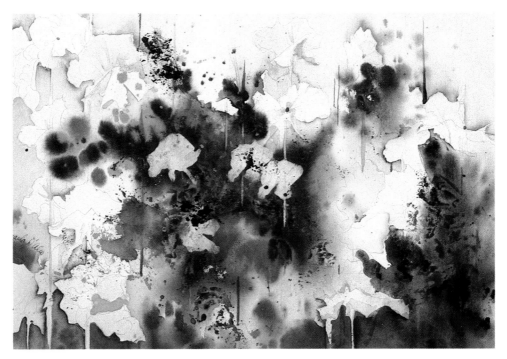

SWEET PEAS *Arches 140 lb., cold-pressed, 15″ × 22″ (38.1 × 55.9 cm)*

This little painting is an exemplary model of a working wet glaze. By creating many openings in the house for the luminous colors to come through, I took full advantage of the glazes. I achieved total unity by mixing together the glazing colors and using them to paint the dark house shape.

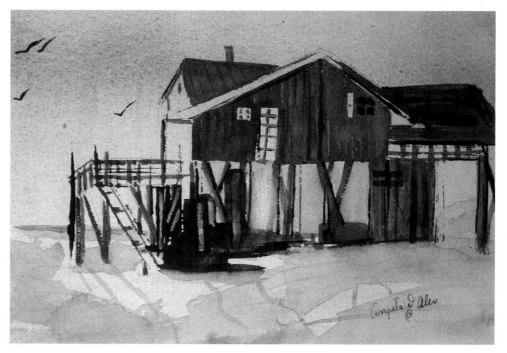

BEACH HOUSE *Arches 140 lb., cold-pressed, 7½" × 11" (19.1 × 27.9 cm)*

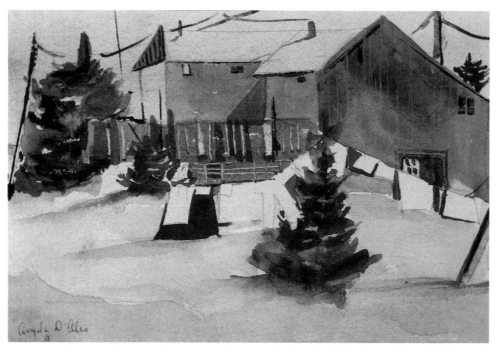

Laundry hanging out on a line is a common sight on Fire Island. The interesting white shapes caught my attention and I sketched this scene. After applying the glazes, I painted around the light shapes of the laundry to allow the colors of the glazes to remain pure. This not only unified the painting, but saved me the trouble of having to modify the whites.

NO-FRILLS BEACH HOUSE *Arches 140 lb., cold-pressed, 7½" × 11" (19.1 × 27.9 cm)*

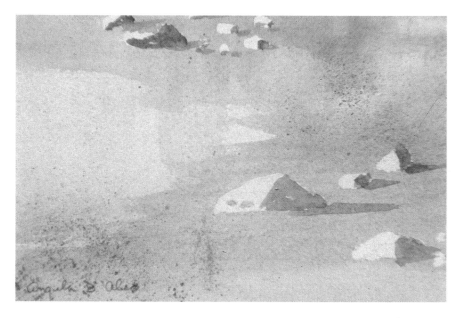

BEACH STONES
*Arches 140 lb., cold-pressed, 4½″ × 6½″
(11.4 × 16.5 cm)*

Looking through my sketchbook while studying some completed glazes I had lined up around the room, I combined a sketch I made of the beach stones with a glazed piece of paper. Very little had to be done to complete this glazed painting since working wet glazes show off the best side of watercolors.

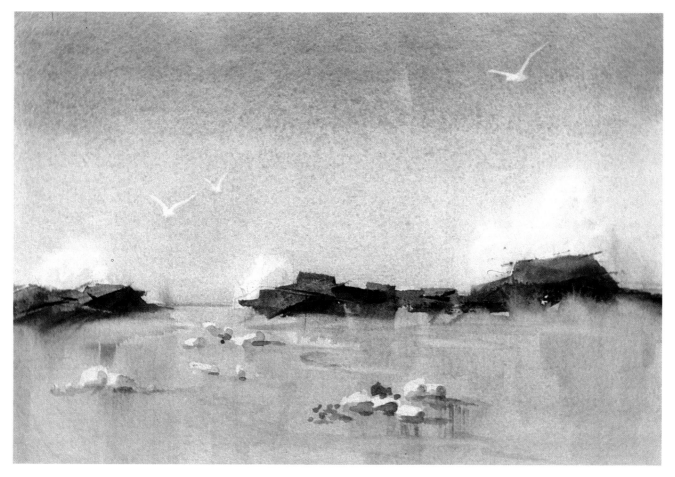

WET SANDS *Arches 140 lb., cold-pressed, 7½″ × 11″ (19.1 × 27.9 cm)*

I often paint with a working wet glaze, using various color combinations. The subjects for many of these paintings are often inspired by the outcome of the glazes. In this case, I saw wet sand.

To complete this painting after the initial glaze dried, I masked out the light foreground rock shapes, painted the dark rocks, sponged out the surf, and used a stencil to scrub out the sea gulls.

9 DEVELOPING A STYLE

Style is the distinct way we express or execute a painting. Some of our style comes from inborn traits that we cannot change. Most of our style is developed from the environment we live in. All these influences work simultaneously to mold an individual style.

The climate of the times we live in (wartime, peacetime, depression) all directly affect the manner in which we will think about our subject. This becomes obvious when studying the old masters. The paintings done during the same period are similar in style. Not only were the themes similar, but the availability of the tools that the artists used reflected their time. Today the ready-made tube paints, the sophistication of brushmaking, and the availability of different papers will tell of our time in our paintings.

Styles change with the times. The entire basis for modern art beginning in the nineteenth century was to paint from a private and personal experience in an individual style, not following the academic formulas of the past. The belief of the impressionists such as Claude Monet, Edgar Degas, and Camille Pissarro was to be yourself. To paint in a style that suited the artist's needs.

Afraid and shocked at the new nineteenth-century art revolution, a group of craftsmen and artists (known as the Pre-Raphaelite Brotherhood) led by Dante Gabriel Rossetti tried to return to the ways of the past. They copied the styles of the late Middle Ages and early Renaissance. Not being of that time, their works were superficial and lacked conviction and spirit. An artist cannot tell of his or her time using the styles and methods of the past. You must be true to yourself and develop an individual style as a way of realizing true self-expression.

Cultural influences are another factor that mold our style. Some of us are exposed to fine art, while others may know very little about art. Those of us who have studied art have a degree of style taught to us by teachers and artists. At one time or another, we have emulated another artist's style. Some artists travel; others never leave their hometown. All artists have influences from their exposure that makes them unique. Influences broaden our sights, widen our capabilities, and give us new ideas. They become a part of us.

The goals we have of wanting to sell, show in a gallery, or please a patron will affect our style. This was clearly the case in France in the 1800s when every serious art student painted only to win the Prix de Rome. This was the most coveted official student award in France that was administered by the French Academy. Winners were chosen by their dedication to upholding and continuing the strict, unyielding academic tradition. Every artist wanting this honor had to study and paint according to the rules. There was only one style, that of the Prix de Rome. Jacques-Louis David was an artist who after four tries finally won. He painted in a style that demonstrated how well he learned his lessons. To win he used all the techniques necessary and gave the judges what they wanted and expected. After painting *Antiochus and Stratonice*, the winning painting, David painted *The Oath of the Horatii*, adopting a new style that he invented to meet his own personal expression. The twist to this story is, the only winners that maintained their greatness and are remembered today are the artists who after winning the Prix de Rome broke away from the rigid, imposed style and became original painters. (Jean Auguste Dominique Ingres and Ferdinand Delacroix were two such artists.)

The Salon des Refuses exhibition in 1863 was represented by the artists who were rejected by the Academy and the official Salon for having their own style. They painted against the formula set by those institutions. Édouard Manet and Pissarro exhibited their paintings there and are fine examples of artists who were true to their own style.

If history teaches us anything, it is that we should not try to paint in someone else's style and abandon our own. No formula can make a mediocre painter into a great artist. Prodigious technicians can be found everywhere. It is applying that skill with sincere purpose that creates an individual style.

Style is something we all have. Unfortunately, sometimes when we consciously try to develop it, we forget our natural traits. Therefore, it is important to decide what it is we want to paint and not think about how someone else would paint it. Accept the style that you possess. Do not hesitate to change your style to meet the needs of the subject you wish to express. Picasso is a perfect example of an artist who utilized many styles in his lifetime. His way of painting was as varied as his subjects.

The key to style is to respond to every subject in a personal way. The subject should express how you feel and think about it each time you paint it. No stock responses should be used to express a subject. Your style is who you are and that is what your painting represents.

The picture above was taken the same day I took the bridge and crane photograph. As I mentioned before, I was not out looking for things to paint. The blurred picture was a result of my taking it on the run. When I had it developed, I found it to be more beneficial in its unclear state than if all the details were filled in. The prevalent light and dark value patterns and the staggered arrangements capture how I remember the scene.

This painting translates how I felt when I first saw the subject. I put in the flowers I wanted, to suit the composition. I did not rely on any set style.

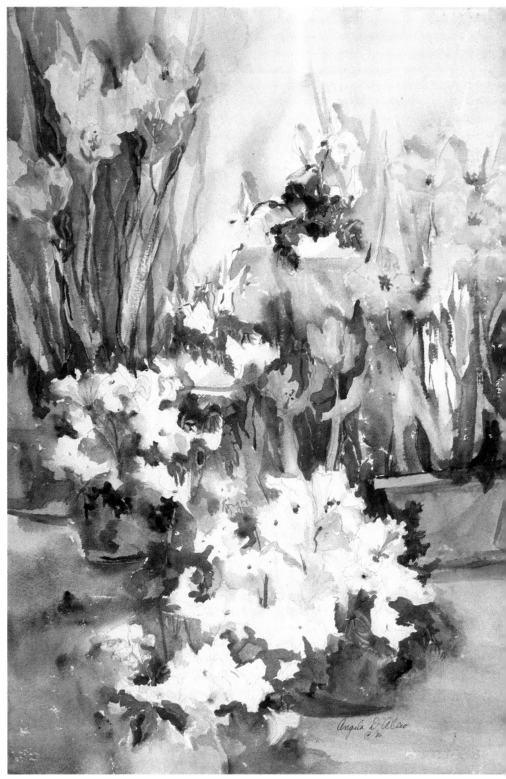

FLOWER SHOP I *collection of Gabbert's, Arches 140 lb., cold-pressed, 22" × 15" (55.9 × 38.1 cm)*

I used the same photograph as I did for Flower Shop I, but I worked this painting up some time later. This time, I saw the flowers with more lace. I wanted to make the arrangement airy and not crowded. The flowers I envisioned were cool. I applied the colors with a loaded brush of pure pigment onto dry paper. Within the wet globs of paint, I dropped in more color to give the flowers form. I did not use a structured drawing for this; I only allocated the main contour shapes. The detail of this painting illustrates how the calligraphy is a separate design from the wash. It was not intended to outline the flowers, foliage, and baskets, but it was meant to connect, describe, and decorate the shapes.

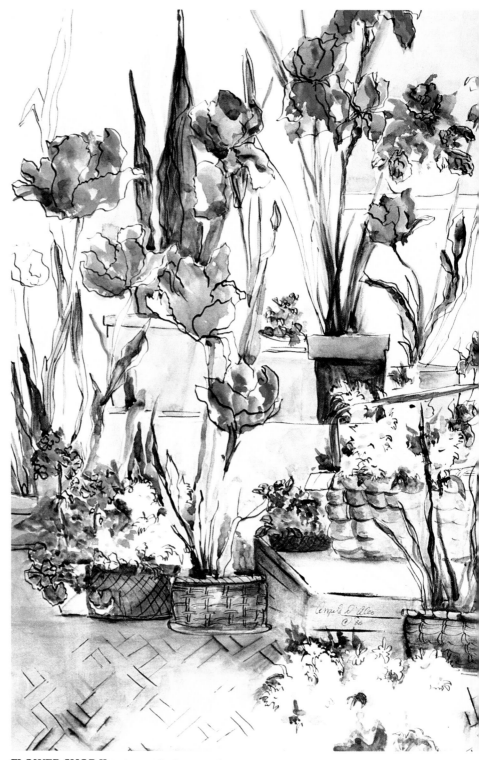

FLOWER SHOP II *Arches 140 lb., hot-pressed, 22" × 15" (55.9 × 38.1 cm)*

10 THINKING AND SEEING AS AN ARTIST

The ability to think and see as an artist is what can make almost anything into a painting. Without this special vision, we would overlook potential subjects for a painting. As Robert Henri once said ". . . there are lots of clever people who can paint anything, but lacking the seeing power, paint nothing worthwhile."

Take the scene of Baker's Pond, in describing it we could say it is a picture of a barn with a silo that is surrounded by trees. There are mountains in the back and a pond in the front. Or it could be described as a good light shape (the barn with silo and connecting road make a good shape) that is surrounded by interesting darks (the foliage and mountain). The pond area is intriguing because it is where the sky colors are repeated. An interlocking shape of tall grasses also connects the foreground with the middle ground.

The first description is the basic information our eyes quickly tell our brain. This process of recognition takes almost no effort. The second description is how an artist sees the subject and then works to translate it into painting terms. This is the language that is used to paint pictures.

Every subject has to be broken down into shapes, colors, dominances, and motives. Seeing the color of the sky and saying it is blue is not helpful. But it is helpful if you say that the sky has a deep, cool ultramarine blue that gradually changes to a lighter, warmer cerulean blue. If there are clouds, think of them as shapes. Look at the positive shape of the cloud as well as the negative shape (the spaces of sky between the clouds). Notice the soft, hard, and rough edges. To look at a tree and say it is an elm or oak will force you to paint a preconceived vision of it. This stock technique will yield a painting lacking expression. Look at a tree and think of it as a shape. The spaces between the foliage are also shapes. Notice the darks and the lights within the tree. Think of what makes that tree special.

Anything we look at can be put into painting terms. When an artist is studying a subject for a possible painting, it is hard work. Many questions are looking for answers during this important contemplative time. The trick is to know what questions to ask about seeing:

- What are the specific colors?
- Does the color grade from light to dark or from dark to light, and in which direction?
- Are the colors intense or muted?
- What shape, or shapes, is the subject?
- Can the shape be connected with other shapes around it?
- Is there anything interlocking the shapes?
- Are the negative spaces good shapes?
- If I squint, do I see a good dark and light pattern?
- Do the various shapes have hard, rough, or soft edges?

The thinking part of this discipline also requires a question and answer series:

- What is it that interests me about this subject?
- What and where will my focal point be?
- How will I get the viewer to look there?
- How will I capture the viewer's attention throughout the painting and in my focal point?
- What will be my directional, temperature, area, and color dominance? What will be my subdominance?
- What technique will I use to express what I want to say about the subject?

This all seems like so much work, but it gets easier as the process of thinking and seeing like an artist becomes instinctive. There are no shortcuts and no quick gimmicks to producing fine art — only hard work that yields lasting rewards.

What I saw here was a good white shape (the house, barn, and silo) surrounded by darks that were also a good shape. I saw the pond as a good place to repeat the colors of the sky and foliage.

There are two sketches here; I did not like the upper one but liked the lower one. In making a statement like the one you just read, I demonstrated how I was not thinking like an artist. The following is the proper description for evaluating these two sketches: I worked out the top sketch and was not satisfied with the space division. It divides the painting in half at the pond's edge and does not give me an area dominance. In the lower sketch, I adjusted the allocation of the shapes by lowering the pond slightly and reinforcing the values.

BAKER'S POND SKETCH *pencil on drawing paper, 11″ × 8½″ (27.9 × 21.6 cm)*

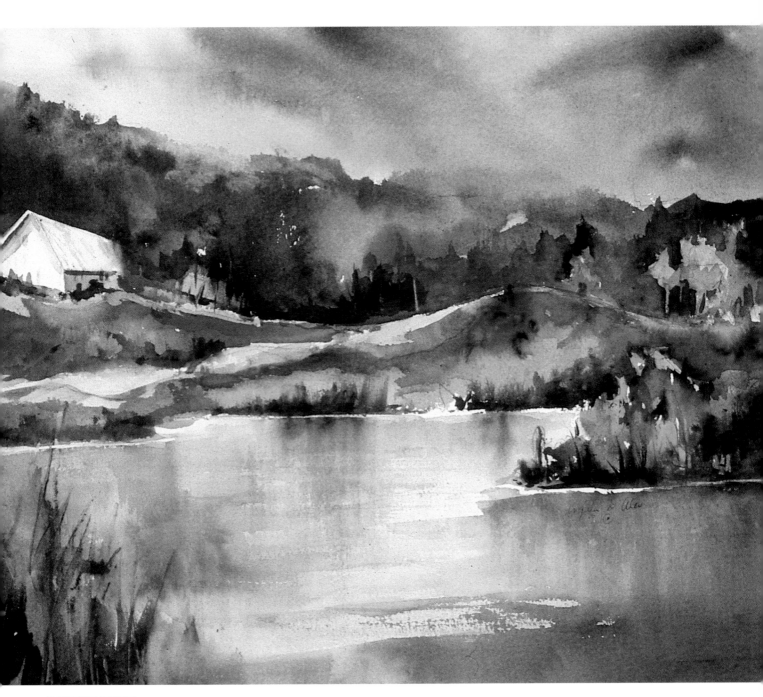

BAKER'S POND *Arches 140 lb., cold-pressed, 15″ × 22″ (38.1 × 55.9 cm)*

In this piece I painted wet-into-wet using Prussian blue, yellow ochre, burnt sienna, and cadmium orange. While the paper was wet, I worked in all my midtone values in the sky, middle ground, and foreground and left the water and house areas white. When this wash was partially dry, I painted in the mountain in the background and some darker values in the middle ground where I wanted soft edges. Before this area dried, I scraped out the light pattern of the road using a plastic spatula. I dried the painting completely and then added the glazes to the pond.

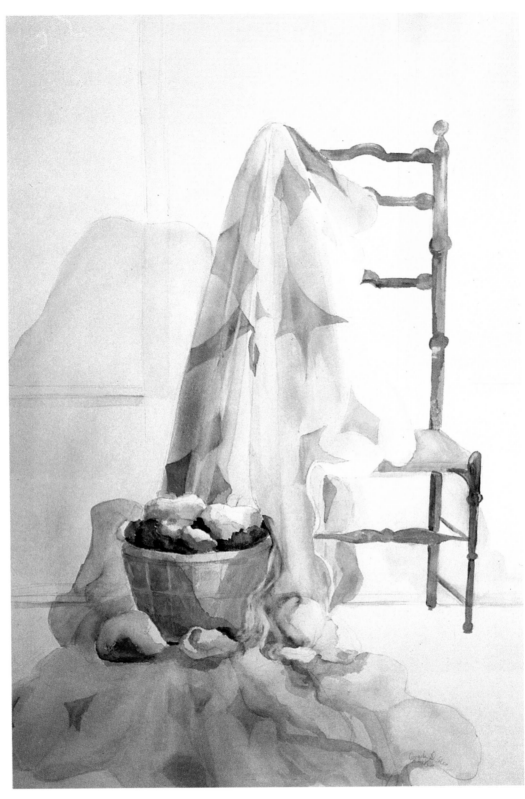

STILL LIFE OF A CHAIR *Arches 140 lb., cold-pressed, 30″ × 22″ (76.2 × 55.9 cm)*

Once I observed and thought about the subject and went beyond the literal elements, I proceeded to interpret how I wanted to paint this still life.
 I emphasized the shapes, played down the fussy details, and reduced everything down to its barest essence. By using pastel colors, I preserved the feeling of simplicity. Only three colors were used in this painting (a triad of rose madder genuine, cobalt blue, and aureolin yellow).

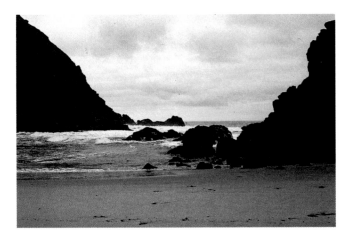

This area of California offers so much to paint. Working with my photographs, I was able to select the areas I wanted to focus on. A series of Big Sur paintings will be needed to show it all.

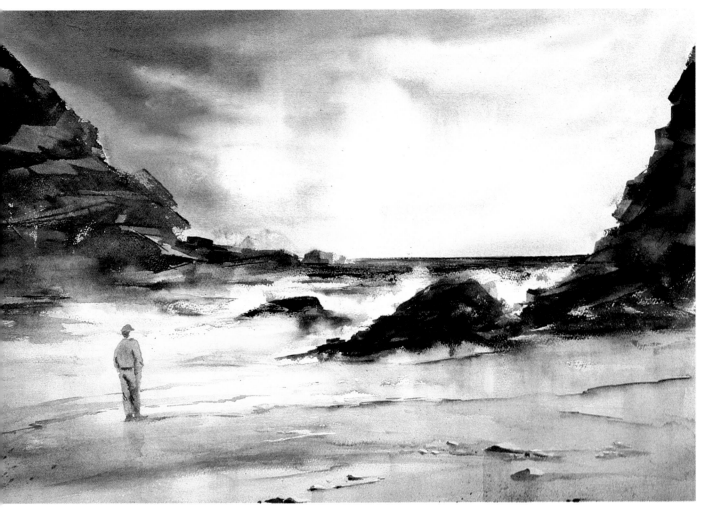

BIG SUR *Arches 140 lb., rough, 22″ × 30″ (55.9 × 76.2 cm)*

Since the rock formations were to be the predominant shapes in this painting, I underglazed them to accentuate their color and value. (I used the underglazing of darks technique.) I thought of them as connected shapes and this helped me to create a good design. I repeated the colors of the wet sand in the areas above and below it. The sky was not where I wanted to focus the attention, so I made sure this area remained quiet. The figure was added to give the rocks perspective and to add a focal point.

11 EDITING

Editing is as much a part of the painting process as any of the other elements involved. The process requires the artist to finish the work before it is ready for the public. The changes can be extreme or slight. Editing is done in all the arts, and it is expected as part of the creative process. Why is it then that watercolorists feel everything in a painting must be perfect the first time around?

Editing does not mean overcorrecting or fussing with a painting when you add those unnecessary, thoughtless strokes. The time to edit a painting is when it is bone dry. When we can stand some distance away from it, to see the whole picture. Judging a work too hastily may ruin a potentially great painting. Changing a color that looks wrong when it is still wet is futile. The paint must be dry to show its true intensity and value. Viewing a painting the next day will reveal its true colors. When the painting is totally dry, the physical properties of the paints begin reacting with one another. The pigments begin to separate and return to the surface. They reveal a new sparkle and glow to the watercolor painting that did not show immediately. Corrections of scrubbing out are done easily when the paint and paper are dry. The paper is vulnerable when it is wet and can be marred.

The extent of successful editing that can be done on a watercolor painting is dependent on several factors:

the type of paper

the colors used

the type of editing

the size of the area to be edited

When we think of editing, we associate it with correcting. But editing can be where we finish a painting. The point where we put down the necessary and planned last strokes, an additional color, or a glaze to tone down an area. We may also want to connect a shape or use calligraphy to unite some areas. These are some simple examples of editing.

The more difficult editing is when we need to take a color or shape out of a painting. When a watercolor painting is done on a good heavy paper such as Arches 140 lb., a reasonable amount of scrubbing and sponging can be done with little or no trace of the correction. To be done properly, a natural sponge is a must (it will not scratch the surface of the paper). The cosmetic size works well for small areas. Before sponging the area to be lifted, you should block off the rest of the painting with masking tape or a flat, nonporous surface (a plastic playing card, a piece of acetate, a piece of mat board, or an old photograph) to protect the rest of the painting from the damp sponge. The clean, damp sponge should be gently stroked over the area to be lifted until the desired amount of pigment is lifted. If it is a staining color, some pigment may remain. The paper's durability will determine how much scrubbing can be done. Keep rinsing the sponge in clean water to ensure the best results. By using a tissue to blot up the excess pigment and water, you will keep things neat. After an area is sponged out, allow it to dry completely before modifying it.

When a large area needs scrubbing out, the paper should be placed in a tub of water large enough to fit the entire sheet. As soon as the painting is submerged in clean water, you can begin editing. Carefully scrub with a sponge or brush only the areas where the pigment is to be lifted. Try not to keep the painting submerged for more than fifteen minutes; the pigment will begin to dissolve and washes will lighten. If done properly, no pigment will lift from the paper unless it is disturbed. After the editing is completed, you can remove the paper from the tub and allow it to dry thoroughly on a board. This method allows large areas such as a sky or foreground to be edited. It can also be used to rewet the paper to work wet-into-wet.

The lifting of small areas can also be done by using a flat, stiff chiseled-edged brush. Again, work should only be done only after the paint and paper are dry. Dampen the brush and proceed to lift the pigment; rinse the brush in clean water after each stroke. This method is very useful for lifting highlights, horizon lines, windowpanes, stems, water reflections, and other vertical and horizontal lights.

Saving the Whites

There are a few preliminary precautions that can be taken to cut down on the amount of editing that may be needed later. Since most editing involves reclaiming lost whites, the following are some ways to protect your whites.

Masking fluid, *liquid frisket*, and *maskoid* are the names of some resistants. They come clear or tinted and can be applied with a brush to the shape you want to keep white. Allow the resistant to dry before you begin painting. After the painting is completed, the resistant can be removed. This method provides freedom to apply large washes without having the paint run into small white areas. Maskoid creates a hard-edged shape that must be taken into consideration. It can also be applied in an unstructured way; by splattering maskoid on a painting, you can create

interesting, irregular-edged shapes.

Masking tape can be torn or cut to create shapes. Torn strips of masking tape can make irregular shapes that can be used to create birch trees, figures, flower shapes, foliage, ruts in the road, wooden fence posts, rocky edges, and distant hills. Cut pieces can be used for structured shapes such as chimneys, windowpanes, straight stems, rooftops, horizon lines, sailboat masts, and picket fences. A large area can be blocked off with masking tape to protect it from spraying, spattering, or running washes.

Clear contact paper (or *frisket*) is a thin plastic film with a low tack adhesive backing. It is a popular resistant that is used in airbrushing. Using an X-Acto knife, intricate shapes can be cut out of this masking material. The positive shape cut from the frisket is placed on the dry, unpainted surface of the paper. When paint is applied, the frisket will prevent the paint from soiling the areas covered. After the painting is dry, the frisket is removed and the shapes can be modified. The disadvantage of frisket is that it can only be used once. You must also be careful when working wet-into-wet that the water does not lift the frisket and allows the pigment to seep under it.

Working around white shapes is the method of saving whites that gives the artist the most control. It is available if you forget to use a resistant on an area. When working around the white shapes, you can decide on the type of edges you want. An edge can be softened, made crisper, or rough-brushed. Never leave an edge to chance. Always know what kind of edge a shape, especially a white shape, is to have. When working around the white shapes, save the modifying for last. Wait until everything has been evaluated. If this rule is followed, very little editing will be needed to claim lost whites. But like all rules there are times when they are not followed, and you must reclaim the lost whites.

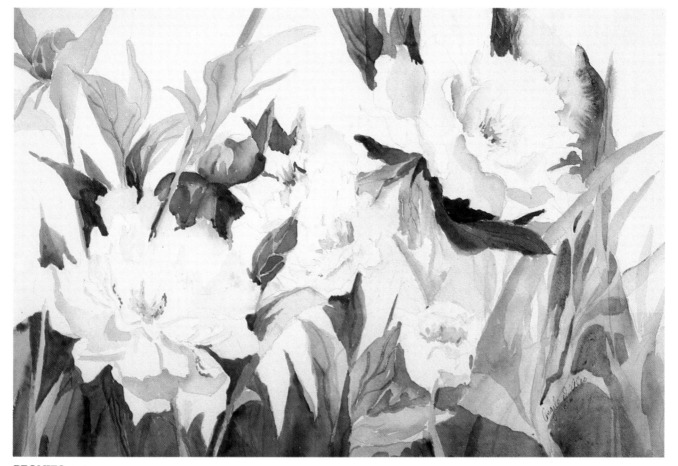

PEONIES *Arches 140 lb., cold-pressed, 15″ × 22″ (38.1 × 55.9 cm)*

Working around white shapes will give you the most control over your edges. In a painting where there are many large white shapes, this is the most efficient way of saving the whites. With so many whites in this piece, the editing of this painting was done by toning or modifying the whites rather than saving them. They had to be read as white but not be left unfinished or ghostly white. In modifying the flowers, I used the colors green (the olive color of the foliage) and pink (rose madder genuine) to create a gray. Throughout the painting the pinks and greens were interwoven.

Working wet-into-wet, I established my overall pattern by creating a fusion of the snow, sky, and foliage colors (burnt sienna and cobalt violet). By masking out the small areas, I was able to put my entire wash on without breaking the flow. I didn't have to work around small detailed areas or have to edit them later to get them back. Since this type of masking leaves a hard edge, I did not use it for the snow or for the light suggestion of trees in the background. I worked around the snow, and the trees were scratched out after the paint dried.

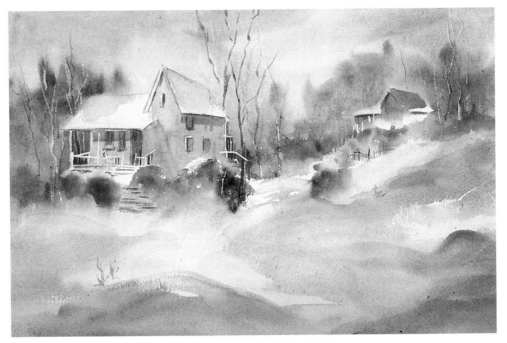

GLOW OF WINTER *Arches 140 lb., rough, 15″ × 22″ (38.1 × 55.9 cm)*

This painting was created with a triad of staining colors: indigo, Indian red, and yellow ochre. These colors made it critical for me to keep the bird shapes white. This delicate editing procedure needed the appropriate protection. Frisket film allowed me this kind of control. I drew the birds directly on the film and cut the shapes out with an X-Acto knife. I then placed the cut frisket on the dry, unpainted surface. This would protect the bird shapes from the sky wash I was about to apply. When the painting was dry, the frisket was removed and the sea gulls were modified.

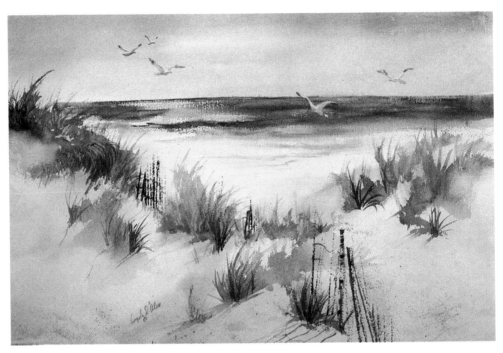

WHERE THE SEA GULLS LIVE *Arches 140 lb., rough, 15″ × 22″ (38.1 × 55.9 cm)*

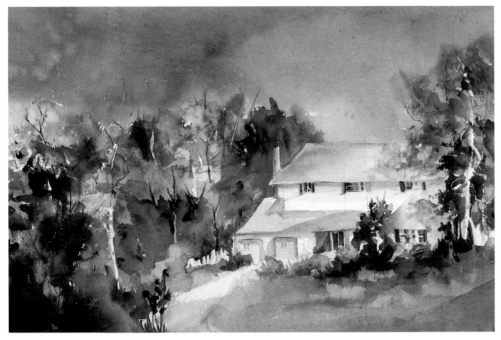

To make the house in this painting a better shape, it was necessary for me to connect it with the picket fence and white birch trees; it would then be two different dimensions— oblique and interlocking. Because these added on shapes were smaller and more detailed than the house, I knew working around them would be difficult. As a solution, I used masking tape to protect these shapes. Because I wanted birch trees, not telephone poles, I ripped the tape instead of cutting it. But to get crisp edges for the chimney and picket fence, I cut the tape.

ANNA'S HOUSE *Arches 140 lb., cold-pressed, 15″ × 22″ (38.1 × 55.9 cm)*

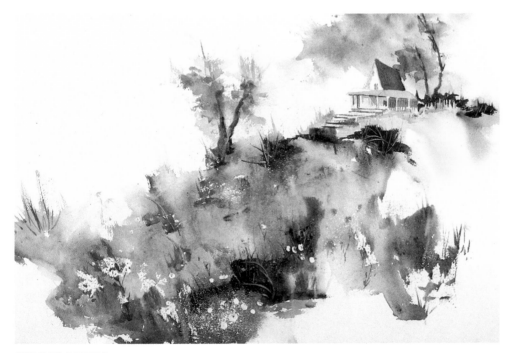

In this vignette I wanted the suggestion of something light and bright in the large foreground to entertain the viewers. The character of the painting would not tolerate structured flowers so I decided to preserve the lights by spattering masking liquid on the dry, unpainted foreground. I controlled the range of spattering by placing tissues to protect areas where I did not want the masking to go. When the masking dried, I freely applied paint to all areas. When the painting was dry, I removed the masking and modified the whites.

WILD FLOWERS *Arches 140 lb., cold-pressed, 15″ × 22″ (38.1 × 55.9 cm)*

Reclaiming Whites

Many artists working with watercolors choose not to use white paint. Instead, they use the white of the paper as their light/white shape. Sometimes it is lost by error. There are times when the white is intentionally covered only to be reclaimed for a specific effect. Whether intentional or not, there are many ways of recovering lost whites. Each method will yield a different outcome.

Scraping is done while the paint is still wet. By using a knife or plastic spatula, you can scrape away the pigment and create a light (not a white but a light). Depending on the colors and how heavily they are applied, you will be able to determine how light the surface becomes. (If the surface is too wet and is scratched, the paint will fill in the scratch and create a dark line.) This method will give you an irregular shape. When a knife is used, this shape will be in the form of an irregular thin line which can suggest stems, veins in leaves, rigging on boats, floor plankings, window frames, and ornamental markings on buildings. When a spatula or any broad-shaped scraping implement is used, more pigment will be pushed, leaving an irregular broad shape. This can be used to create paths, rocks, cliffs, highlights for an area, flowers, trees, and foliage.

Stenciling is the method where the outline of the shape to be reclaimed is cut from acetate. The stencil is reusable and can also be turned around to reverse the shape. The acetate comes in varying thicknesses. The thicker acetate lasts longer and will not shift while being scrubbed, but it is more difficult to cut detailed stencils. To use the stencil, lay it on top of the area to be sponged out (make sure the paint and paper are dry), and with a soft, natural clean sponge gently lift up the pigment. Stenciling creates a more subtle white/light shape than masking tape or frisket, and it gives a more controlled shape than scraping. When a softer look is desired, this method is to be considered. It can be used to create flowers and foliage shapes, sea gulls, rooftops, figures, puddles, fences, boats, or any other shape desired in a painting.

Scratching is different than scraping. A sharp pointed object, a razor's edge or pin, gently picks out small areas of pigment from the surface of a dry painting. This will create a sparkling effect. The paper will tear if this process is not done carefully. Scratching should be used sparingly or it can look overdone and lose its effect. With this process you can create stems, flower centers (especially scratching highlights out of flowers with dark centers), small wet areas on rocks, or the glistening effects of water.

Creating a light illusion is the method to use if the whites are hopelessly lost. The illusion is created by placing a darker value behind the area to be reclaimed. By doing so, you create a light that pops out. This is also referred to as *negative painting*. In this process, you can bring out any shape by making it appear lighter. This is a valuable skill in watercolor painting.

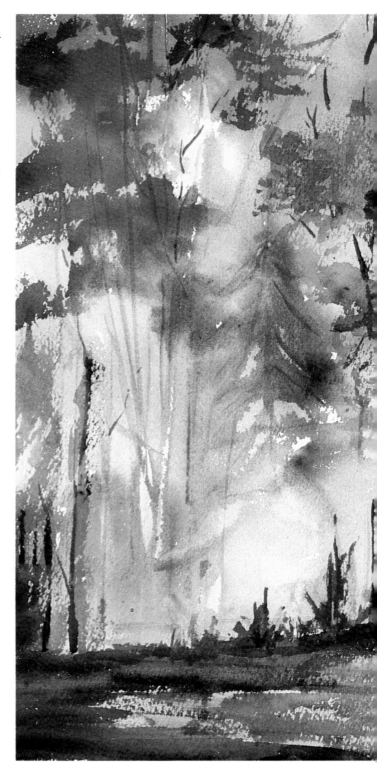

I filled the paper with wet loaded washes of color, allowing no boundaries to stop its flow. The suggestion of trees gives the viewers something to focus on. To reclaim my lights, it was necessary for me to scratch the tree shapes out by using the point of a knife. This was done while the paint was still damp. The irregularity of the line as well as the stain of color left on the paper give the suggestion of trees, and little or no modifying was necessary.

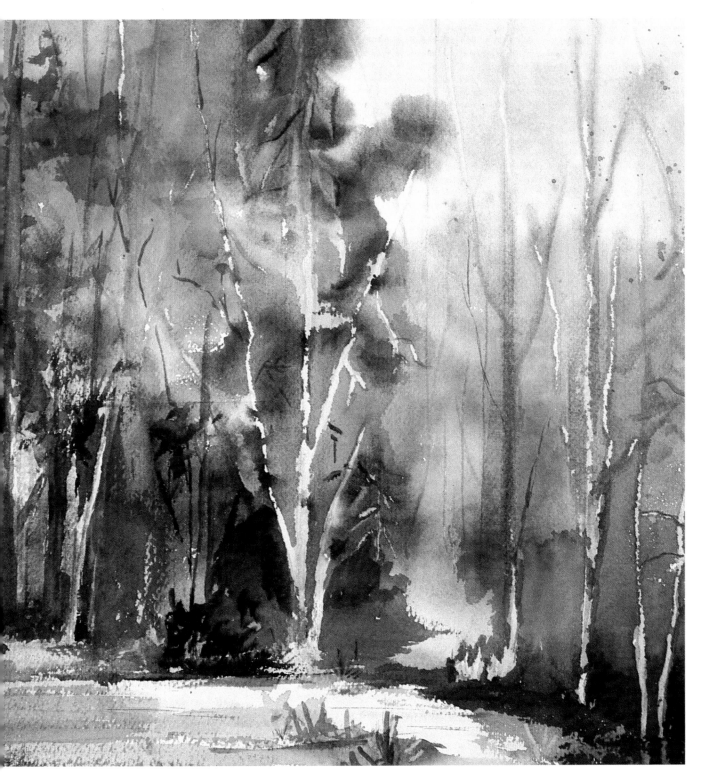

FOREST INTERIOR *Arches 140 lb., cold-pressed, 15" × 22" (38.1 × 55.9 cm)*

12 CRITIQUING YOUR OWN WORK

There comes a time when you will be the only one who can judge your paintings. You cannot rely on what has been done in the past or what is being accepted now. It is up to you to set your own standards and to understand how to judge. The philosopher George Santayana once said, "We are confirmed or made happy in our doubtful opinions by seeing them accepted universally. So people who have sensations and do not know why they judge, are always trying to show that they judge by universal reason."

Sometimes, hearing the name of a famous artist will cause a preconditioned response. This may determine how we react to his or her painting — even before seeing it. This means never being able to view the painting objectively. If we could put these preconditioned responses aside, how would we judge portraits painted by Sargent, Daumier, Rembrandt, or Picasso? Would it be based on the subject (whoever did the most appealing personality)? The one that captured the best likeness? The one that had the best technique? Or the colors that were used? We are told by the art world arbiters that they are masters, and we assume they must be good. But if they were unknown, what would be our reaction to their work?

To judge an artwork by any artist, even our own paintings, we must distinguish *arbitrary preference* from *value judgment*. We all innately possess arbitrary preferences. Based on our emotions and prejudices they qualify our likes and dislikes. It is our value judgment that needs to be cultivated to critique a work. Even if we do not like a painting, through value judgment we will understand why. But more important, we learn to appreciate and tolerate a wider range of art. Criticism, to be effective, must be objective and based on intellectual reasoning and deduction. It cannot be based purely on an emotional response. Constructive criticism will give the solution to a problem. To judge a painting by how well it fits in with the decor of your home does not give constructive criticism to an artist looking for a value judgment. It does not help us to understand and broaden our own vision of what and why a painting works or does not work.

The most difficult paintings to judge objectively are the ones you paint — often blinded by emotional involvement. One of my favorite authorities on art, John Canaday, has stated, "It is usually easier to explain what is wrong with a picture than to show what makes it good. The better a picture is, the more likely it is to communicate in terms that cannot be expressed as well in any other medium."

When I have a painting that needs to be critiqued, I must look to my own instincts and judgments to find a solution. The first step is to view it from a distance. Walk away from it to refocus and become less emotionally involved. This sounds obvious but I have seen many artists, after painting for several hours, stand only a few inches away from their work to try to critique it. Then they hastily determine how awful the painting is and drop it into a sink filled with water to be scrubbed out.

To properly critique a painting, you must wait until it is completely dry. You also need to stand a few feet away from it. Verbalizing to yourself, or others if necessary, what is bothering you about the painting is one way of pinpointing your feelings. You should try to state specific points and stay away from the general statements such as "I hate it" or "it's terrible." In order to improve your paintings, you need to understand the reasons why you do not like the artwork.

Study the painting from all angles. View it in different lighting. Dim lighting will distinguish shapes and values clearly. This type of light will take your focus away from the subject and into the design. If a painting is a real problem, you may want to leave it up to be viewed for a few days or a couple of weeks. Constantly looking at it with a fresh eye, or renewed senses, will give you different perspectives. There are also times when I will be looking to see what to do next, and then after a long study I will realize the painting is finished.

Try putting different size mats on the work. By focusing in on specific areas, you can isolate sections which may be helpful in analyzing problem spots. Look at the painting in a mirror or hold it upside down. Anything we can do to make us look at the painting in different ways will help us determine if we are pleased with the results.

Critique Checklist

When standing in front of a painting you want to critique, there is a logical and constructive way to evaluate it. By using this checklist, you can cover all the major points needed to conduct a successful critique.

1. Do I have a point of interest, and do the viewers know where to look for it?

A focal point can be two things: the starting place for the viewers, or the most important part of the painting (the object or shape that the painting's motive is based on). Not knowing where or what to look at in a painting can be a major problem. One solution is to develop a focal point that has sharp values. Other solutions are to use bright colors or to show a temperature contrast in the focal point. Giving the viewers a clue as to what they must look at keeps them interested in the artist's intention.

A variation of this problem is having too many focal points. This may happen when there are too many interesting details in the subject. Each one calling for attention, and you are not sure which one should be the star. When this is the case, do more than one painting of the subject and in each painting choose a different part to be the focal point.

2. Is the focal point a good shape, and is it in a good place?

You may have a focal point, but there still may be something wrong. Once you call attention to an area, it needs to be interesting, otherwise there is no reason to look there. Making an object a good shape before it is a subject can be the key point to a painting's success. If the focal point is not a good shape, try to connect it to another shape. Another solution is to add a shape to the existing one. If the focal point is a good shape, but in a place that directs you out of the painting, then moving it will be the solution.

A good place for the focal point is off-center and not too close to an edge. There is a natural tendency for viewers to focus on the center of things. If you direct the viewers' attention elsewhere, they will naturally come back to the center, but only after they have traveled around the painting. Having the point of interest too close to the edge will lead the viewers right out of the painting. There are times when an artist may intentionally place the point of interest in the center or up against an edge and it may work, but the careful balancing of all the elements are necessary.

3. Do I direct the viewers through the painting, or do I direct them out of the work?

If there is no way for the viewers to get through a painting, it will be passed by quickly. If you feel your vision is being directed out of the picture, or you are not sure where to focus next, then that means too much emphasis was placed on painting isolated things. This stifles the rhythm that shapes and values can create. Usually, spotty darks and popping lights cause this to happen. This problem can be solved by connecting shapes and readjusting values—toning down the popping, aggressive whites, and/or lightening the spotty darks.

4. Do I have good negative and positive shapes throughout the painting?

When concentrating on painting a specific subject (a flower, a person, or a house), you usually think of it as the positive shape. Many times you accept it as a good shape because you like the subject for what it is. But when you view the subject for a period of time, you may realize the shape needs more definition. It is also possible that the subject may have a good positive shape but a poor negative shape. This is usually simple to correct. The edges of the positive shape can be softened so that they blend or overlap with the negative shape. This will create a new shape. Interlocking positive and negative shapes will also change the shape without altering the subject's identity.

5. Do I have dominances and subdominances of color, temperature, direction, and area?

If you are unhappy about a painting, it is probably because there is a lack of dominances. They are easy to check and most often easy to correct. If you discover that there is no area dominance, sometimes adjusting the mat will solve that problem. If the painting is too warm or cool, add a touch of the appropriate color temperature. If there are only obliques or curves throughout the painting, add a slight conflict. The problem of no color dominance can be solved by finding the most predominant color and imposing it wherever possible.

6. Do I have good relationships?

If all the objects in a painting are scattered around the paper, you will have poor spatial relationships. (It does not matter how beautifully the objects are painted.) You must also determine if colors and values have good relationships. Having all similar elements painted in a vertical or horizontal line may cause problems for you. This may be solved by relating them obliquely. Remember, repetition with variety is the solution to many of these problems.

7. Is my style consistent?

Working in different styles in one painting can cause disunity, unless it is intentional. For example, you would not paint a landscape in Turner's style and then insert a house painted like Wyeth in the same painting. No matter how well the handling of the subject may be, the inconsistency will cause the painting to lack conviction. Another problem may be when one part of a painting utilizes a specific technique, such as spatter, salt, calligraphy, or white paint, and it is not used in any other part of the painting. The technique will look out of place and accidental. It must be repeated somewhere in the painting with variation. The repetition can be very subtle or extreme.

8. Do I have too many distracting, unessential things in my painting?

This problem can cause a painting to become confusing, distracting, annoying, and lacking unity. Many times this will happen when you do not know what to do next. Or when the painting is not working, you begin putting in little details hoping it will fix the problem. The solution to this problem is to reevaluate the large shapes and get rid of all the unessential details in the painting.

9. Do I have enough interest in all areas to hold the viewers' attention?

Every part of a painting must be interesting and have a purpose. Background, foreground, negative spaces, and rest areas need to be entertaining. They cannot exist as parasites of the painted subject. A gradation that whispers a subtle change is guaranteed to engage the viewer in an area that is meant to be quiet. Darks need to be interesting. Nothing is worse than a large dark area that reads as an empty space. Underglazing can remedy that situation, or you can make darks out of rich colors (without overmixing) so that the colors can keep their identity. The focal point must be interesting in its shape, color, and value.

10. Do all my areas have variety in the way they were painted?

This is a common fault in any form of painting — treating each thing, shape, or color the same way throughout a painting. You find some technique or color that works in one part of the painting and repeat its effect throughout without variation. As a result, the painting becomes boring and overdone. Repetition with variety is the solution to this problem. An example of this would be if you were painting flowers and you painted the centers the same size, shape, and color. All the flower centers would have equal handling. The same thing may occur for the leaves. If you use the technique of scratching out veins on the leaves with a knife tip and handle each leaf the same way, there will be no variation. This analogy usually applies to any painting where similar objects are being painted. It is very common when a new technique is discovered to overuse it thoughtlessly. Variation and moderation are the key words. Repeating a technique is necessary but must not be obvious. If you try a color or technique in one part of the painting and love the way it works, resist the temptation to go around to all the similar objects doing the same thing to each one. Another tendency is when you have a color on your brush, to find all the places in the painting to put the color until it is used up.

11. Does the painting read from a distance, or is it to be viewed from closeup?

Working at an arm's length from a painting, and not stepping back occasionally, will bring you many surprises when it is viewed from a distance. Most paintings when hung will be viewed from several feet away. Therefore, the large shapes, values, and colors must be clearly distinguishable at a distance. If the painting falls apart when you see it at a distance, then strengthening the shapes and colors is the solution. Some paintings are meant to be viewed from closeup; they are small and have fine detailed work that demands close scrutiny. As the artist, you make the decision. You judge whether the painting meets the criteria you chose. Most paintings will read from a distance, lure the viewers closer, and then give them something to look at up close.

12. Do I have good technique?

When everything previously mentioned proves to be satisfactory, and you are still not happy with the results, then it may be that your technique is less than desirable. In painting with watercolors the worst offense is if the painting is not fresh and expressive of the medium. Muddy, overworked areas; careless edges; and poorly drawn objects can detract from the painting. When this happens, you should redo the painting or try some editing to see if it can be saved. Again, recognizing the problem means you can come up with a solution.

13. Did I fulfill my purpose?

Many times artists are not pleased with their finished paintings. Peers and admirers may think highly of the painting, but you may feel less than satisfied. If your purpose was not fulfilled or clearly identified, you will feel the painting is not right. When this happens, keep the painting but do another one. Restate your purpose and work out ways of fulfilling it in the new painting.

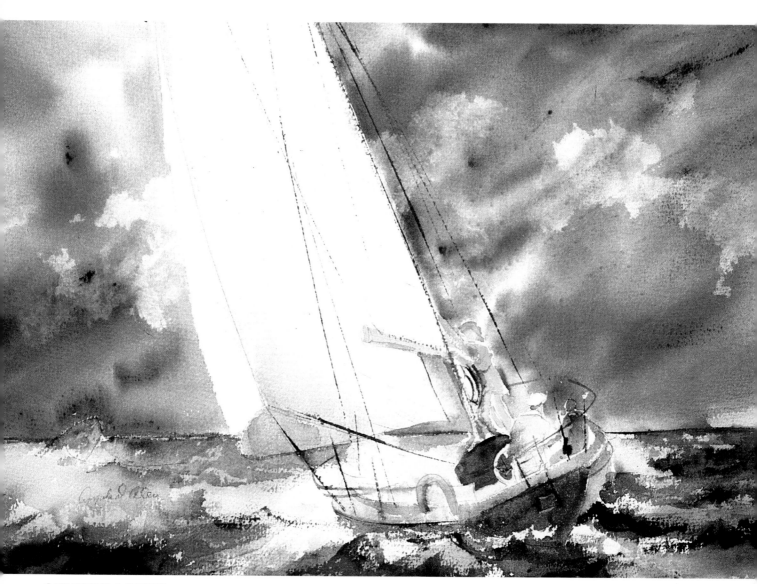

SAILING IN A STORM *Arches 140 lb., rough, 15" × 22" (38.1 × 55.9 cm)*

In this scene there were a number of factors I had to take into consideration. The focal point (the standing figure) needed a good shape and had to be in a good position. I needed to relieve the oblique directional dominance with subtle curves (the sail, rigging, and shape of the boat). I imposed a color subdominance of reds and yellows to the blue dominance. And I made sure that all my repetitions of the different elements were done with variety.

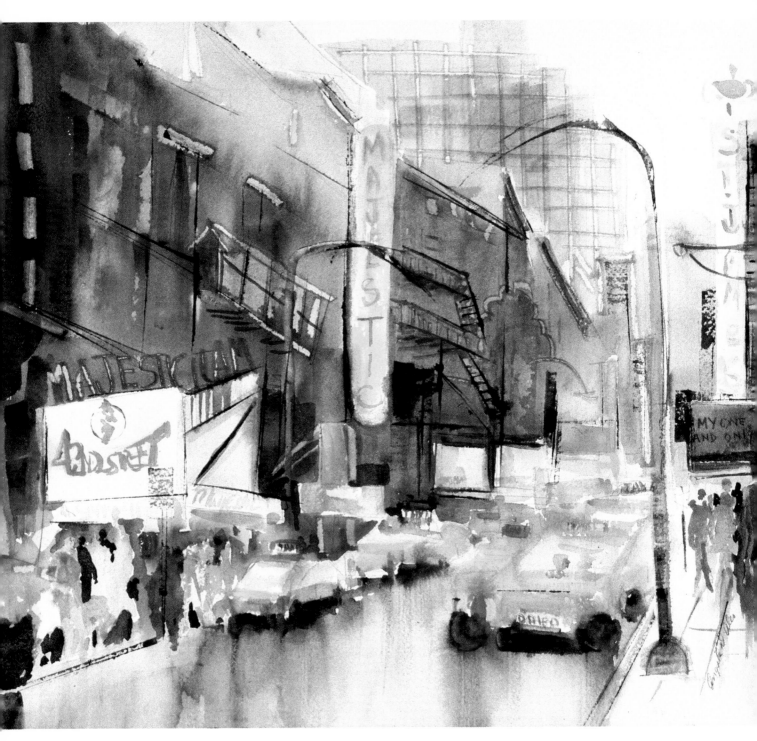

42ND STREET *Arches 140 lb., cold-pressed, 15" × 22" (38.1 × 55.9 cm)*

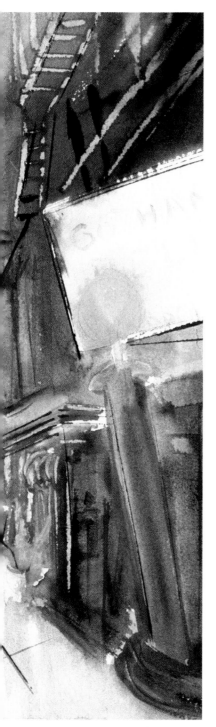

My purpose for painting 42nd Street was to capture the anachronistic character of the theater district with its old decorative buildings. I wanted the painting to express the emotions of the anonymous theatergoers (filled with their built-up anticipation of the evening to come). The movement throughout the painting had to be in tempo with the fast pace of the subject matter. Symbols were used for everything, so the viewer instantly recognizes things and moves on. Understanding my purpose clarifies the way the painting was executed. I must judge it from the standpoint of whether it fulfilled my purpose, and not whether it met anyone else's criteria.

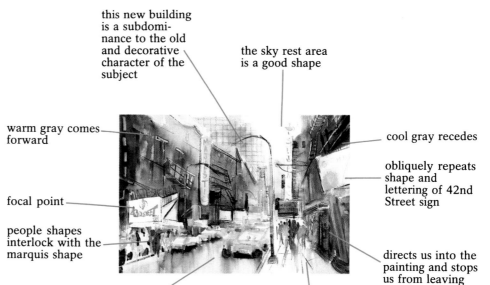

this new building is a subdominance to the old and decorative character of the subject

the sky rest area is a good shape

warm gray comes forward

cool gray recedes

obliquely repeats shape and lettering of 42nd Street sign

focal point

people shapes interlock with the marquis shape

directs us into the painting and stops us from leaving

street is a rest area that directs us in; it repeats the colors of the buildings

calligraphic markings point us in and repeat the rectangular dominance

13 WHEN IS A PAINTING FINISHED?

A painting is finished when you have said something special — no more, no less. You must possess restraint. I was told that paintings are never really finished, only stopped in a good place. It is important not to finish a painting to please the expectations of others. You get to choose the degree of finish you want your paintings to have. There are signals when a painting is finished, you just don't recognize them. A painting is finished when you do not know where to put the last stroke. You stand alone in making the decision that this is how you want the painting to be.

Every work of art can always have additions made to it — improving it or destroying it. A soft, pale painting can be made richer to bring out more color, but it will no longer be a soft, pale picture. More details can be added to a painting, but if the painting works without them, don't put them in. There are parts of a painting that should remain vague, especially if they are subordinate to the focal point. Everyone's idea of finished is different.

Most problems are not in finishing a painting, but in overfinishing one. Putting in too many of those last deadly strokes. The part of the painting that is tortured to death is usually around the whites. Afraid of losing the whites, we tend to overpaint the areas around them. In watercolor painting we work around our white shapes and modify them later. But the feeling of wanting to save the whites and keeping them pristine and untouched is a fear that must be overcome. Modifying the whites will probably be the finishing touches to the painting. Slight alterations can be done to the shape to make the whites work with the rest of the painting. It can be a pale glaze, a softened edge, a slight gradation to give form to the shape, or the addition of a shadow.

Going through the critique checklist, you will rationally and systematically be able to finish a painting; but always keep that rational part in check with the emotional part. There are times when in spite of all the rules, lists, and traditions, you know the painting is finished. When you feel the painting is right (it has said all it has to say), then do no more, for that is the final word.

After dropping in all my colors, most of them staining, I realized that the bouquet had no lights in its center. It looked like a big ball of color. Lights had to be added to this area. I cut stencils out of acetate, in the shape of flowers, and gently scrubbed to lift as much color as possible. The subtle remains that tinted the scrubbed areas created a good transition of values— these newly made shapes did not pop out or need modifying.

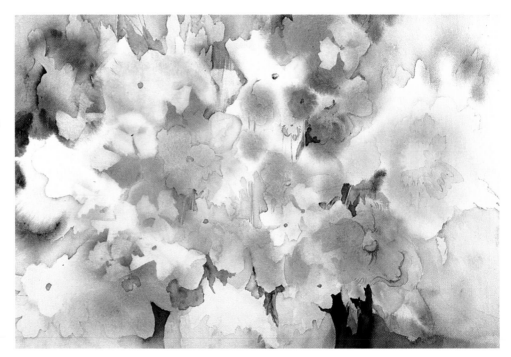

MARIE'S BOUNTIFUL BOUQUET *Arches 300 lb., rough, 15" × 22" (38.1 × 55.9 cm)*

In this painting, I concentrated so much on the lower white shape that I lost all my whites up above. Flower shapes were needed in this upper area, but I did not want dark flowers. By negative painting, I was able to create a light pattern in the areas around the large white shape that suggests small light flowers.

FINDING FLOWERS *Arches 140 lb., cold-pressed, 11″ × 15″ (27.9 × 38.1 cm)*

The painting process in this piece went so quickly that I never thought of it as finished. I chose to leave this painting in what I initially thought was the beginning stage of the work, but when I went back to complete it, I did not know where to put the things I intended to use.

I put the painting aside to study. As I looked at the piece, I realized objects would destroy the reverie brought on by the painting. There is a contemplative mood that the colors and movement suggest. In spite of contrary opinion, as to what others feel the painting needs, I declared it finished. It said what I wanted it to and I stopped.

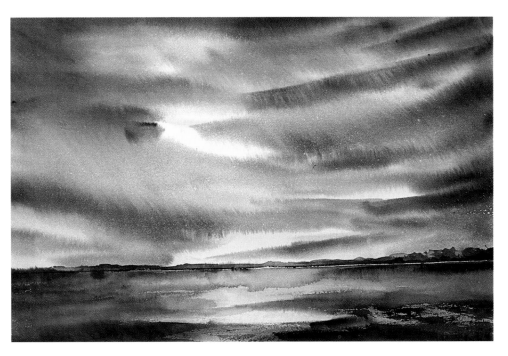

SUNSET *Arches 140 lb., rough, 15″ × 22″ (38.1 × 55.9 cm)*

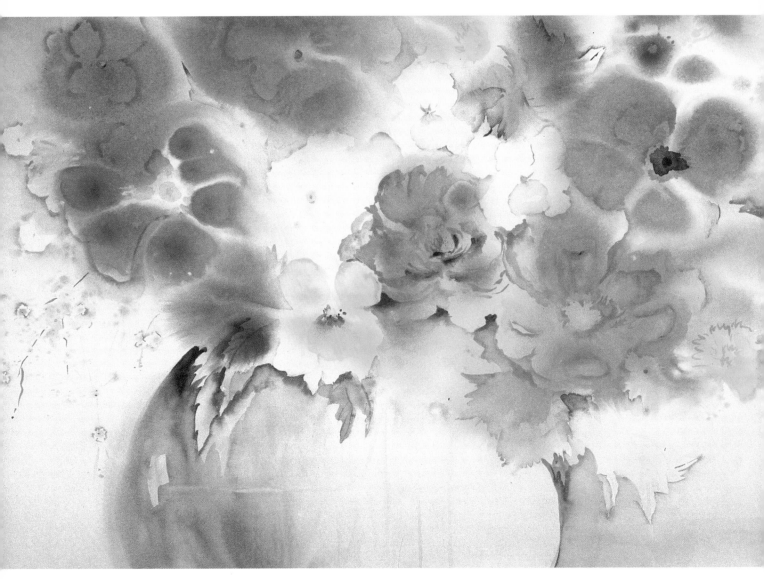

FROM JENNY'S GARDEN *Arches 140 lb., cold-pressed, 22″ × 30″ (55.9 × 76.2 cm)*

There is no doubt that this painting could be considered "unfinished." As the artist, I had to decide how far I wanted to go in describing the subject. A sense of mystery and viewer participation was achieved by leaving the outer flower shapes vague. The focal point was developed with the description of the yellow pansy and the adjoining pink peony.

BIBLIOGRAPHY

Canaday, John. *What Is Art?* New York: A John L. Hochmann Book, Alfred A. Knopf, Inc., 1980.

College Edition Webster's New World Dictionary of the American Language. Cleveland and New York: The World Publishing Company, 1962.

Henri, Robert. *The Art Spirit.* Compiled by Margery A. Ryerson. New York: Harper & Row Publishers, Inc., 1960.

Santayana, George. *The Sense of Beauty.* New York: The Modern Library, Random House, 1955.